D1271779

THE NATURE OF YOSEMITE

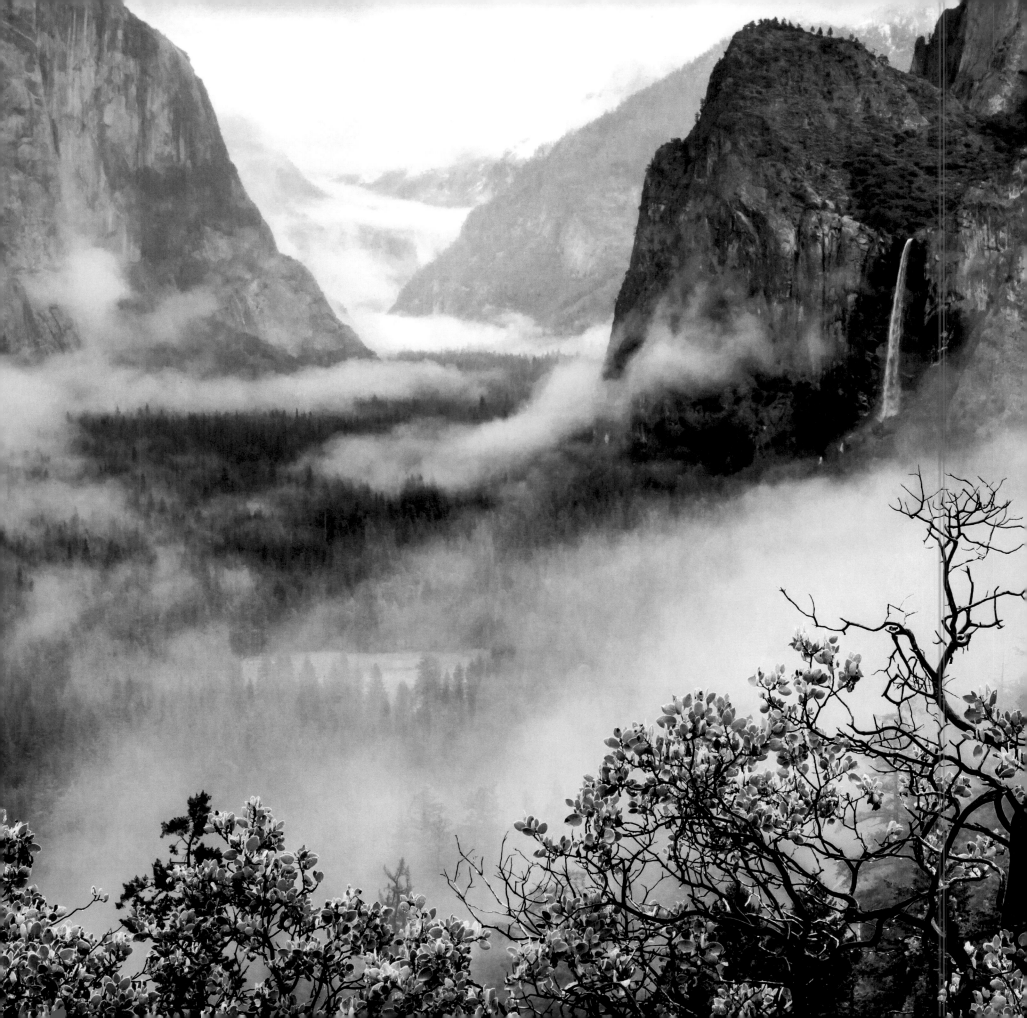

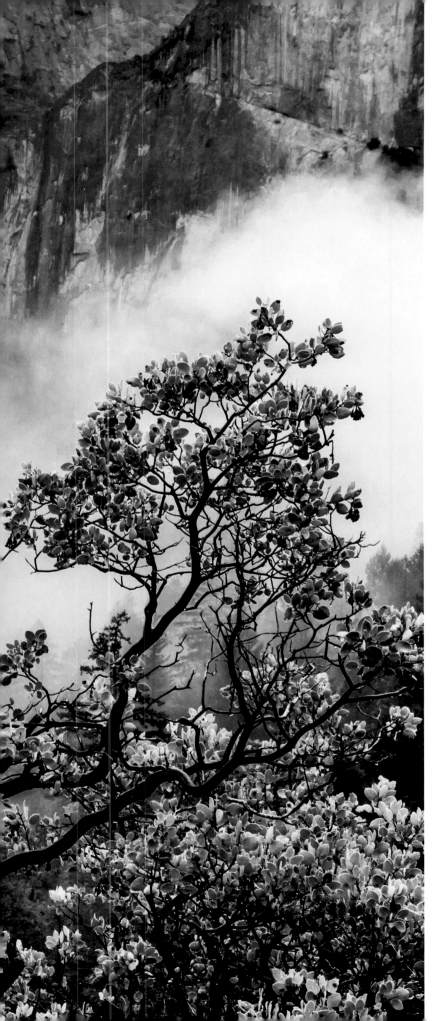

THE NATURE OF YOSEMITE

A Visual Journey

Robb Hirsch

FOREWORD BY JOHN MUIR LAWS

YOSEMITE CONSERVANCY
Yosemite National Park

Manzanita and Bridalveil Fall

Individual contributions copyright © 2019 by the individual authors, with the exception that the essays by Karen Amstutz, Rob Grasso, Nathan Stephenson, Greg Stock, and Sarah Stock are works of the United States government and are not subject to copyright protection in the United States.

All other text and photographs copyright © 2019 by Robb Hirsch.

Published in the United States by Yosemite Conservancy. All rights reserved. No portion of this work may be reproduced or transmitted in any form without the written permission of the publisher, except in the case of brief quotations embodied in critical articles or reviews.

YOSEMITE
CONSERVANCY.

yosemiteconservancy.org

Yosemite Conservancy inspires people to support projects and programs that preserve Yosemite and enrich the visitor experience.

Library of Congress Control Number: 2019933836

Book design by Eric Ball Design

Hardcover ISBN 978-1-930238-91-6
Paperback ISBN 978-1-930238-92-3

Printed in China by Artron Art (Group) Co., Ltd. through Crash Paper

1 2 3 4 5 6 – 23 22 21 20 19

MIX
Paper from
responsible sources
FSC
www.fsc.org FSC® C019910

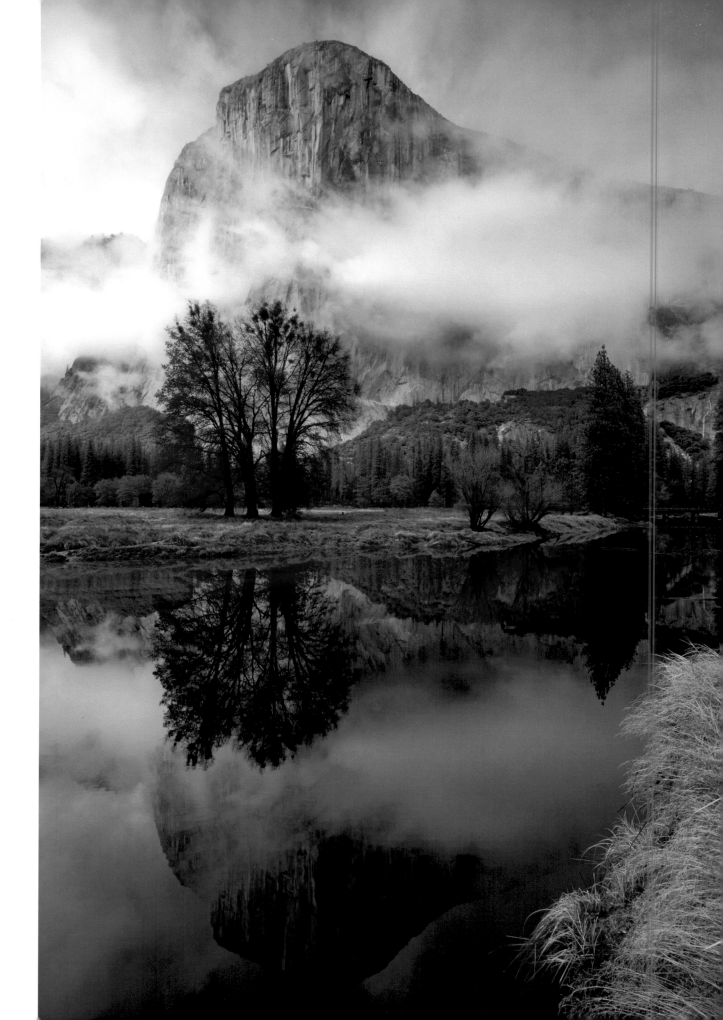

EL CAPITAN AND THE MERCED RIVER

For my son, Noah

MAY YOU ALWAYS FIND INSPIRATION
IN THE NATURAL WORLD

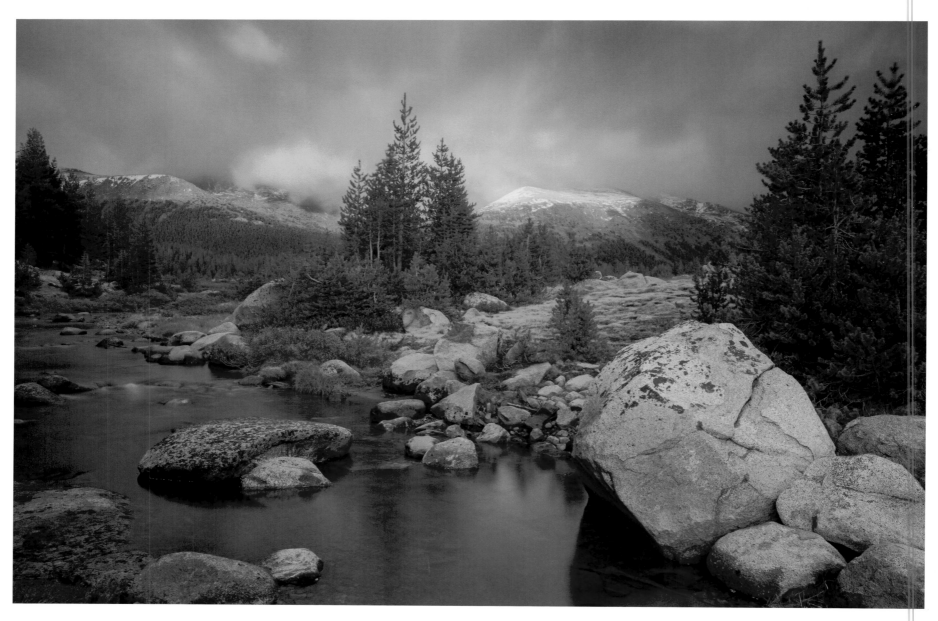

DANA FORK OF THE TUOLUMNE RIVER

CONTENTS

........................

FOREWORD ix

 On Wonder, Beauty, and Nature | *John Muir Laws*

INTRODUCTION xiii

VALLEYS 01

 Yosemite: Granting the Long View | *Adonia Ripple* 06

 The Influence of Art: Inspiring Appreciation and Protection | *James McGrew* 21

FLORA 29

 Sierra Wildflowers: An Alluring Beauty | *Dan Webster* 34

 Fire: Agent of Change and Renewal | *Kurt Menning* 41

 Giant Sequoias: Drama on a Grand Scale | *Nathan Stephenson* 47

 Leaf Litter: Where We Walk | *Pete Devine* 53

HIGH COUNTRY 57

 Tuolumne Meadows: An Unparalleled Landscape | *Karen Amstutz* 60

 The Rivers of Yosemite: Shaping Land, Nourishing Life | *Tim Palmer* 71

FAUNA 77

 Yosemite Birds: Diversity of Splendor | *Sarah Stock* 82

 The Pika: King of the High Country | *Beth Pratt* 89

 Yosemite Toads: Life on the Edge | *Rob Grasso* 96

WILDERNESS 103

 Yosemite Geology: Glaciers on Granite | *Greg Stock* 108

 The Water Cycle: Range of White | *Brock Dolman* 119

ACKNOWLEDGMENTS 125

ABOUT THE AUTHOR 128

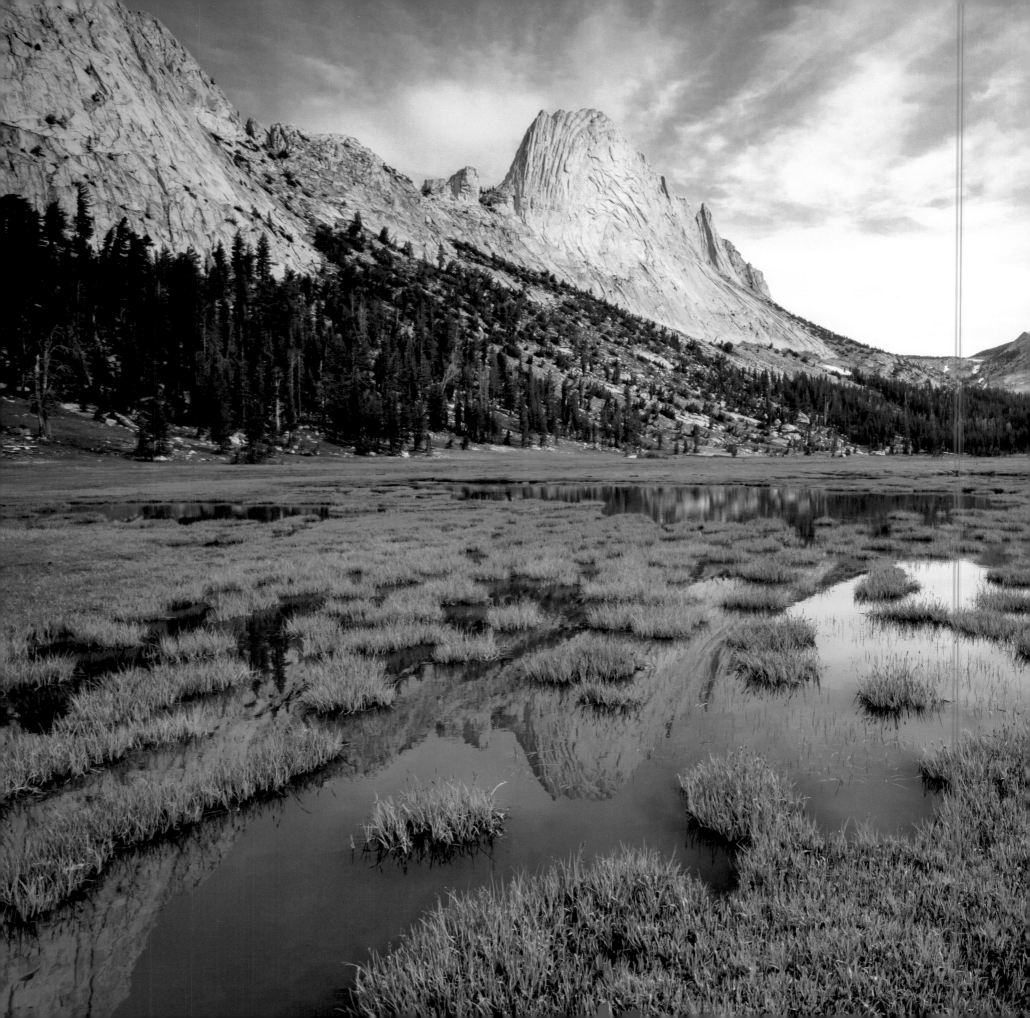

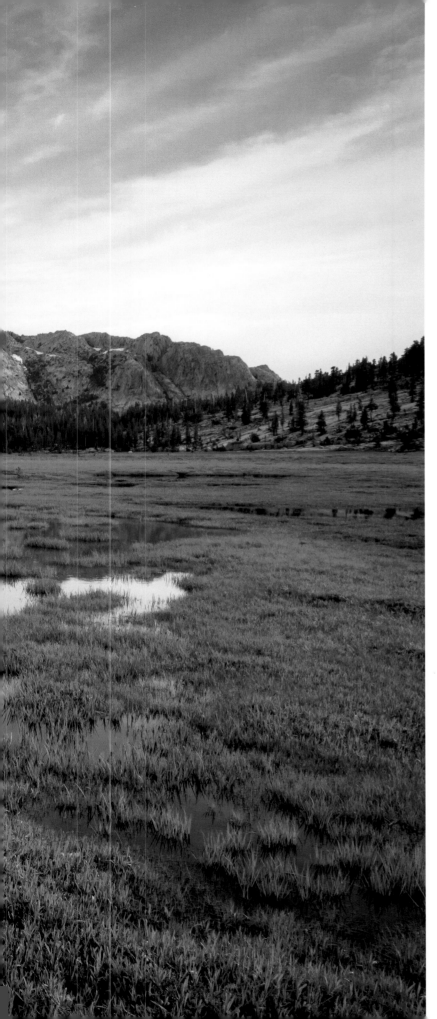

On Wonder, Beauty, and Nature

..........................

Yosemite is known worldwide for its beauty. The waterfalls and glacially sculpted domes and valleys have called generations of painters, writers, and photographers. The wonder and awe of Yosemite Valley inspired citizens to have their lawmakers protect this land and to develop the national park system. Few visit this landscape without being moved. Behind the grandeur are infinite layers of beauty, wonder, and complexity, that can be observed by those with the patience of a naturalist attuned to the senses and subtleties of the place. This allows for a deeper and more transformative experience of Yosemite. Robb Hirsch has spent decades immersing himself in the art, science, and history of this landscape. The images in this book are a window, not just to the glory of Yosemite but to a way of seeing. His photographs, informed by love and patient study, contain lessons for the photographer, naturalist, hiker, or curious rambler.

The first step to engaging with nature is to go outside. Build time in nature into your routine. You do not need to be in a national park or to go to great extremes or even to go someplace new to make discoveries. Any place where you can find plants or birds is a great start. Even if you only have

MATTHES CREST

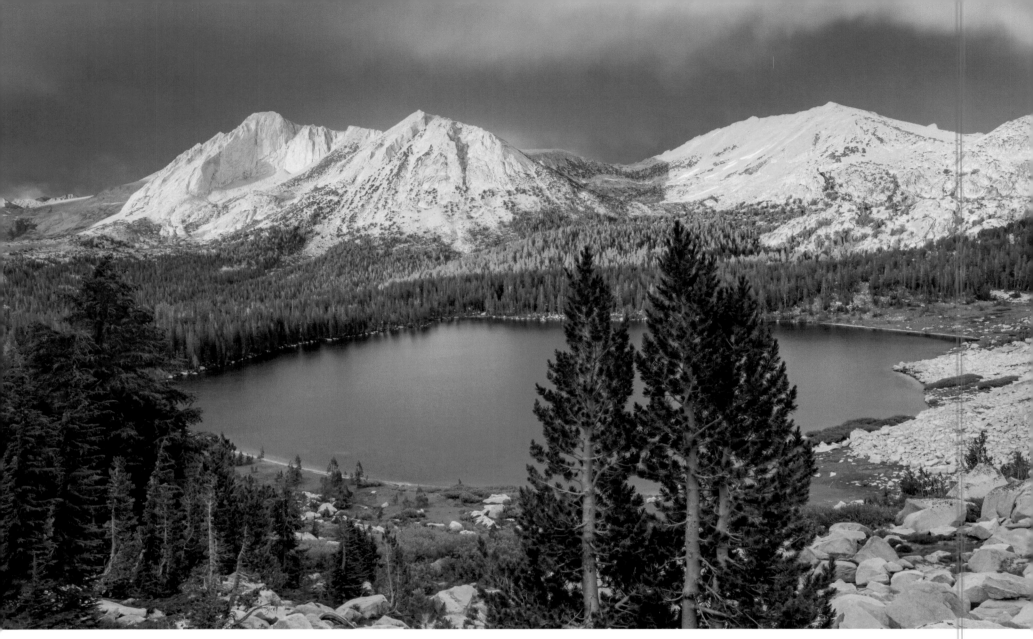

MOUNT CONNESS AND WHITE MOUNTAIN OVER LOWER YOUNG LAKE

fifteen minutes, a little nature break helps you find peace and calm. Lay the foundation for your nature connection by focusing your attention, and staying with a subject, to find the novel in the familiar. Hone these skills in your own backyard. When you find yourself in a place as grand as Yosemite, you are primed to get even more from the experience.

If spending time in nature is already a part of your life, push yourself to go further. Get out and explore at unusual times, especially when it is inconvenient or uncomfortable. Early morning and late in the evening are magical times to be outside, yet most people remain indoors and miss the long

shadows, sunrise and sunset. If you want to see something special, "bad" weather is good weather. Everyone comes out on a sunny day, but real treasures are hidden on a frosty morning, in a heavy fog, in a breaking rainstorm, or during falling snow. You may risk cold fingers or wet boots, but these are small prices to pay for finding something wonderful.

Once you are out the door, the world opens itself before you. Revel in the small things. Anyone can notice a spectacular sunset, but many people overlook the little things along the path to the scenic overlook. Search for microbeauties. Stop anywhere, along any trail, and take

a beauty break. Look around and find a tiny moment of splendor. It could be the way the sun reflects off blades of grass, backlit leaves glowing yellow-green, the shape of a gnarled tree trunk, or snow atop a willow branch. Frame that moment with your hands as if you are taking a photograph and share it with a friend. The more you practice, the more you will find magnificence everywhere.

An insatiable curiosity drives Hirsch's photography. Curiosity is not a fixed trait but an essential skill of the naturalist, to be nurtured and developed. Many of us have the illusion we understand the way things work and the cause-and-effect of ordinary events, but scratch beneath the surface and the world is a grand unknown. Countless small wonders surround us, but we need to train our minds to recognize them, to slow down and be amazed. Instead of searching for what you already know—familiar wildflowers or known rock types—seek that which is strange. Monitor your senses for the subtle feeling of "that's odd." Surprise is your physiological reaction to discovering that reality is different than what you expected. Lean into these moments and learn something new.

When you become curious about something, your brain washes with the neurotransmitter dopamine, attention becomes focused, and memory improves. It is fun, and your brain is ready for its best work. You do not need to wait for curiosity to strike. Initiate it whenever you want. Look for rabbit holes of wonder to go down. Explore how something works, or why it exists in that specific way. Understanding the processes behind your observations does not rob nature of its mystery. It amplifies the unfamiliar and deepens your appreciation. Scientific explanations help you see levels of nuance and complexity. An explanation can be a fresh platform from which to launch deeper inquiry. Curiosity is a happy hydra, where answering one question leads to other, more informed and subtle questions taking its place.

The deep nature connection that arises from these practices motivates and supports us to act as stewards of wild places and things. As powerful humans, we have the ability, privilege, and responsibility to act on behalf of nature. This

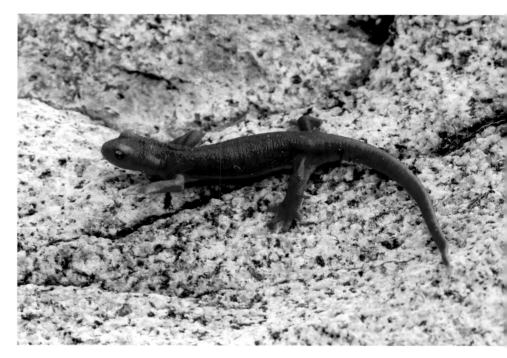

CALIFORNIA NEWT (*Taricha torosa*)

work is challenging and taxing, but nature gives us patience and perseverance to do what we need to do. So wake early on a frosty morning. Step out into nature. Look for wonder and beauty, get curious, look deeply, and be moved. Nourish your heart in nature and let that love move you.

John Muir Laws
MAY 2019

..

John Muir Laws is a scientist, educator, and author whose work is at the intersection of science, art, and mindfulness, helping people forge deeper and more personal connections with nature. Trained as a wildlife biologist, he observes the world with rigorous attention, looking for mysteries, playing with ideas, and seeking connections. Curiosity and creative thinking are not gifts but skills that grow with training and deliberate practice. Jack teaches techniques and supports routines that develop these skills so they become a part of everyday life. An associate of the California Academy of Sciences, he has written several books, including *Sierra Wildflowers, The Laws Guide to Nature Drawing and Journaling, The Laws Guide to Drawing Birds, The Laws Guide to the Sierra Nevada,* and *Sierra Birds: A Hiker's Guide.*

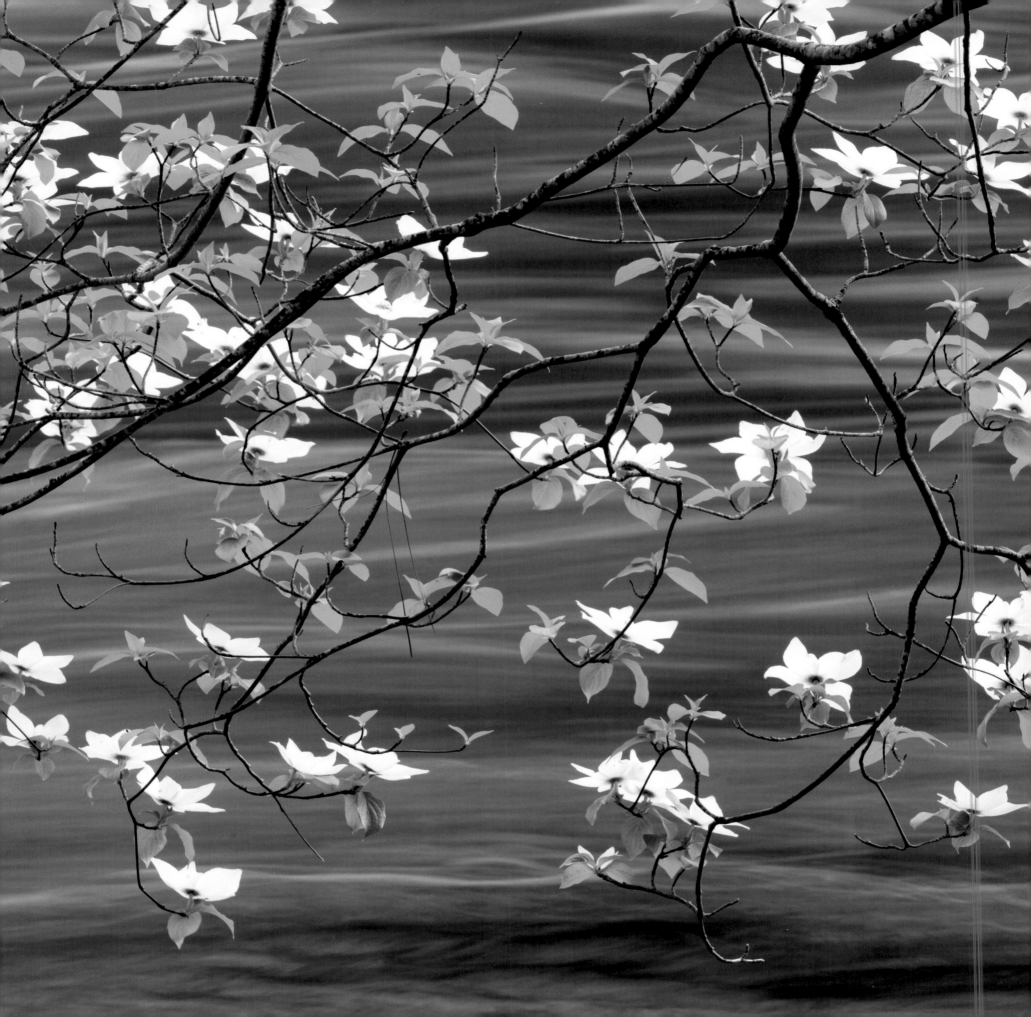

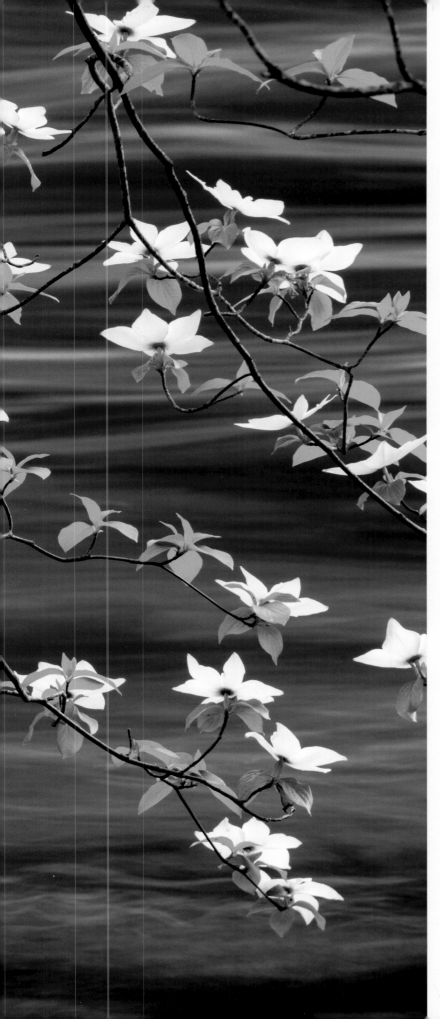

INTRODUCTION

..........................

As I write this, I'm in Yosemite's Mariposa Grove of Giant Sequoias, hunkered down during a rainstorm, trying to keep myself and my camera gear dry. While typing on my phone, I watch for the sun, which I hope pops through the clouds before sunset. Despite the discomfort—and the low odds of success—there's no place I'd rather be.

My training as a biologist and naturalist enhanced my deep appreciation of and fascination for the natural world and all its inhabitants, and I'm most content outdoors—exploring, learning, teaching. I would choose to be here even if I weren't taking photos: I'm not in nature because I'm a photographer, I'm a photographer because I love being in nature. Whether my subjects are wildlife or landscapes, photography gives me opportunities to connect to the world at a sensory level.

Photography is a wilderness experience for me, and to feel the most present in my work, I usually go out alone. Without distractions, I observe more wildlife and become more creative with compositions. Most of the pictures included in this book were taken on solitary day or backpacking trips and often during storms so as to be on location when they clear. Usually, there are no other photographers in sight, which is why there are so few images from iconic locations.

I often use places that I've previously scouted; the physical and intellectual challenge of finding interesting viewpoints, predicting when and under what circumstances the scene will be most photogenic, and getting there when those conditions are present is extremely rewarding. Other

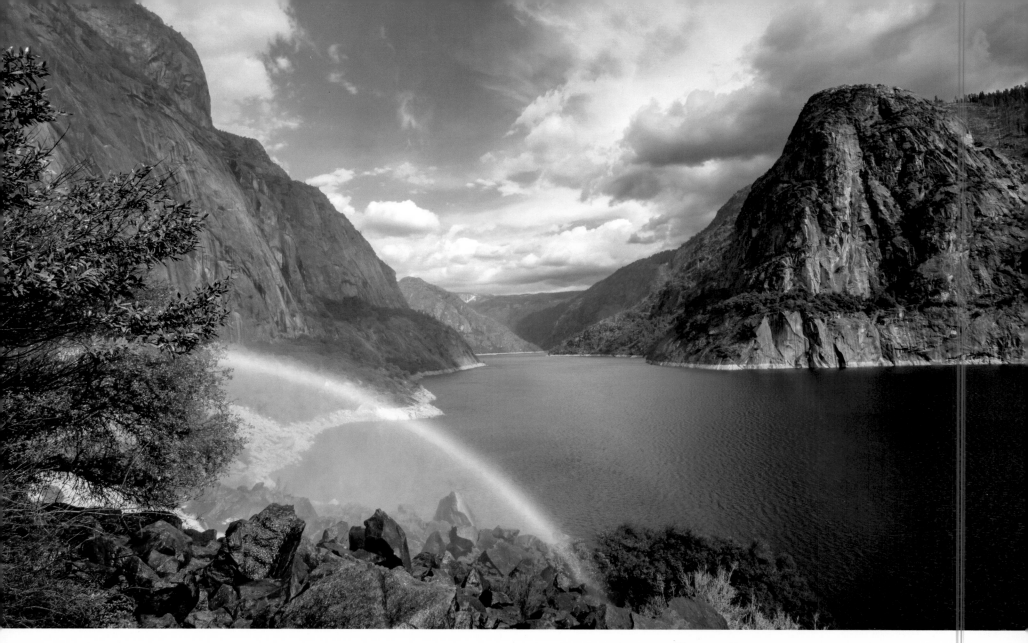

WAPAMA FALLS RAINBOW, HETCH HETCHY

times, I head into the field without preconceived notions—encountering the unknown and the unexpected fuels the excitement. In either situation, adjusting and adapting as light and conditions change is a thrilling part of the experience and I relish the entire journey.

Photography is often humbling; a large investment of time and energy in scouting and waiting for interesting light (or scrambling around chasing it) doesn't always pay off. More often than not, I fail photographically. But whether or not I'm able to capture a stellar image, being there (wherever *there* may be) is always a stellar moment.

Now, to the book in your hands. Giving natural history talks and slideshows on a variety of topics taught me that people are most likely to engage with a subject when the story is illustrated by appealing pictures. That concept—using attractive imagery to connect people to wilderness and share natural history information—was the model for this book.

Most of the photographs are accompanied by a story of some sort, either short captions based on my particular experience or essays covering topics specific to Yosemite and the Sierra Nevada, including general ecological concepts, geological history, and compelling species. I wrote the

captions, and the essays were contributed by thirteen amazing individuals and experts—Karen Amstutz, Pete Devine, Brock Dolman, Rob Grasso, James McGrew, Kurt Menning, Tim Palmer, Beth Pratt, Adonia Ripple, Nate Stephenson, Greg Stock, Sarah Stock, and Dan Webster—whose work enhances the book immeasurably. It is truly an all-star cast, and I'm extremely grateful for their participation.

While the book's intention is to reveal the sublime wonders of Yosemite, there is no way to cover a nearly 1,200-square-mile (3,100 km²) park in one volume. So, on these pages, you will find a sample of the park's fascinatingly diverse plants, animals, habitats, and geographic areas. Yosemite is officially designated nearly 95 percent Wilderness; for the purposes of this book, wilderness areas are simply places that are more than 2 miles (3.2 km) from a road. I've considered anything else to fall under, as appropriate, valleys or high country. My hope is that the photographs and stories engage your mind, spark your curiosity, and encourage your own exploration and questions, whether in Yosemite or in a wild place closer to home. Nothing would make me happier than if, for example, while you were out with friends or family, a bald eagle were to swoop down and grab a fish and you were to describe the eagle's amazing spicules!

Appreciating and understanding the natural world—from how birds of prey hunt to how ecosystems function—can lead to becoming a better steward of our lands (private and public). Volunteering time or contributing financially to organizations doing great work on behalf of wild places are also ways to make a difference. The best way to start is to go outside and discover for yourself nature's infinite opportunities for intrigue. Until then, join me on this visual journey through Yosemite.

To those interested in the technical details . . .

Photographers are often asked about their equipment, though I think this is the least important question. Photography is all about composition, light, apertures, and shutter speeds, and high-quality images can be made with a variety of cameras. I use Canon gear, and the photographs

included in this book were captured with an assortment of bodies (5D Mark II, 7D, EOS 1N) and lenses (17-40mm f/3.5, 28-70mm f/2.8, 70-200mm f/4, 100mm f/2.8, 400mm f/5.6).

To minimize post-processing, my general approach is to photograph compelling scenes in appealing light with the best possible field techniques. I'd rather take the time to capture a quality image in the field than to fix or create a photo digitally after the fact. That being said, all raw files require some degree of processing to most accurately portray the scene; typically, this includes adjustments to contrast, sharpness, and color. The lighting in a couple of scenes was beyond the contrast range of the camera, and these images needed more extensive processing.

SNOWY OAK

VALLEYS

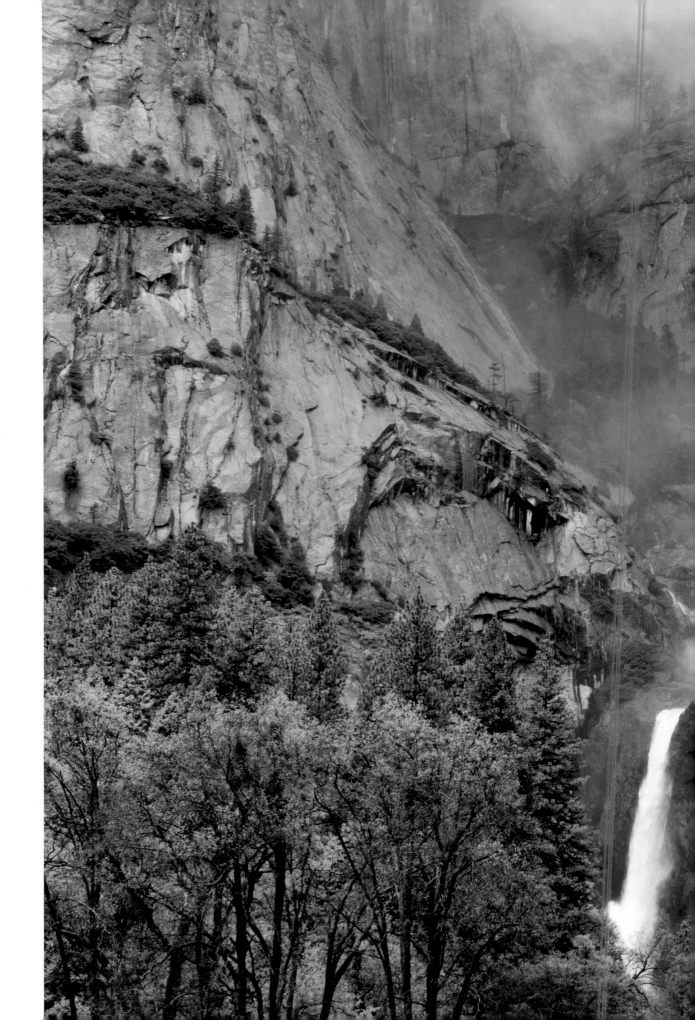

YOSEMITE FALLS

The rain stops, the clouds lift, and I run from shooting close-ups in the forest to one of the few locations on the Valley floor from which it's possible to see both Upper and Lower Yosemite Falls. I have long wanted to capture an intimate image of these falls that also conveyed their size and grandeur. For fifteen minutes, I watch the clouds dance around the cliffs; then the sun pops through and the clouds briefly outline the upper fall. A colorful treeline of oaks just beginning to leaf out completes the scene.

For a fleeting time in late spring, the Valley echoes with the roar of Yosemite Falls' cascading water; at full flow, an estimated 2,400 gallons (9,085 l) per second plunge 2,425 feet (739 m) to the base of the granite cliffs. They usually reach peak power in May; by August, the torrent—fed only by snowmelt—has been reduced to, at most, a trickle. The south-facing, hard-rock watershed has no lakes or wetlands to store water; when the spring flow is done, the waterfalls go quiet until the seasonal cycle brings them to life again.

CLEARING SPRING STORM

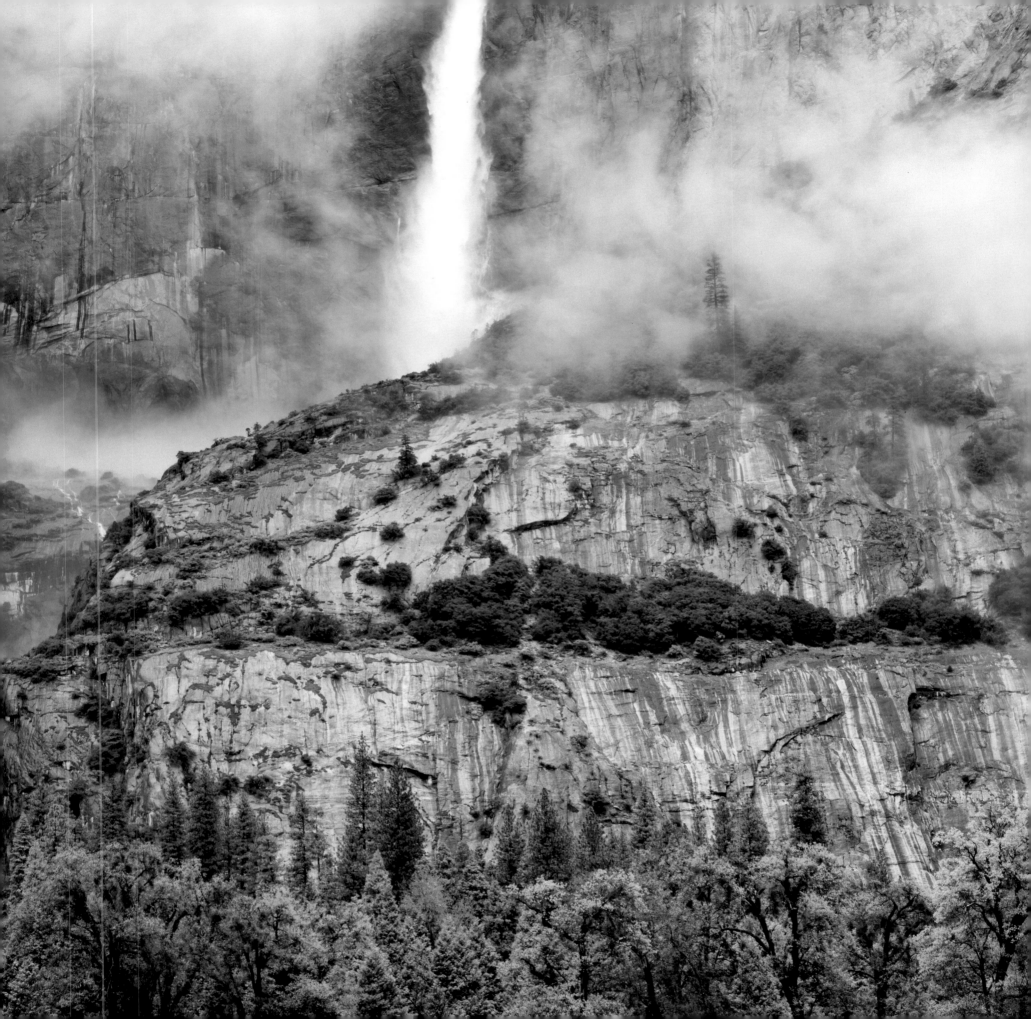

EL CAPITAN

Rising 3,300 feet (1,006 m), one of the
largest exposed granite formations in the world,
El Capitan dwarfs the surrounding landscape
and is the Valley's commanding presence. Its
sheer face was shaped by the long-gone glaciers
that slid slowly past and eroded the rock bit
by bit, burnishing it smooth. Extremely hard
and minimally fractured, El Capitan lures rock
climbers from around the globe, eager to test
their physical and mental strength against its
smooth, unforgiving surfaces and overhangs.

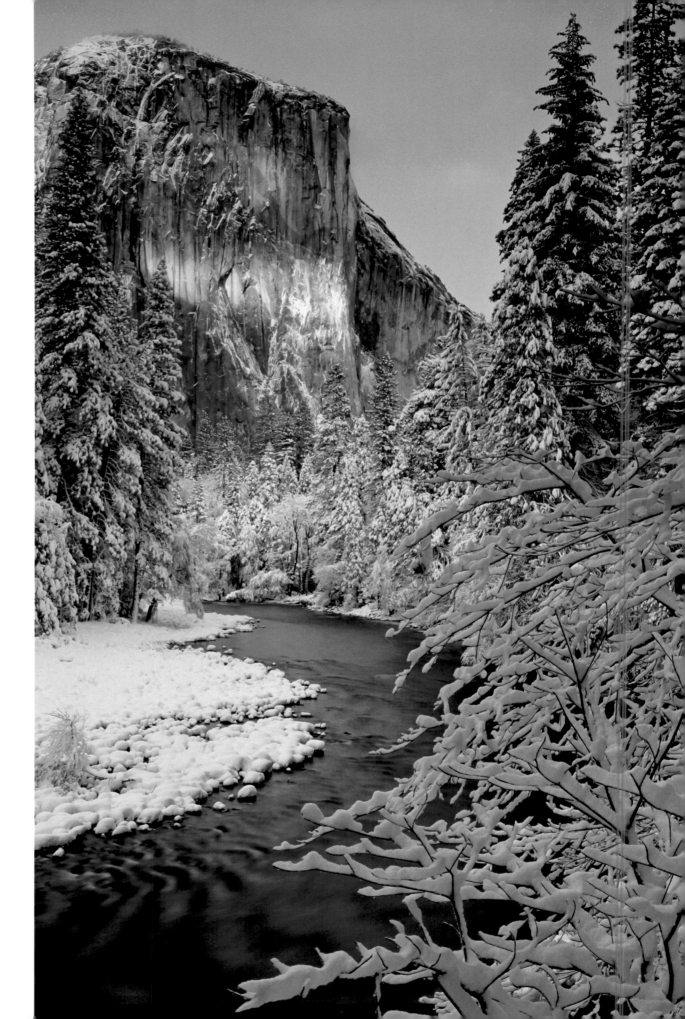

EL CAPITAN AND THE MERCED RIVER
IN WINTER

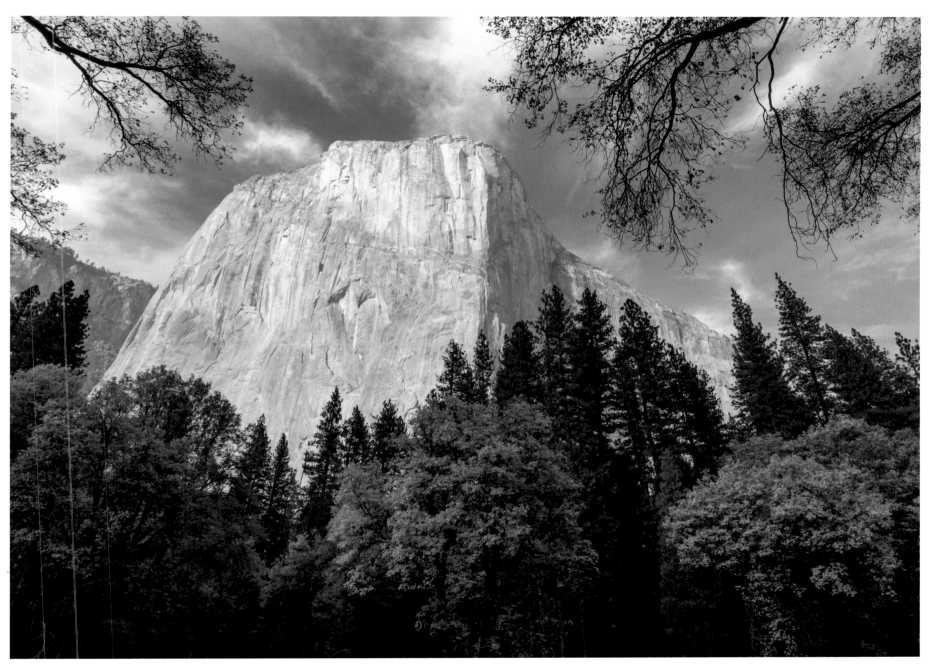

EL CAPITAN AND BLACK OAKS

Lying on my back in the meadow beneath El Capitan, staring up at the massive monolith, I can't help but think about the concepts of size and scale. It is difficult to contemplate a feature so large, but there it is, right in front of me.

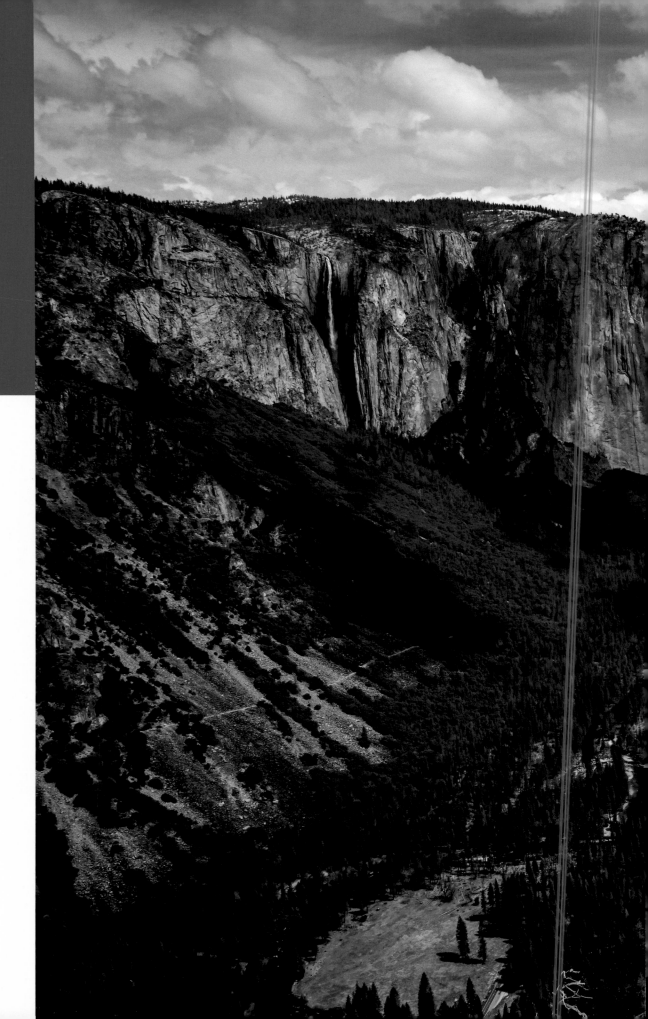

Yosemite

GRANTING THE LONG VIEW

BY ADONIA RIPPLE

can find the shape of Yosemite on any map of the world. It's in the heart of California. A boundary carefully drawn to contain the headwaters of both the Tuolumne and Merced Rivers. Of the twelve major river drainages that flow west out of the Sierra Nevada, how did the landforms of Yosemite end up so unequivocally beautiful? I know this answer intellectually: granite plutons, uplift, glaciers, river incision, succession of plant and animal species, and so on. But the Sierra is built of rock and water and plants and animals arriving at just the right time. There must have been some extra-special combination of elements that made Yosemite. No other river flowing west out of this range reveals such a perfect and ancient excavation,

YOSEMITE VALLEY FROM THE SOUTH RIM

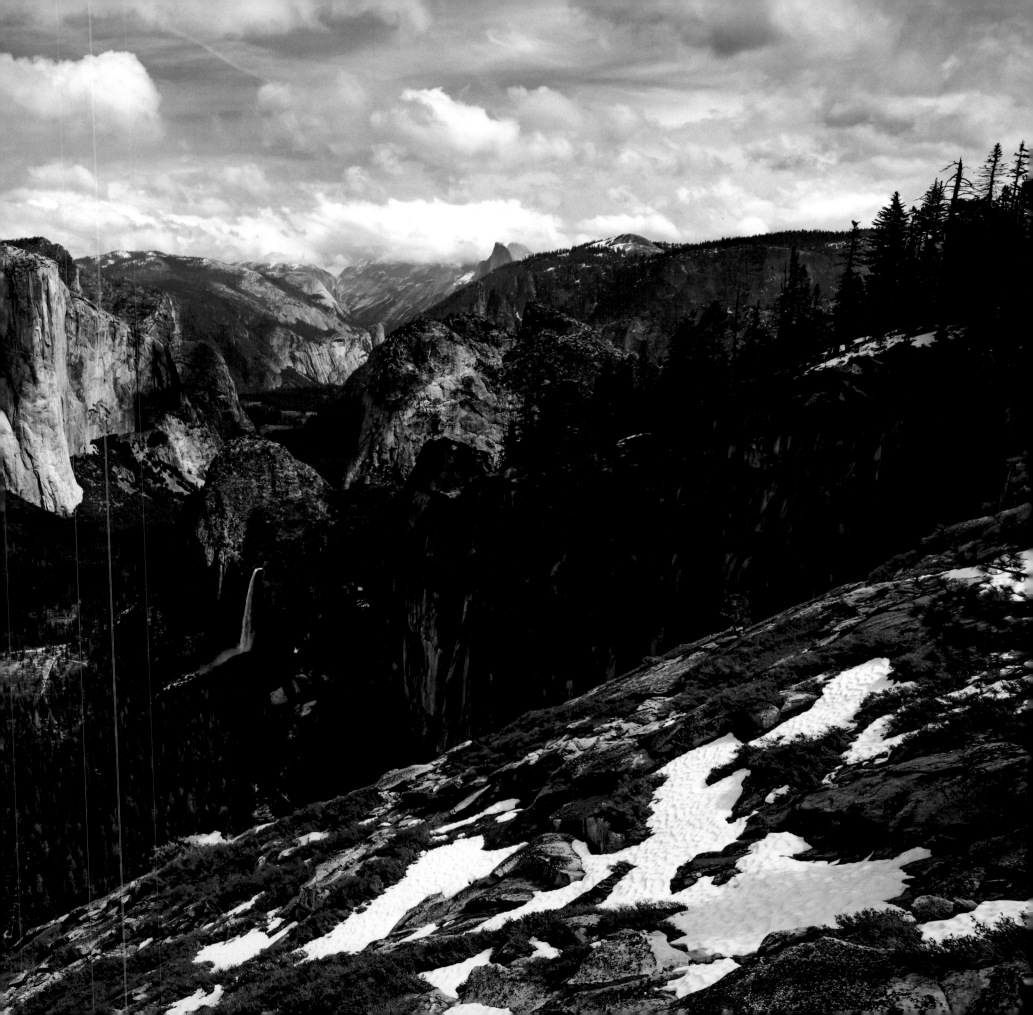

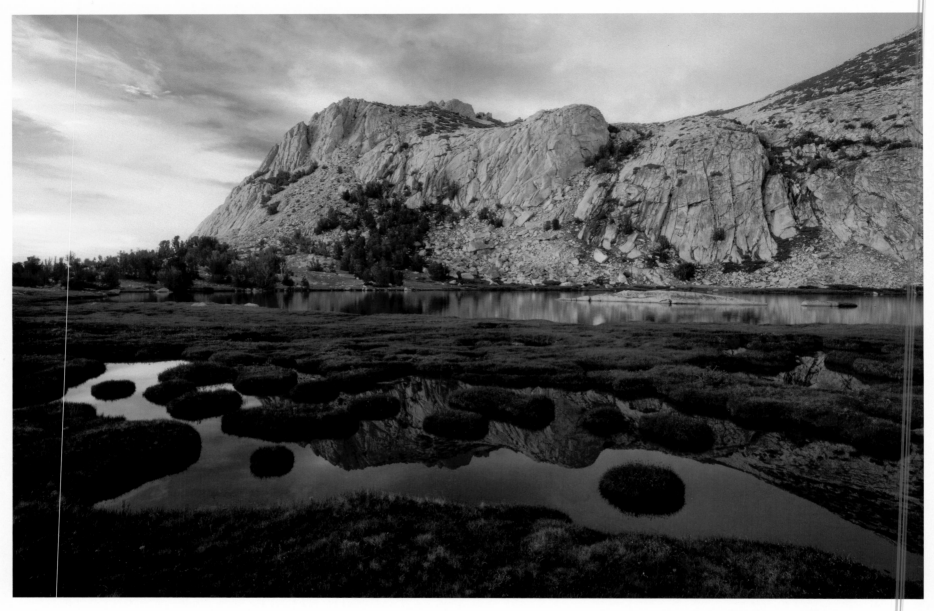

where the granite cleaves at just the exact angles to catch the sunrise and alpenglow for all the world to enjoy. The commanding profile of El Capitan, the hunch of Half Dome's whale back, the serrated spire-topped Cathedral Range, where sharp mountain ridges escaped the crush of glaciation.

People store these shapes in their memory banks and let them soak into their DNA. Appreciation of these essential forms is passed down between generations. For both brand-new and long-term Yosemite lovers, these places seep into their minds and live in their bodies. Descendants look over dusty pictures of grandmothers long ago sitting in the same places as their now great-great-grandchildren, in a Yosemite changed yet unchanging. Something about that Yosemite-specific rise and fall of the horizon line draws us in. The distinct shape of Yosemite Valley triggers something deep in our primordial selves, offering a sense of being protected and inspired at the same time. It is a land that beckons you to come closer and listen. These universally gorgeous forms

Yosemite seems almost uniquely made to create a sense of comfortable humility.

call to generation after generation. It called your parents' parents to honeymoon, an uncle to camp at the river, families to return in recognition of life's benchmarks—a special birthday, a college graduation, the birth of a child, the death of a parent. And on it goes; Yosemite receives us. It is big enough to hold our aspirations and our pain, to be our steady when all of life seems upended. Yosemite welcomes us to sometimes kneel, sometimes strive, sometimes just sit on that smoothed granite and feel the brevity of human life that only all that geologic time can reveal.

Yosemite has played host to my most formative life scenes. Ascending steep vertical walls and the resultant tears and smiles of a young climber's early learnings. Dashing deeper into the winter wilderness on skis with storms nipping at my heels to high and lonely peaks. Freewheeling climbs with air under our feet over spiny granite ridges in the company of dear friends. And now, scrambling and rambling in the company of our young children and taking time to swim and throw rocks in those two rivers that flow west out of this most singular place on Earth. Again and again, in the most reassuring of ways, Yosemite shows me my life is small and that time moves along without much care for our victories and travails.

Yosemite seems almost uniquely made to create a sense of comfortable humility. It readily offers us the knowledge that our lives are so brief in comparison to the acts of granite making and glacier moving and big tree growing. With every distinct cliff face and treasured high-country ridgeline, Yosemite purveys perspective, encouraging the long view. There is comfort in knowing that under Half Dome's gorgeous eternal gaze, human lives will ebb and flow. No matter how it turns out, a million more ruby sunsets will be catching that rock face long after we are gone. All this beauty will outlast us. There is infinite wisdom in that rocky place.

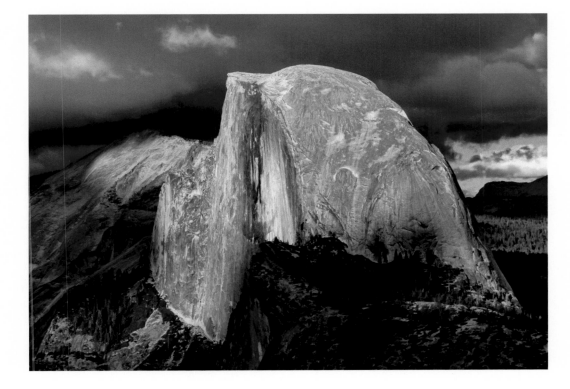

Adonia Ripple has lived and worked in Yosemite for more than twenty years. She came in on the floodwaters of 1997, when all her possessions still fit in a sedan and she could survive on seasonal work and sunsets. Forging her Sierra love affair as a mountain guide, Adonia has also worked as a naturalist, educator, and nonprofit director. She currently serves as the director of operations for Yosemite Conservancy, helping visitors from around the world connect with Yosemite.

STORM OVER HALF DOME

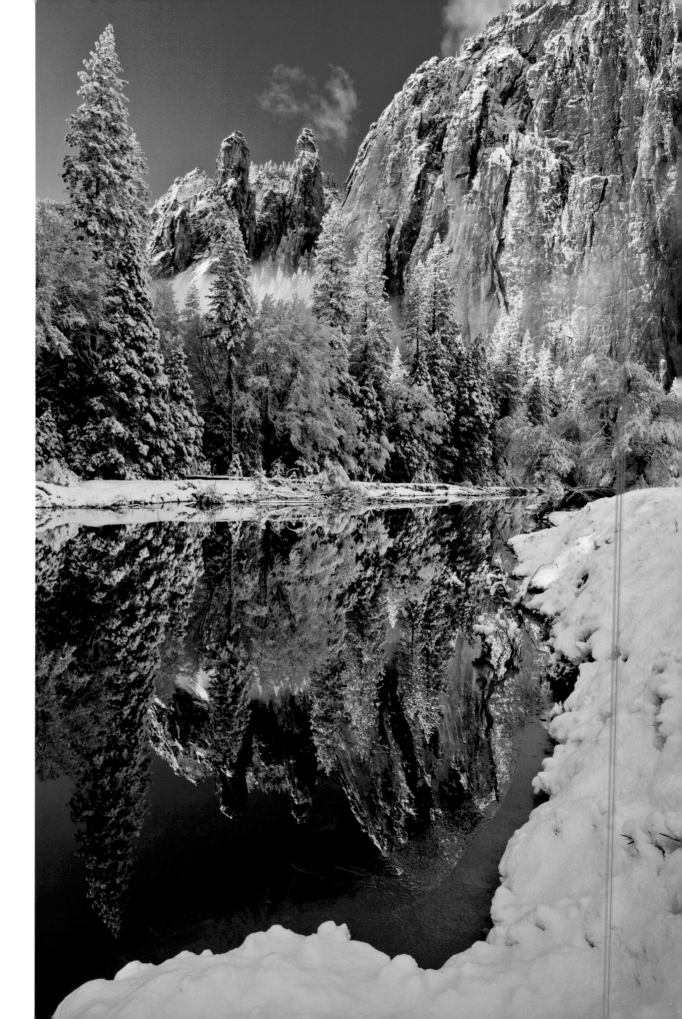

CATHEDRAL SPIRES

Winter is a special time in Yosemite Valley. The majority of visitors have gone, leaving a quiet solitude to explore, and when a storm blankets the terrain in snow, it creates the most magical wonderland.

Cathedral Spires, jutting up beside the south rim of the Valley, can be easily overlooked during most seasons, blending in as they do with the surrounding granite. But when outlined by snow, they seem to jump out of the landscape and make their presence known. During the last glacial period (the Tioga), the river of ice extended only partway up the Valley walls. These spires sat above the ice level and were thus spared the glacial scouring that shaped the granite below.

Winter is also cold in Yosemite Valley, but the opportunity to capture sublime moments makes numb fingers and toes worthwhile.

CATHEDRAL SPIRES REFLECTION

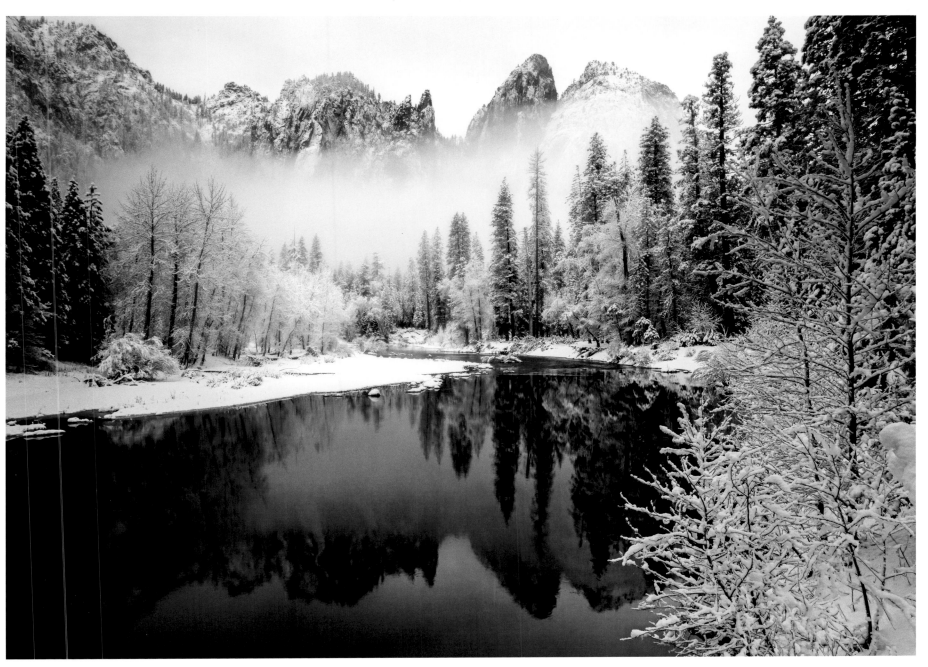

CLEARING WINTER STORM, THE MERCED RIVER AND CATHEDRAL SPIRES

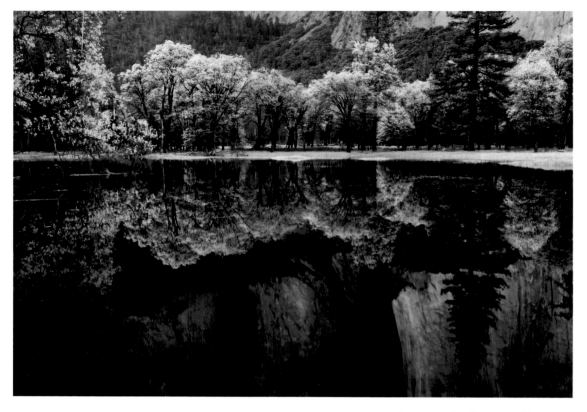

YOSEMITE VALLEY, SPRING FLOOD

In the spring, as the high-country snowpack melts and sends its water roaring down into Yosemite Valley, vast standing pools appear in meadows and other low-lying areas, overflow from the Merced River and its tributary creeks. This flush of water, a critical part of the Valley's ecosystem, recharges the water table and deposits the nutrients and minerals upon which so many other organisms depend. The pools don't last long, though; like giant sponges, meadows absorb the water and move it along on its hydrologic journey. So when they appear, I can often be found sitting nearby, watching waterfowl explore their expanded habitat and marveling at the way a horizon-to-horizon reflection makes an already majestic landscape even more grand.

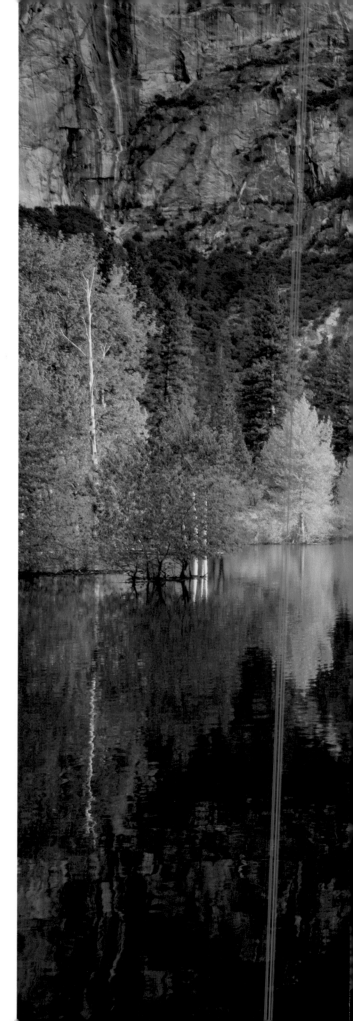

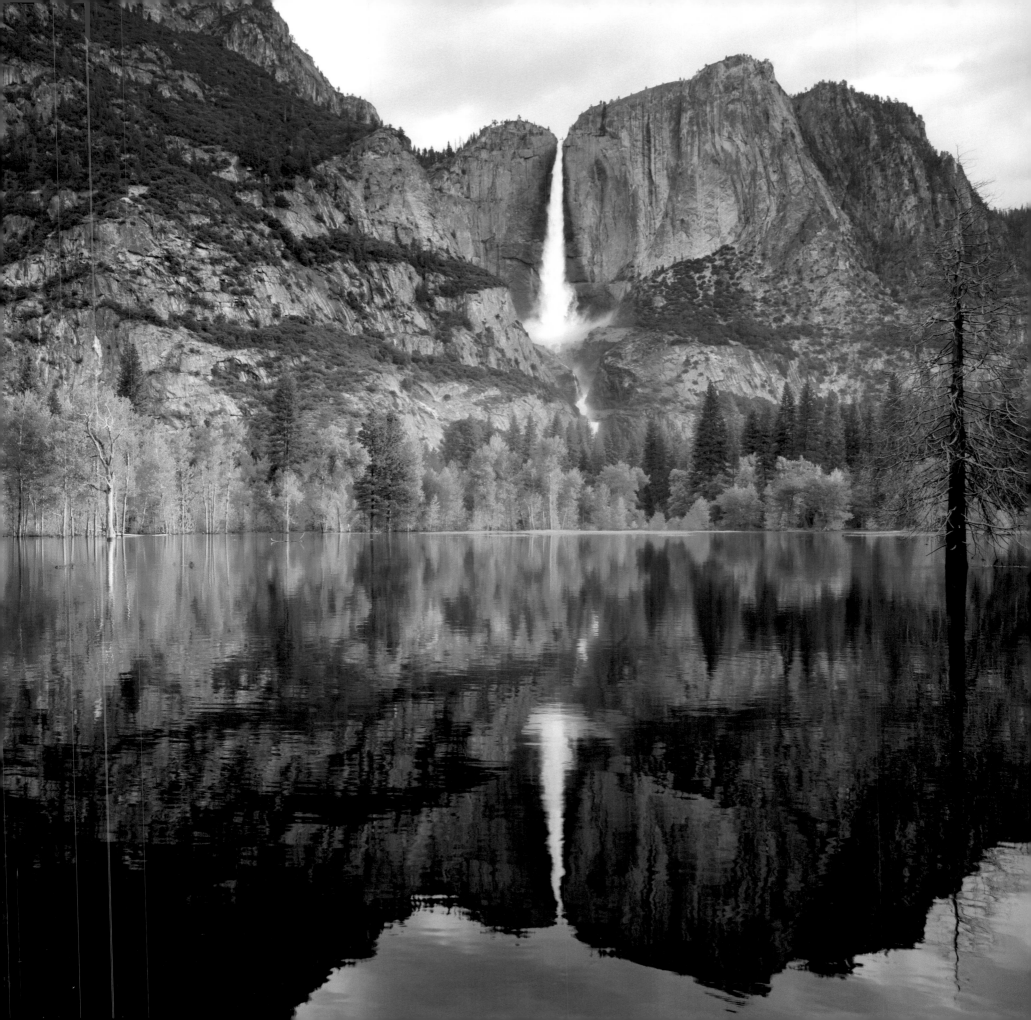

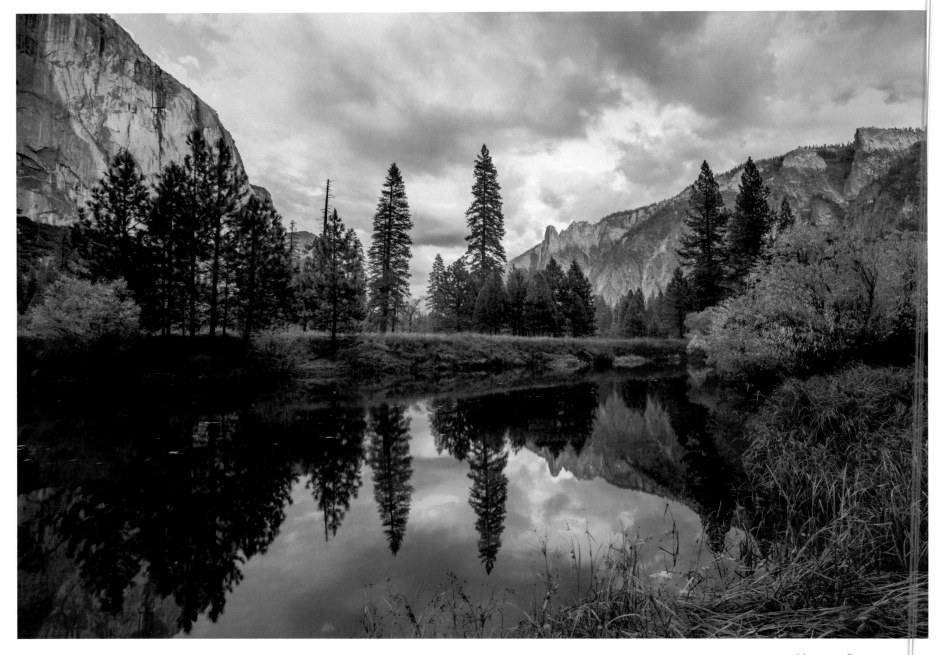

MERCED RIVER, SUNSET

LIGHT

Light—it's all about light. Because it can be difficult to predict where the best light will appear, especially when clouds are involved, I'm partial to photographing in locations that offer opportunities to shoot in different directions. I try to identify a variety of interesting scenes, prioritize them based on what I consider to have the best potential for a compelling image, then work through the list as the light changes.

Late on a November day on the Merced River, I start out facing away from this view, but the light in that direction remains relatively flat. Then I turn around: the sun is just starting to kiss the Valley walls, and the glowing clouds are bouncing illumination downward into the bottom of the Valley. I run to my predetermined option facing upriver, compose the frame, and take a deep breath, soaking in the view.

HETCH HETCHY

Scrambling around on the rocks and surveying the vast expanse of granite above the reservoir, I can't help but wonder what this valley looks like under all that water.

Another magnificent and similarly formed landscape can be found less than 20 miles (32 km) to the north of Yosemite Valley. Originally a typical V-shaped canyon, carved by the Tuolumne River, Hetch Hetchy Valley was deepened, widened, and straightened into its current shape by successive glaciations. However, in contrast to Yosemite Valley, recent glacial periods filled Hetch Hetchy with ice to the brim and scoured its walls smooth, which is why it lacks the dramatic spires of its famous neighbor.

Prior to and, especially, following the devastating 1906 earthquake and fire, the city of San Francisco petitioned the federal government for rights to build a dam and develop the Tuolumne River for water security. Thus began a contentious national conservation battle (one that continues today). The city ultimately triumphed, and O'Shaughnessy Dam was completed in 1924, filling the valley with water for the Bay Area.

GRAY PINE (*Pinus sabiniana*) OVERLOOKING HETCH HETCHY

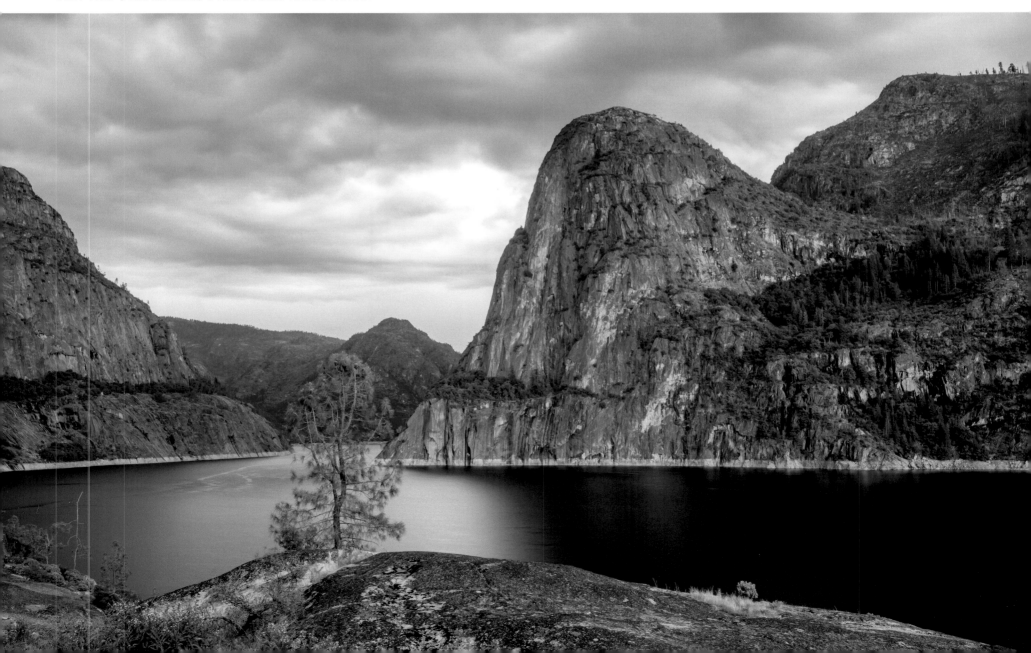

LEAF TRAILS

Rambling along the Merced River under a cloudy sky, I come across a colorful combination of rocks, moving water, and fallen leaves. I study the scene and formulate a concept for an image using a polarizing filter and long exposure times. Composing the frame, I partially rotate the filter to take in the reflection of the trees and cliffs as well as the rocks in the riverbed. Then I wait.

As leaves blown into the current from upriver trees float slowly toward me, I take a thirty-second exposure, which creates streaks. I repeat this process, one frame per gust of wind, for a few hours. When I'm done, I have eighteen images. In this shot, the position, direction, and flow of lines come together in a way far superior to the other frames. The Valley's abundance of impressive icons can make these intimate scenes difficult to focus on, and as a result, I find them extremely rewarding challenges.

MERCED RIVER, AUTUMN

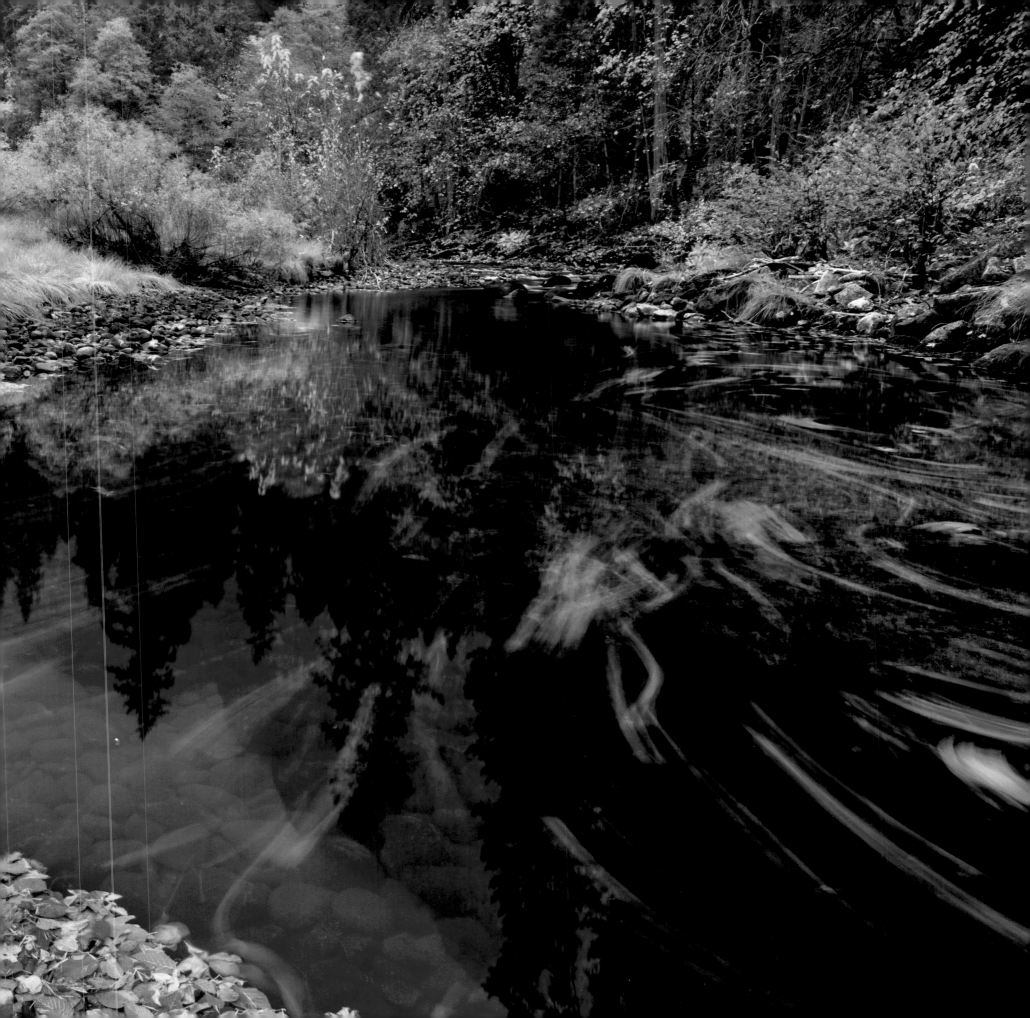

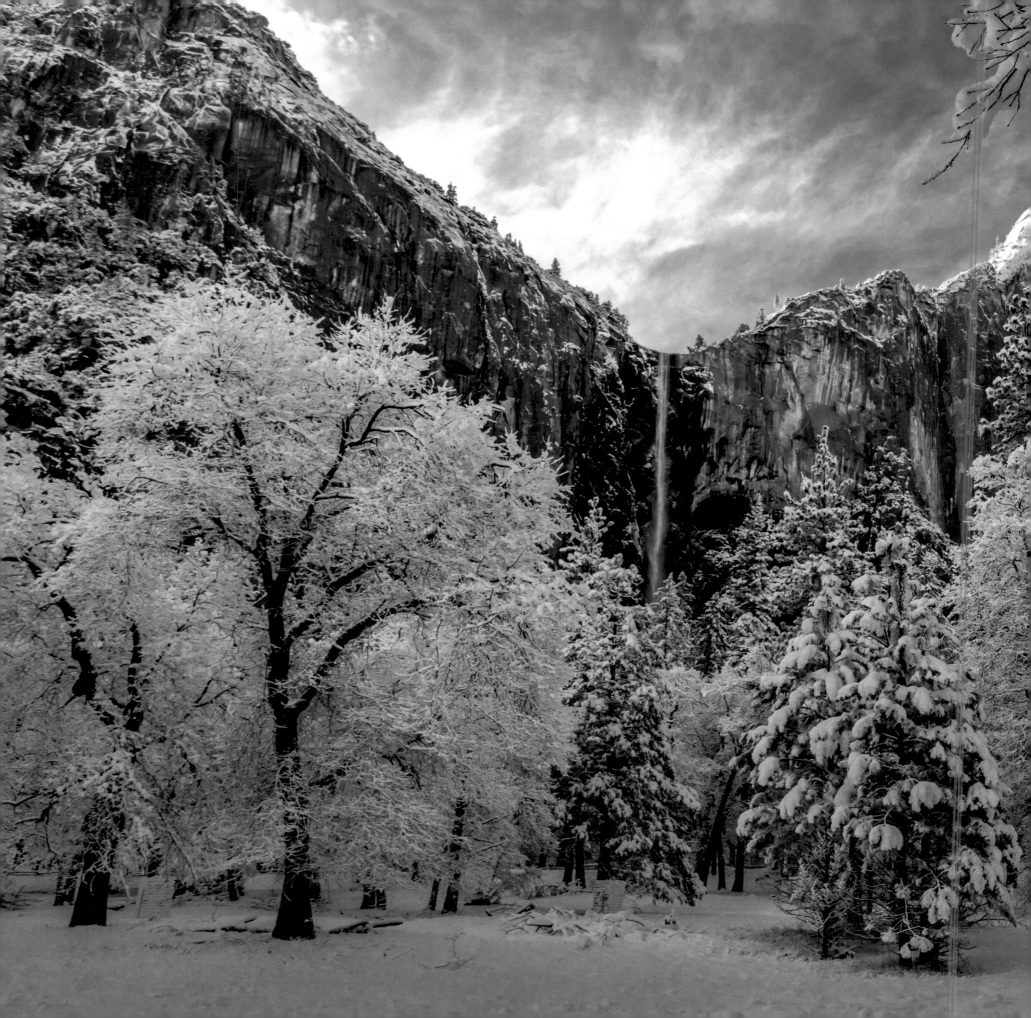

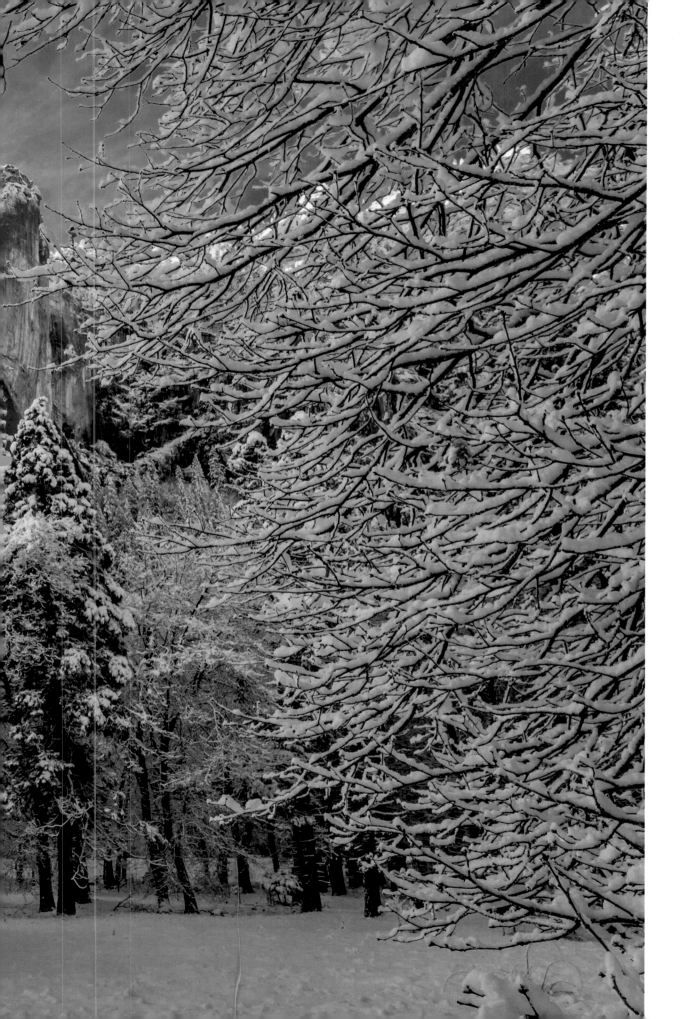

BRIDALVEIL FALL

Leaping over the edge of the south rim and plunging 620 feet (189 m) before eventually flowing into the Merced River, Bridalveil Creek feeds the first of several spectacular waterfalls visitors are likely to encounter when entering Yosemite Valley. Bridalveil Fall—a testament to the slow and magnificent forces of nature—typically flows year-round, thanks to a watershed filled with lakes, marshes, and groundwater-retaining meadows, as well as to its north-facing aspect, which means reduced evaporation.

Imagine the scene two million years ago: the floor of Yosemite Valley was near the top of the modern-day waterfall, and the creek was a simple tributary draining into a larger waterway. Then came the glaciers. Rivers of ice from the Tuolumne ice field repeatedly flowed into the Valley from both the Merced and Tuolumne crests, their massive weight cutting downward faster than the creek's primarily water-driven erosional process. When the ice ultimately retreated, a hanging valley was left, a most striking and photogenic geologic phenomenon.

BRIDALVEIL FALL, WINTER

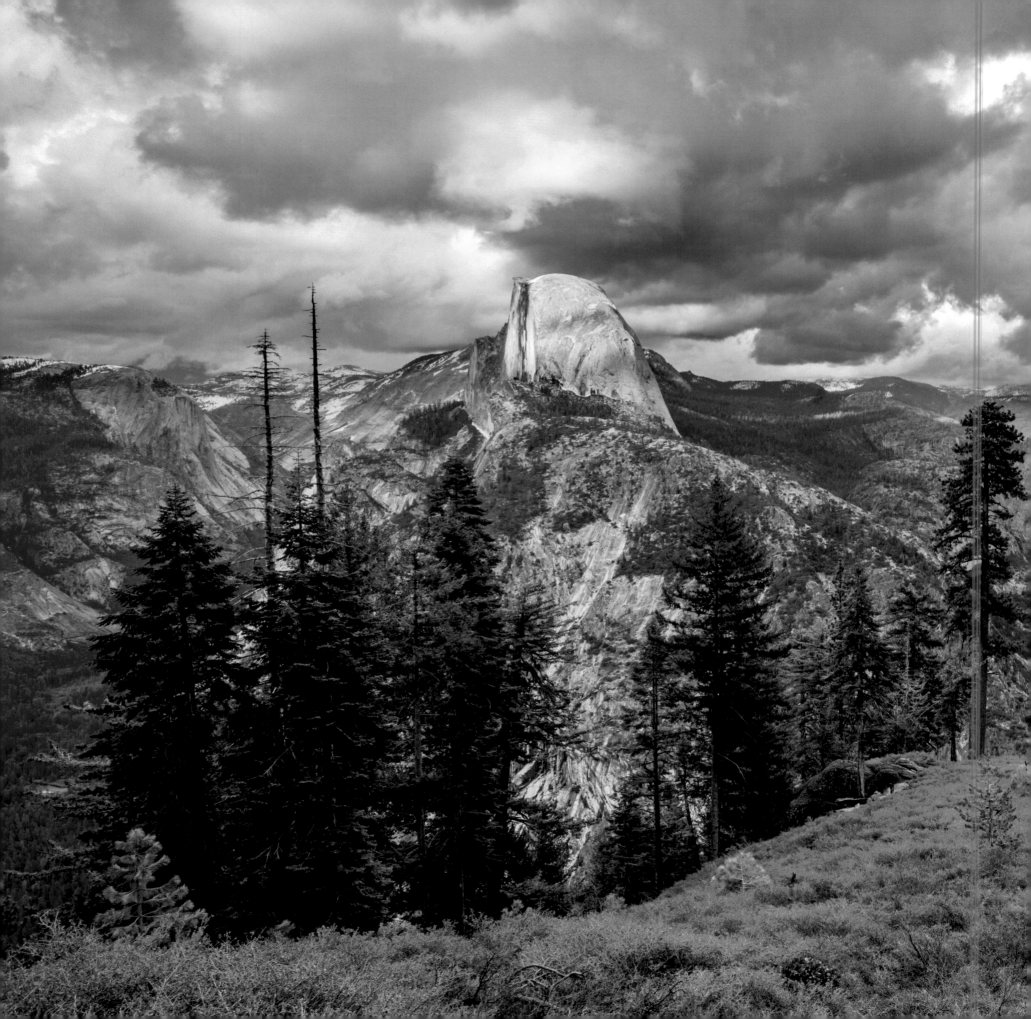

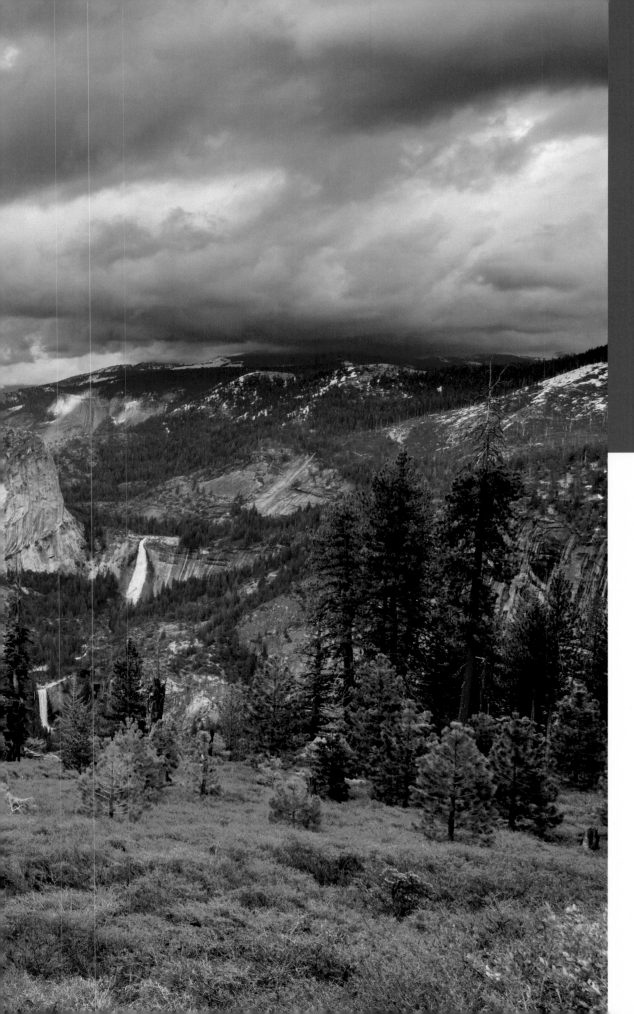

The Influence of Art

INSPIRING APPRECIATION AND PROTECTION

BY JAMES MCGREW

For many centuries, native people created basketry and obsidian points of such fine craftsmanship and beauty that they stand as Yosemite's original artworks. Later, the first published representational art depicting Yosemite resulted from the entrepreneurial efforts of James Mason Hutchings in the mid-nineteenth century. In 1855 he brought to the Valley artist Thomas Ayres, who portrayed the landscape in a series of illustrations, and then in 1859 Hutchings brought in Charles Weed, who captured the first photographs of the area. These images accompanied articles in *Hutchings' California Magazine*, offering the public a visual reference of Yosemite's legendary

HALF DOME, AND VERNAL AND NEVADA FALLS

21

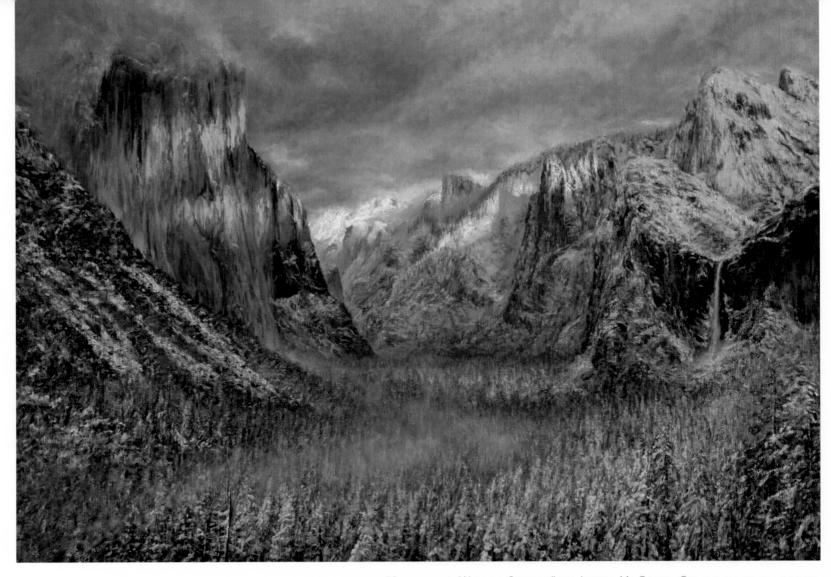

"AHWAHNEE WINTER SUNSET" BY JAMES MCGREW. OIL ON LINEN ON BOARD.

wonders. From this point on, art influenced the visitation, preservation, and management of Yosemite.

In the wake of initial portrayals, other artists ventured to Yosemite and created works instrumental in establishing the world's first park of its kind and the foundation for our National Park System. In 1861 photographer Carleton Watkins made mammoth plate photographs, which were exhibited in New York and inspired the celebrated Albert Bierstadt to travel west and paint Yosemite in 1863. Bierstadt painted plein air oil sketches that he later used as reference in conjunction with photography and artistic license to orchestrate grandiose, romantic studio paintings, such as *Night at Valley View* (Yosemite Museum). Numerous art historians have noted the connections between these artworks and influential US political leaders. Congress and perhaps even President Lincoln observed Watkins's photos, potentially helping persuade for the establishment of the Yosemite Grant on June 30, 1864.

In his commissioned management plan for the grant, titled *Yosemite and the Mariposa Grove: A Preliminary Report, 1865*, Frederick Law Olmsted wrote, "It was...when the paintings of Bierstadt and the photographs of Watkins, both productions of the War time, had given to the people on the Atlantic some idea of the sublimity of the Yo Semite, and of the stateliness of the neighboring Sequoia grove, that consideration was first given to the danger that such scenes might become private property." Soon thereafter, many famous artists painted Yosemite, including Thomas Moran, whose paintings inspired preservation of Yellowstone, the Grand Canyon, and Zion. Of greater significance to Yosemite was Thomas Hill, whose

monumental canvases rivaled Bierstadt's in status without resorting to such melodramatic distortions. Hill's mature paintings, influenced by the Barbizon school, convey the power, light, and scale of Yosemite.

As painters spread awareness of the Yosemite landscape, luring visitors and entrepreneurs, conservationist John Muir recognized the need for federal protection of the watersheds surrounding the Yosemite Grant. To persuade his audience, Muir used photography by George Fiske and paintings by Thomas Hill and others to illustrate his eloquent writings as he campaigned to establish Yosemite National Park, designated October 1, 1890.

Throughout the twentieth century, artists continued interpreting Yosemite in diverse styles. Modernism simplified Yosemite's iconic features into expressive color and abstract form. Other artists created political commentary on management, crowding, and exploitation. Many examples exist in the Yosemite archives. Ansel Adams, the twenty-first-century modernist whose name arguably is most synonymous with Yosemite, simplified compositional elements and manipulated his images through filters, dodging, and burning. His unique style focused on emotional impact as he expressed his personal passion, working tirelessly as an environmentalist. Adams's images inspired the public and politicians alike.

By 1980, Yosemite management progressed from visitor-centric manipulation of park resources to allowing natural processes to prevail. Historical images have proven invaluable as they offer managers documentation for understanding a changing landscape influenced by climate change, fire ecology, meadow and forest succession, rockfall, river hydrology, and other processes over time. Artwork has also inspired awareness for park cultural resources. Early artists documented Ahwahneechee culture as they included local native people in their landscapes. As the mainstream art market grew more interested in works created by American Indians during the twentieth century, basketry flourished into larger, more beautifully elaborate artworks popularized especially by Lucy Telles, Carrie Bethel, and Julia Parker.

Historical artwork has influenced initial preservation as well as inadvertently benefited park management and understanding of natural and cultural resources.

Recent advances in digital technology have brought changes to how artists capture their impressions of Yosemite. Previously, only professional photographers could create and publish quality images. However, proliferation of smartphones, digital cameras, image-editing software, the internet, and social media enable not only pros but almost anyone to create and publish stunning images. As a result, Yosemite's art progresses from spectatorship to active participation, allowing many to connect with nature and interpret their own experiences. As digital photography both benefits and adds competition for photographers, it has also opened new opportunity for teaching workshops and reaching a new generation of visual storytellers. Likewise, a growing trend in plein air painting leads more people outdoors, where they may stand for hours in a single location, slow down, and experience Yosemite more deeply. As our modern digital society disconnects from nature, perhaps we crave such opportunities more than ever.

My goal in painting Yosemite is to carry on the legacy of historical artists and photographers who have inspired appreciation and protection for more than 150 years. I hope to inspire others to experience their own connections to Yosemite and ultimately help preserve the environment far beyond park borders.

James McGrew is an artist and educator whose lifelong passion for Yosemite grew out of childhood visits beginning at just four months old. His undergraduate and graduate work includes degrees in biology, chemistry, geology, and environmental education. He combines his art and science backgrounds to carry on the legacy of nineteenth-century artists who helped establish Yosemite and other national parks. Working mostly in plein air, James has received prestigious awards and exhibited in many solo shows, galleries, and museums, as well as in top national and international exhibitions. His artwork hangs in collections around the world. James is a signature member of the American Impressionist Society and the Laguna Plein Air Painters Association, and his work has been featured in most major art publications. Since 1996, he has shared his knowledge as a summer seasonal Yosemite interpretive park ranger.

LUNAR RAINBOW

Spring is "moonbow" season at Yosemite Falls. When conditions are right—the moon is near full, the night sky is cloudless, and the water is flowing at high volume—the moon reflects the sun's light through the mist, where it refracts and bounces out as a lunar rainbow. To the naked eye, the rainbow is often subtle and muted; the sensors in digital cameras are better able to capture the intensity of the colors. The phenomenon draws hundreds of photographers to a couple of well-known vantage points, where they stand shoulder to shoulder, watching the scene through their viewfinders.

That's not my thing at all, so I wait until the crowd's thinned out and set off in a different direction. I walk for a couple of hours, following the rainbow's progress across Upper Yosemite Fall. About two in the morning, the elements come together—the right combination of composition and intensely colored rainbow— and I marvel that there is nobody else in sight.

UPPER YOSEMITE FALL AND MOONBOW

24

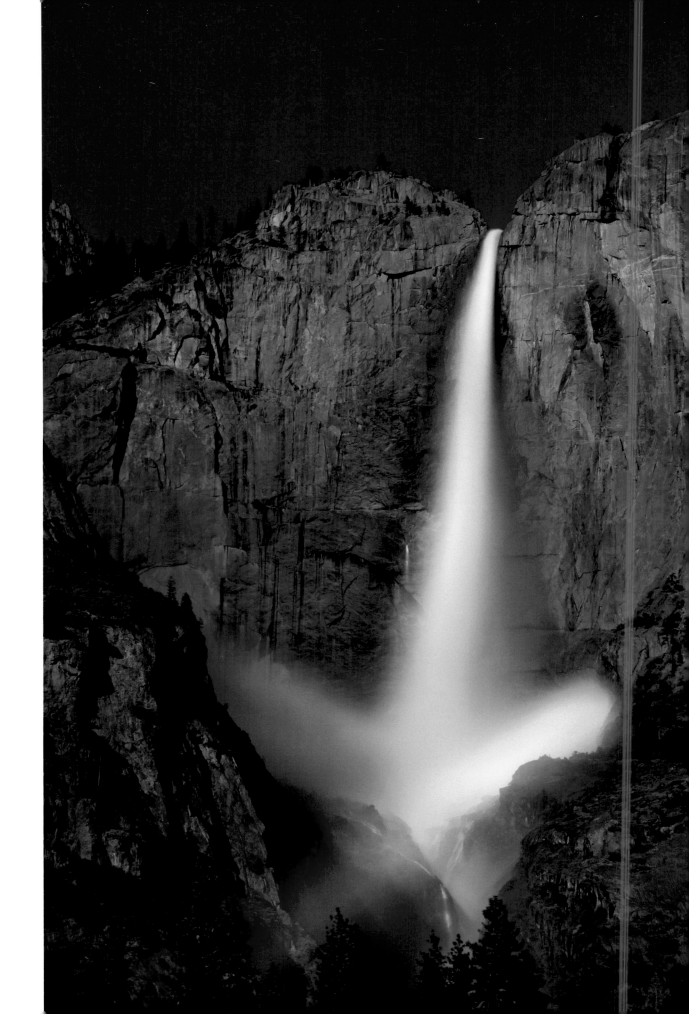

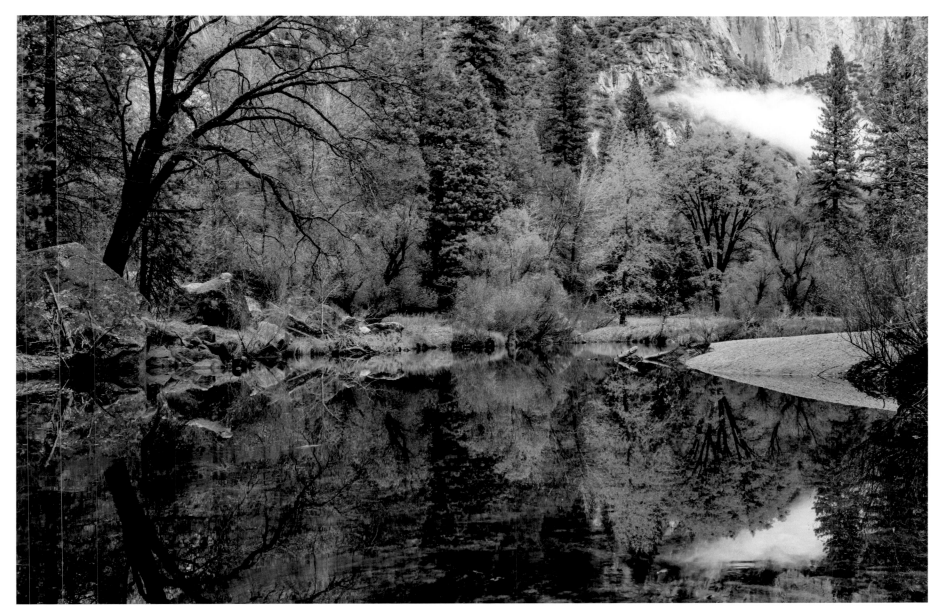

FALL COLOR, YOSEMITE VALLEY

AUTUMN, MERCED RIVER

Nature photography is often a waiting game—waiting for the right light, or the right moment. This day, I shoot for about an hour before a low cloud moves in, completing the scene better than I could have imagined.

I've spent countless hours wandering along the Merced River, following its meanders, learning what it has to teach, and looking for compelling scenes to photograph. On this drizzly fall afternoon, I choose a stretch of river I have not previously explored. In the distance, a large, leafless black oak with striking lines catches my eye, and I begin considering ways to compose the photograph.

This is often my practice in the field: looking for one particularly interesting subject, then working to incorporate it into the broader context of its surroundings. Moving downriver, I find this spot and instantly know it's the one.

WINTER
CONDITIONS

I spend a lot of time outdoors thinking about what makes the current situation unique, then work to photograph those aspects. In December 2012, a warm storm that filled the waterfalls was followed by a cold one that blanketed the landscape in snow, creating a rare intersection of conditions. It was still snowing, and the cloud cover was thick, so I needed an intimate perspective, excluding the dull sky, from which to capture the juxtaposition of flowing and frozen water. This location had long been on my radar as a place for just such a photograph. I chose moments when the cascade was slightly obscured by the clouds to create a moody feel and subtle interpretation of Lower Yosemite Fall.

LOWER YOSEMITE FALL, CLEARING SNOWSTORM

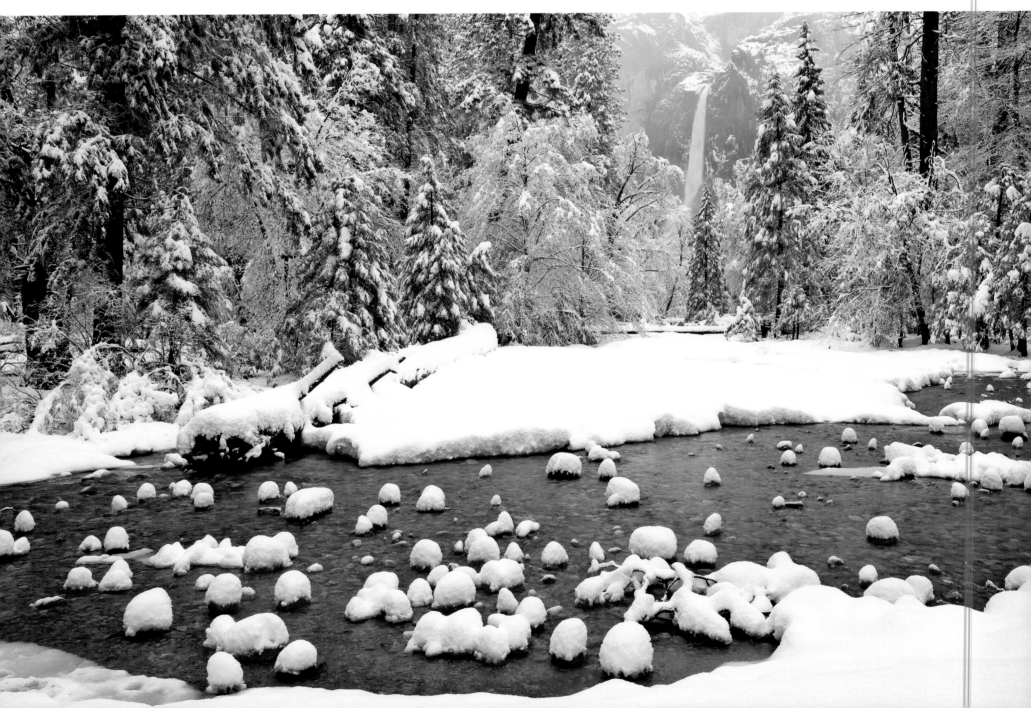

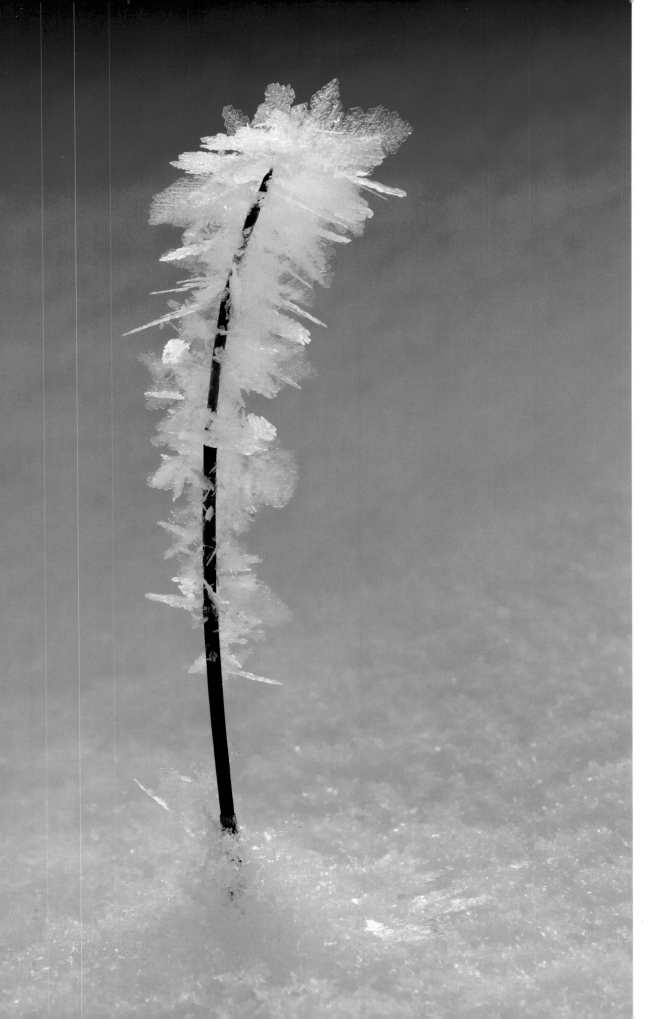

HOARFROST

On a cold, quiet winter morning in Yosemite Valley, I notice stunning examples of the hoarfrost that occurs when the air is sufficiently humid and the temperature is well below freezing. In these conditions, water vapor settling on exposed surfaces bypasses liquid form (dew) and jumps directly from gas to solid, coating the object with the most intricate and striking ice crystals.

I head out to search for compositions in an area that is still in shadow but is bordered by a 3,000-foot (914 m) cliff face bouncing lovely light onto the scene. After trying several options, I find in this lone sedge the most simple and elegant variation, evoking the frozen serenity of the morning. To establish a separation between the hoarfrost and the background, I set a ten-second shutter delay and run behind the sedge to throw a little shadow on the snow, which highlights the delicate crystals.

HOARFROST ON SEDGE

FLORA

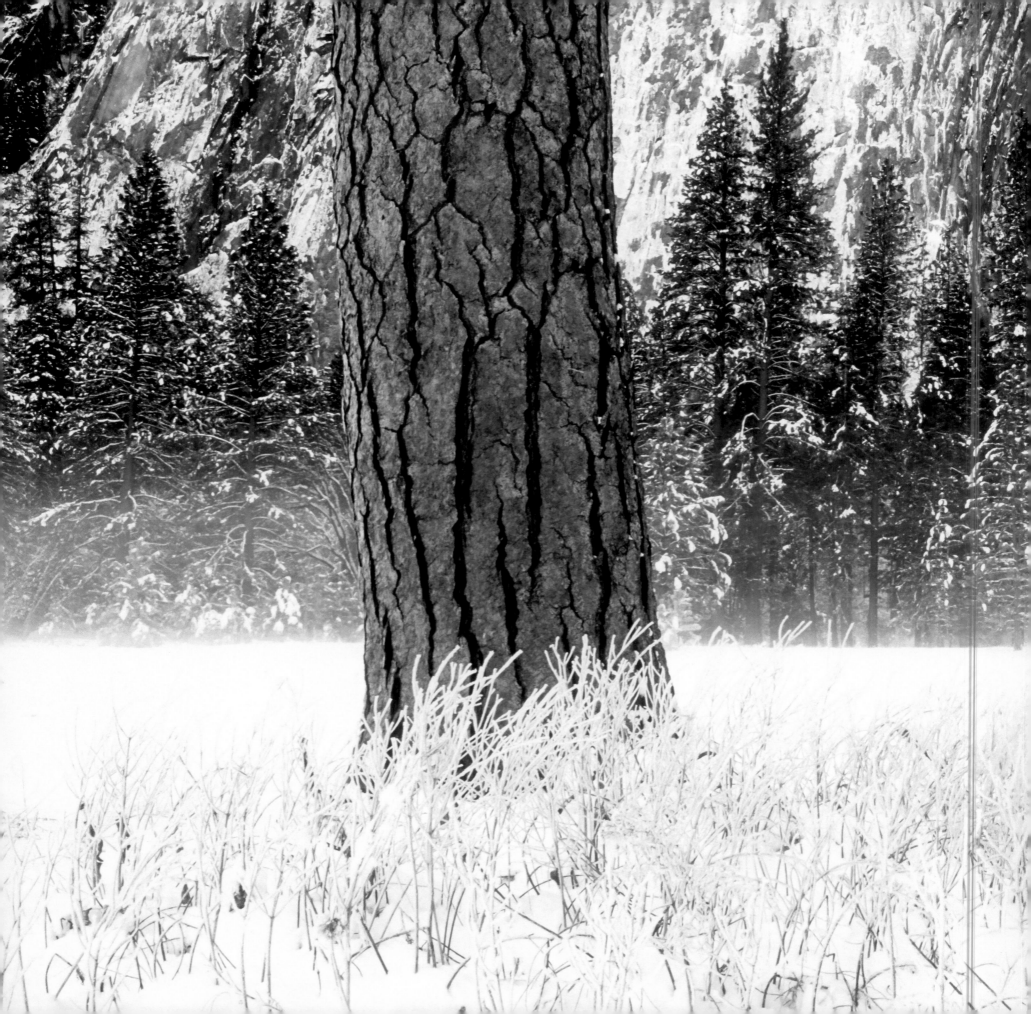

PONDEROSA PINE BARK

PONDEROSA PINE
(Pinus ponderosa)

Yosemite Valley is home to many impressive ponderosa pines, and I've spent time in the company of several of them. On a winter-morning drive, I see this one through the low-hanging mist, glowing in El Capitan's reflected light; grabbing my gear and snowshoes, I head for it.

The ponderosa's thick, deeply fissured bark improves the odds that a large tree will survive an understory-clearing fire. Though not as fragrant as its relative the Jeffrey pine, many individual trees smell faintly of vanilla, a scent produced by the tree's essential oils, known as terpenes. (Yes, I admit it: I sniff trees!) Ponderosas, the most widely distributed pine species in North America, grow in relatively dry places and can live as long as five hundred years. Their vigorous root system contributes to their success by helping them both absorb water and stay upright in high winds. This day, however, it's the tree's aesthetics rather than its botanical qualities that compel me to photograph it, and I choose an intimate perspective.

PONDEROSA PINE IN EL CAPITAN MEADOW

31

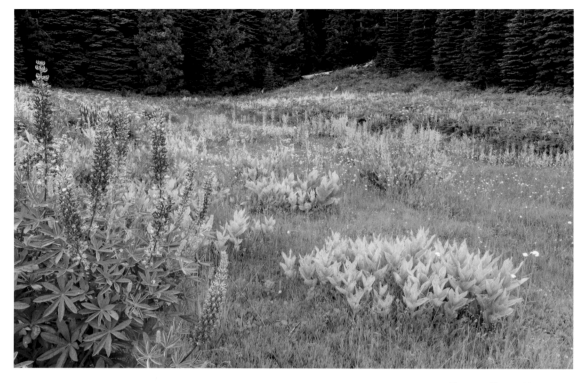

CRANE FLAT MEADOW

MEADOWS

As I quietly approach the edge of one of Yosemite's meadows, all my senses are on high alert. There's always something going on in these biologically rich areas; though they make up only 3 percent of the park, they host a disproportionately large number of species. Over the years, I've spent time in them observing owls, watching bears, following butterflies, photographing flowers (like these lupines in both images), and chasing beetles.

Islands of diversity laid out in a patchwork across the landscape, meadows also play a critical role in the hydrological cycle, capturing water like giant sponges and purifying it as it percolates down to recharge the groundwater aquifers we depend upon during times of drought. The critical importance of meadows to the ecosystem is well understood, and in Yosemite they're protected. In the foothills outside the park, though, they remain habitats of special concern.

ACKERSON MEADOW

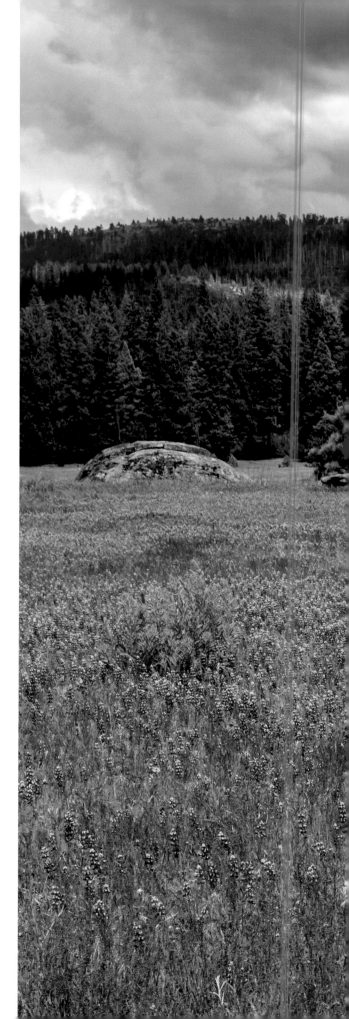

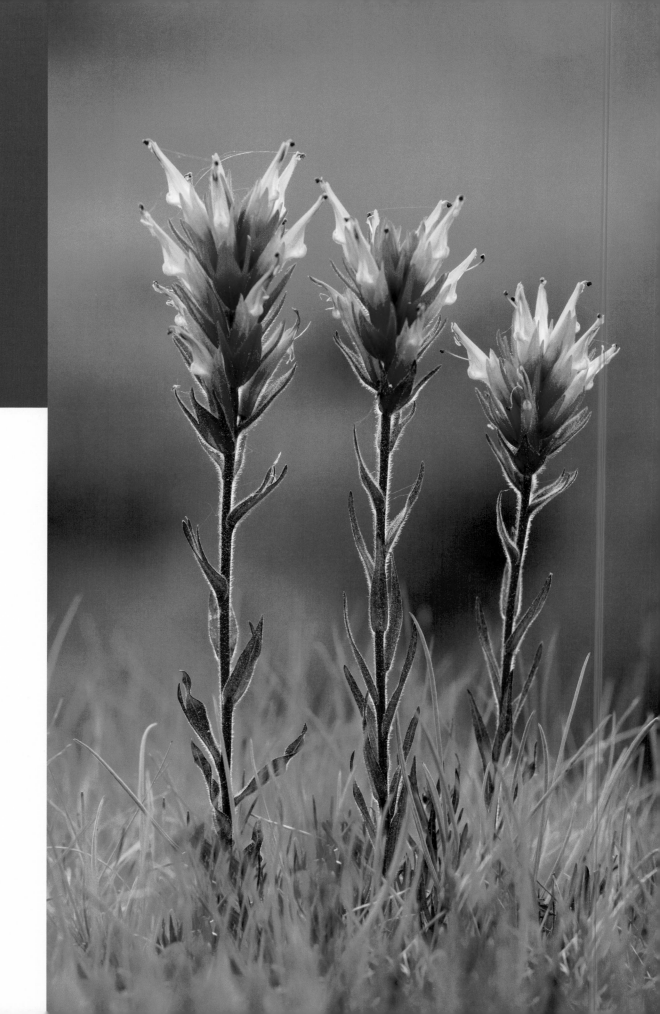

Sierra Wildflowers

AN ALLURING BEAUTY

BY DAN WEBSTER

The Sierra Nevada delights the observer, from casual passerby to ardent naturalist, with a nearly unparalleled palette of botanical diversity. These wild beauties turn each nature stroll into a treasure hunt. The Sierra spans approximately three lines of latitude from south to north, but it's the elevational change—from several hundred feet (100 m) above sea level in the lower foothills to 14,505 feet (4,421 m) at Mount Whitney—that is the primary driver of such striking biodiversity.

Not long after the first rains of fall soak the parched ground, the first leaves of the early wildflowers begin to appear. Several months later, while snow still covers the

SUBALPINE PAINTBRUSH (*Castilleja lemmonii*)

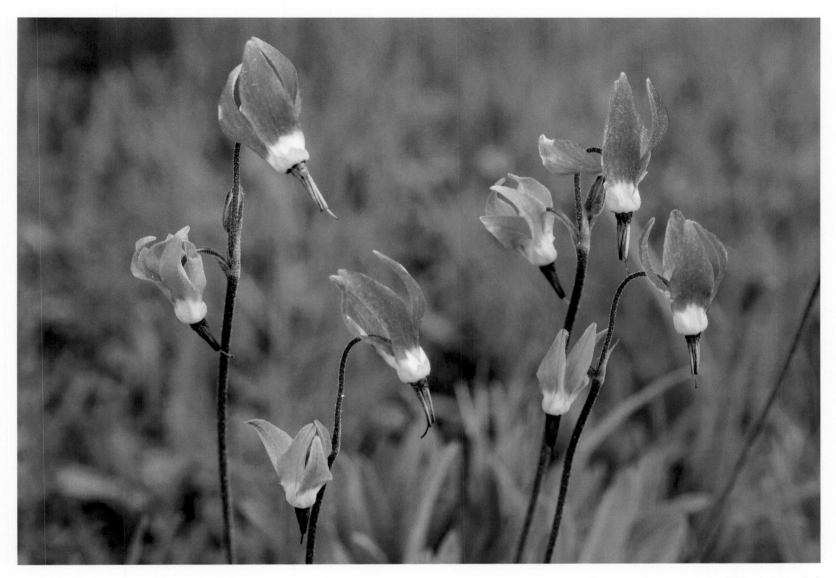

ALPINE SHOOTING STAR (*Primula tetrandra*)

high country, spring in the foothills begins to reveal one crop after another of verdant delicacies. Lupines *(Lupinus)*, poppies *(Eschscholzia)*, shooting stars *(Primula)*, numerous species of *Lillium* and *Castilleja* and many more rise, bloom, attract pollinators, produce seed, and fade away into the surrounding grasses that transition from green to brown. By July and August, when the annual flora of the lower elevations are withered and crunchy underfoot, the montane and mixed conifer forests and meadows are awakened and play host to many more dazzling blooms. Those who explore the subalpine and highest Sierra above the tree line are privy to secret gardens of such gems as sky pilot *(Polemonium eximium)*, Whitney's locoweed *(Astragalus whitneyi)*, ranger's buttons *(Sphenosciadium capitellatum)*, and even more rare specimens.

Sierra-lovers are blessed by the fact that from east to west and north to south there are only a few deep winter months when the range is bereft of blossoms. Such is the gift of geography, soils, and climate. The California Floristic Province, with its Mediterranean climate, has been recognized by Conservation International as one of the world's thirty-three biodiversity hot spots due to its high number of endemic

Evolution has provided plants with an astonishing array of botanical lures and tricks to attract pollinators—in a word: flowers.

ALPINE LILY (*Lilium parvum*)

(those found nowhere else) plants. According to the World Wildlife Fund, the Sierra Nevada is home to 50 percent of the plant species found in California, including four hundred endemics and two hundred rare species.

"When we try to pick out anything by itself," John Muir wrote, "we find it hitched to everything else in the Universe." This elegant and simple ode to interconnectedness is especially true when applied to wildflowers. Roots, anchored

in the soil, give stems the stability to thrust leaves skyward, where they seek the solar rays of Earth's nearest star, some 93 million miles away. Leaves and blossoms attract diverse pollinators, herbivores, and omnivores. Explore the nature of wildflowers and you open the gates of symbiosis.

Evolution has provided plants with an astonishing array of botanical lures and tricks to attract pollinators—in a word: flowers. The bee, fly, beetle, and bird are attracted by the prospect of food, and as one sip of nectar leads to another, they become unwitting matchmakers to lovers with mobility issues. Legumes, such as lupines and peas, draw bees in with an attractive banner petal, and as the insect nuzzles into the nectar folds and presses down the keel petal, she is bopped from below by the stamens (male) and pistil (female). As she visits the next blossom, the pollen left on her from the previous bloom's stamens is rubbed onto the next bloom's pistil. The pollen then begins the journey to the ovary, where fertilization transforms the ovules into seeds.

Our attraction to flowers is deep and enduring. Research has revealed what we instinctively know: flowers trigger happy and positive human emotions. Their presence brings a smile to our lips, while softening feelings of sadness. Love is deeply entwined with our passion for flowers. The artist, poet, and lover in us responds to the sight and the smell of blossoms. The naturalist is seduced by the diversity and structural elegance that await discovery. Perhaps the greatest virtue of wildflowers is that they need no introduction. A hillside ablaze with spring blooms does not need interpretation. The honey-scented meadow breeze carrying the volatile compounds of the perennial western azalea (*Rhododendron occidentale*) delights our olfactory sensitivities and does not beg for scientific explanation. We just like it!

Wildflowers make a strong and positive first impression. Once we are lured through our senses, we find that the beauty and sophistication of the flowers often induce in us a thirst for information. Whether the attraction is casual or all-consuming, the rewards of seeking the glory of flowers is gratifying beyond measure.

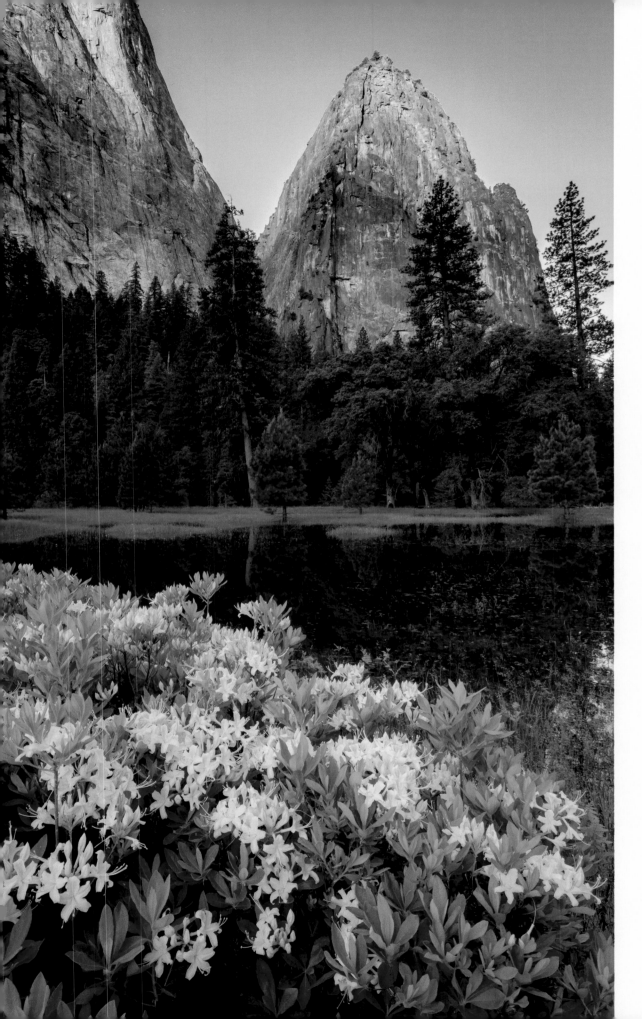

CANYON LIVEFOREVER (*Dudleya cymosa*)

...

Dan Webster is a science teacher and Sierra Nevada naturalist guide based in Sonora, California, near Yosemite National Park. He teaches high school science, coordinates the seven-day summer workshop called the (Tuolumne) Forestry Institute for Teachers, leads field activities for a summer science camp, and is a STEAM (science, technology, engineering, arts, and math) facilitator for local teachers. Before teaching in the classroom, Dan spent many years as an outdoor-school naturalist, summer camp trip leader in Maine, and rural independent studies teacher. When not teaching or guiding, he loves to be outside cutting wood, walking the dog, exploring new and favorite ecosystems with his family, or immersing himself in mountain meadows studying and photographing flowers, bugs, and the myriad marvels of Mother Nature.

WESTERN AZALEA (*Rhododendron occidentale*)

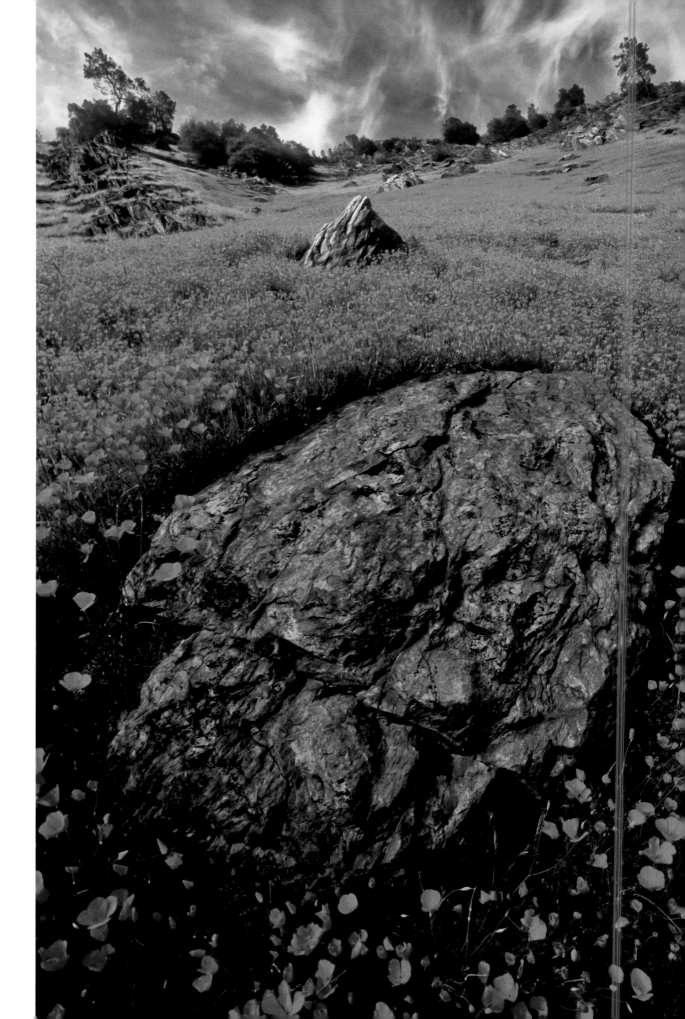

TUFTED POPPIES
(Eschscholzia caespitosa)

Gazing up at the super-steep slopes awash with color, I couldn't believe I'd forgotten my hiking boots! It was spring 2009, and the annual wildflower bloom in Merced River Canyon, west of Yosemite Valley, was putting on an epic show. Although known as a wildflower hot spot, there is still huge year-to-year variability in the intensity of the display. The potential is always there—an abundance of seed is ever present in the soil—but the combination of temperature, light, and precipitation determines how many seeds germinate and mature. That year, optimal conditions were enhanced by the ash deposits from a recent nearby wildfire, and the result was the most spectacular poppy bloom I'd ever seen. Wearing the only shoes I had (casual slip-ons), I spent the entire day photographing the luminous orange glow while doing my best to avoid sliding down the slope.

MERCED RIVER CANYON POPPIES

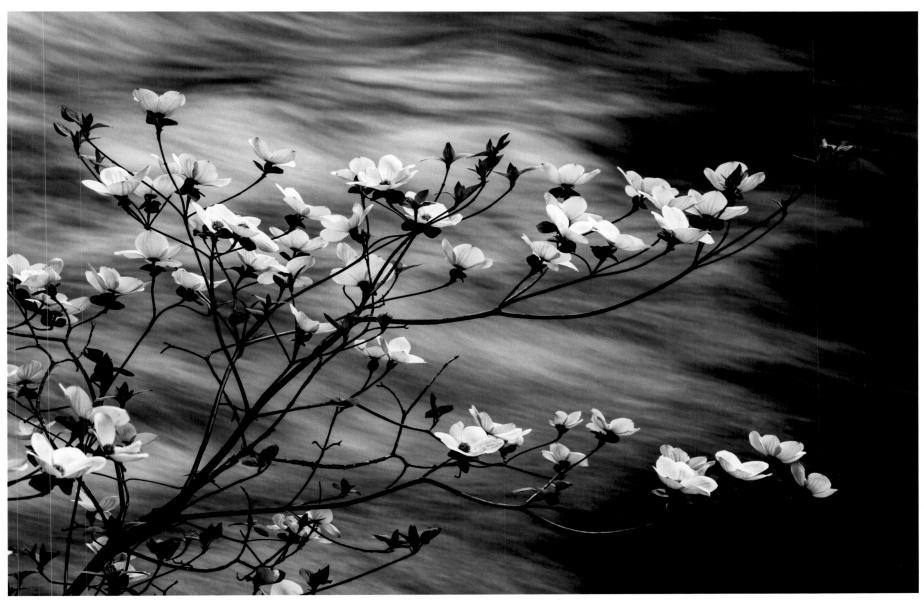

FLOWERING DOGWOOD OVER THE MERCED RIVER

MOUNTAIN DOGWOOD
(*Cornus nuttallii*)

In spring, Yosemite Valley's waterways swell as snow melts in the high country, and the forest scenery is punctuated by elegant dogwood limbs and the unmistakable glow of their large flowers. The flowers emerge before the leaves and, with nothing to obscure them, they appear to float in midair. The showy white "petals" are actually bracts, modified leaves associated with the tree's reproductive structure. The real flowers are small, inconspicuous, and tightly clustered in the centers of the bracts, where they attract a variety of insect pollinators.

The mountain dogwood has adapted to growing under the canopy by evolving to maintain full photosynthetic capacity while receiving only a fraction of the sunlight. A common challenge in photographing dogwood flowers is creating separation between the subject and the visually busy forest, so I often look for appealing displays on the banks of rivers, as a slow shutter speed turns the moving water into a pleasing backdrop.

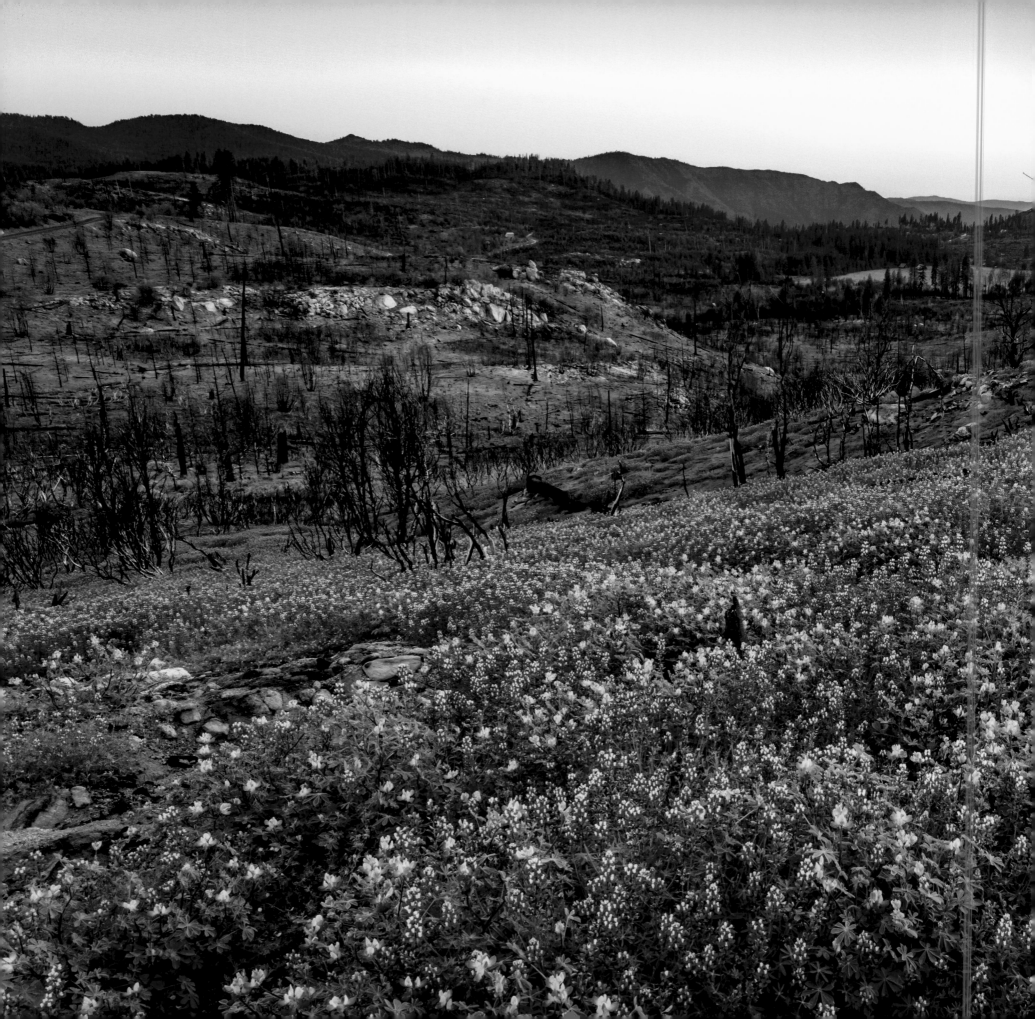

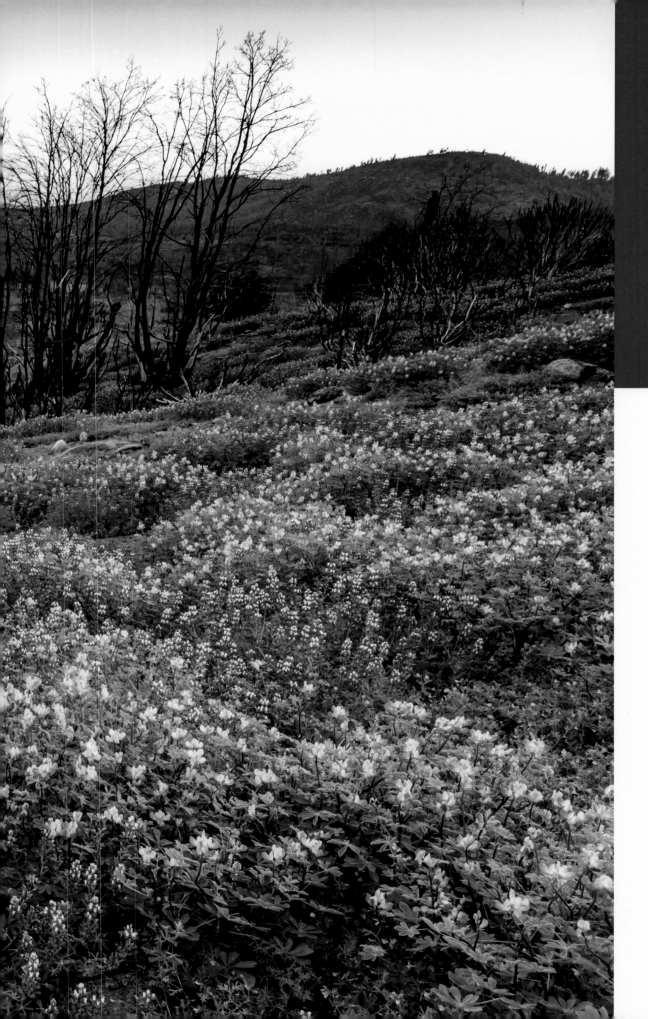

Fire

AGENT OF CHANGE AND RENEWAL

BY KURT MENNING

John Muir famously proclaimed the Sierra Nevada the Range of Light for its long, clear vistas from granite peak to granite peak. Had he visited a century before, when American Indians lit frequent fires to clear routes, open wildlife habitat, and promote growth of desired plants, or a century later, when buildups of fuel led to some severe and extensive fires, he might have called it the Range of Haze. Indeed, for several thousand years fire has been a common and integral part of Sierra Nevada ecosystems. From low-elevation oak woodlands, where fire might recur every two to three years, to higher-elevation red fir forests, which experience fire every fifteen to thirty years, smoky air has been common from summer into autumn.

LUPINE BLOOM, FIRST SPRING FOLLOWING A FIRE

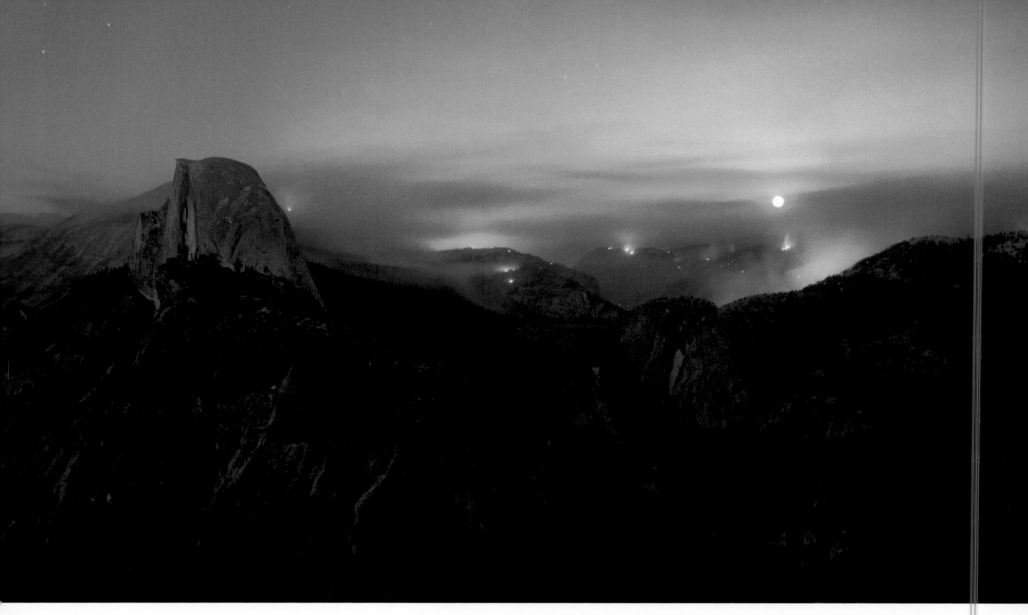

Many people see flames arise from the forest floor and assume they are agents of destruction. For individual trees, this may be the case. But in terms of ecosystems, flames are agents of change and renewal. American Indians, preferring uncluttered routes for migration, embraced burning long ago, knowing that browsers like elk and deer favored the freshly cleared landscape as well. Muir reveled in being able to ascend from the Central Valley to the crest of the Sierra Nevada with arms spread wide, never brushing a tree. This was a landscape cleared by fire of low aerial fuels, a landscape without excessive ladder fuels that can carry fire from the ground into the crown, leading to its rapid spread through whole stands of trees. Of course, much of the story

of fire—and the reason we shouldn't consider it as solely destructive—is about what transpires after.

There is an important and much overlooked distinction between fire itself and the effects that follow. The behavior of fire is often described in terms of fire intensity, a measure of energy released on the flaming front. The assessment of fire effects—such as fire severity, the degree of mortality of trees and loss of biomass—comes later, long after the event. After the great drama, with surface fuels (litter and duff) burned away and crowns scorched and thinned, the stage is set for sweeping changes. Life proves to be tenacious, adaptable, and diverse. Conifers typically survive if at least 50 percent of the crown remains, and after a period of regrowth they

actually thrive with reduced competition for light, water, and nutrients. Surviving pine, fir, and sequoia rain seeds down upon the freshly bare earth. Winter's moisture soaks into the raw soil, and in spring a carpet of seedlings covers the forest floor. After a fire in the 1990s, walking through a mixed conifer stand, I felt I was looking at a freshly sown lawn, so thick were the little fir and sequoia aspiring to become the next giants. Most of these tiny trees wither and die over time, unable to compete with rapidly growing neighbors. Some may survive to be saplings and die in the next fire. Among the thousands that germinate, only a few grow to full size and create the next generation of forest crown.

But the renewal of life in the burned areas of the Sierra Nevada has more pathways than the survival and reproduction of conifers. Oak and manzanita, even with tops completely burned, survive beneath the soil. They resprout from their bases, blistering through charred bark, pushing up, living. A few chaparral species survive fire, which flashes overhead, in the form of dormant seeds banked in the soil. Scarified by heat but not burned, the awakened seeds are primed for the rains to trigger germination. In contrast to these "stay at home" strategies, many herbs survive on the wind, blowing in as seeds from outside the fire perimeter. Indeed, refugia—islands of habitat untouched by fire—provide more than seeds to the burned landscape; from insects to birds to bears, animals pour back into the burned area, exploring and repopulating it. In many ways, and from many places, life returns and often thrives. Fire may have destroyed trees, but at the ecosystem level there is change rather than destruction.

Across the range, nothing remains the same now, not even the cycles of fire that can be measured in observed fire-return intervals. Climate change is expected to bring longer, drier summers with reduced autumn rains and dwindling winter snowpacks. As a result, the fire season may extend with changes to both fire intensity and severity. Yosemite's visitors and managers are fond of ecological regeneration that comes with fire, but many people are relatively intolerant of smoke. Will prescribed burning continue?

HALF DOME IN SMOKE

How will we respond to wildfires that mar the scenery? Certainly there will be days of smoky haze occluding long, clear vistas. Yet after the fires pass, life will flourish, raining down from above, arriving on the wind, pushing up from below, and traveling across the land. Once again, the air will clear, and the Range of Light will shine.

Kurt Menning was born in Yosemite Valley (his father was a ranger), thus beginning a lifelong national park connection. He grew up in Rocky Mountain National Park and later directed the University of Colorado Wilderness Study Group. For his master's degree, he examined a national park and biosphere reserve as a visiting scholar in Russia. Later, he censused sea lions and puffins in Kenai Fjords National Park, in Alaska. In Sequoia National Park, with a Canon National Parks Science fellowship, he completed his PhD at UC Berkeley, investigating landscape-level fire effects. For more than a decade, Kurt has been an adjunct professor of geography at San Francisco State University, where his teaching includes national park management. He backpacks in Yosemite and Rocky Mountain National Parks with his family every summer.

Bigleaf maple foliage

FALL COLOR CHANGE

As days grow shorter and cooler, deciduous trees perform a biological magic act—they change color. Chlorophyll, the compound responsible for photosynthesis, is the reason leaves are green. In preparation for winter, when there is not enough sunlight and water to make energy, the tree's production of chlorophyll slows, then stops. Any chlorophyll left in the leaves degrades, revealing other pigments and their related colors, including xanthophyll (yellow), beta-carotene (orange), and anthocyanin (red).

Curiously, anthocyanin only appears after chlorophyll begins to break down, and the reason is not entirely clear. It's possible that anthocyanin protects the leaves long enough for trees to reabsorb vital nutrients, or that it's a deterrent for insect pests (in nature, red often signals danger).

Whatever the reason for this riot of color, it's like catnip for a photographer, and I've spent many an overcast or rainy day entranced by the tones, textures, and light bouncing through the autumnal forest.

Fall in Tuolumne Grove of Giant Sequoias

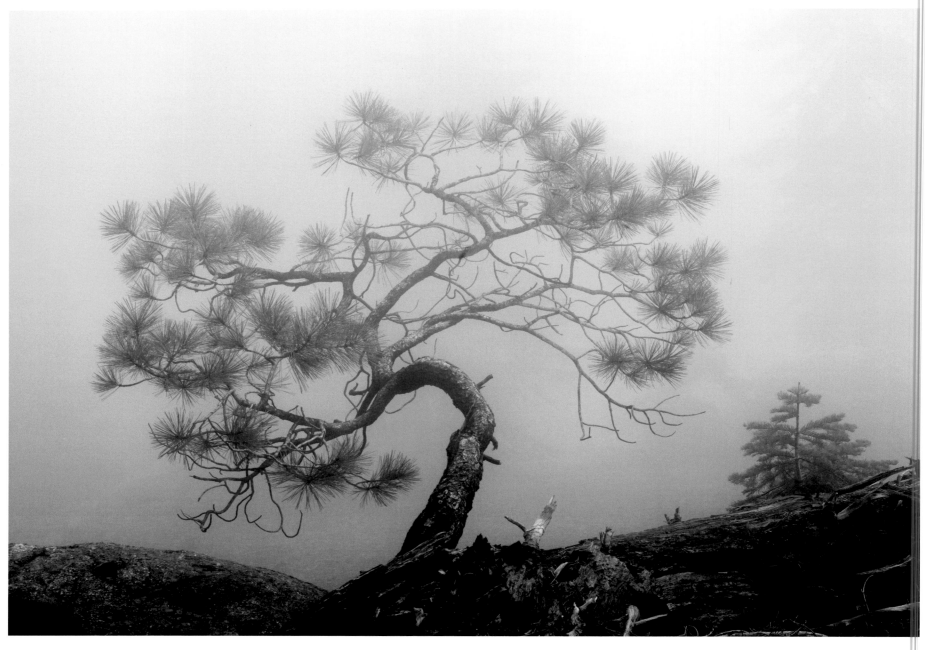

JEFFREY PINE, KRUMMHOLZ FORM

(Pinus jeffreyi)

Fog ebbs and flows around me, washing the peaks and ridges in a fine mist, as I hike the high country. Suddenly, a gnarled, stunted pine comes into view, its exposed roots clinging tightly to the rock. Looking like a supersized bonsai, it's been sculpted by wind and snow into a form biologists call krummholz, a German-derived term that translates to "twisted wood." Their growth throttled by extreme conditions and a short growing season, krummholz are often far older their size would suggest.

I'm always inspired by these trees' tenacity, and this specimen is particularly compelling. They can be very challenging to photograph, as it's often difficult to isolate them from their surroundings. This time, however, the weather is with me; there's just enough fog to blot out the background and create an ethereal, moody effect, but not so much as to obscure the tree's contorted trunk, limbs, and needles.

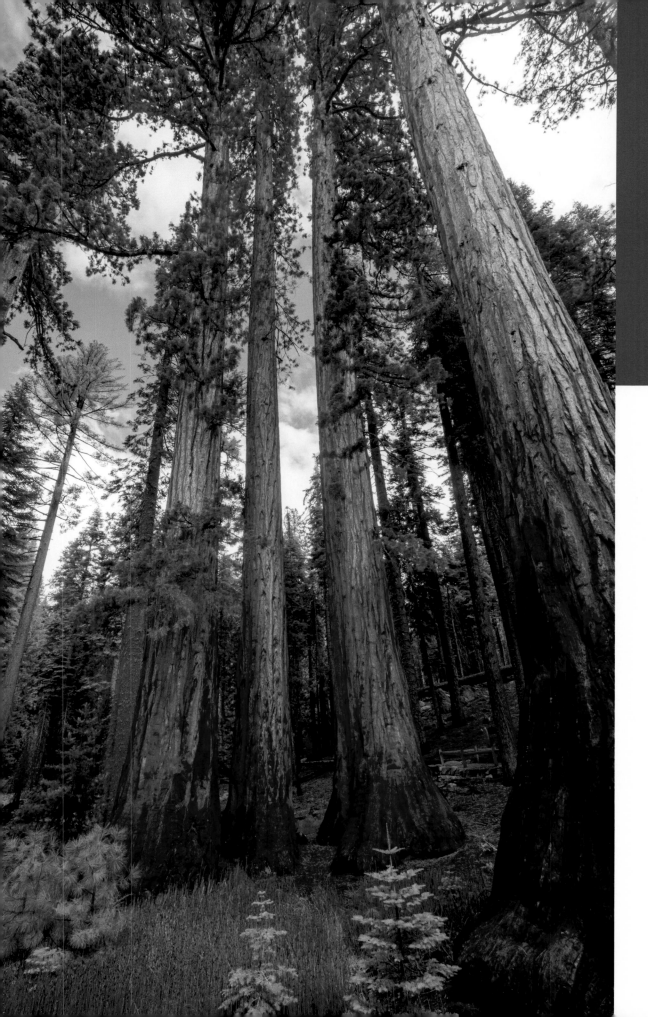

Giant Sequoias

DRAMA ON A GRAND SCALE

BY NATHAN STEPHENSON

To get to one of the small, isolated groves of giant sequoias (*Sequoiadendron giganteum*) scattered along the western flank of the Sierra Nevada, visitors must first pass through forests of huge pines, firs, and incense cedars. But these massive conifers do little to prepare us for the breathtaking immensity of the sequoias themselves. Walking among the sequoias' towering cinnamon trunks evokes a deep, gut-level feeling of peace and timelessness. Here are ranks of enormous living things that have stayed rooted in the same place for millennia, seemingly immune to the effects of the ever-changing world around them. Our worries seem less significant in their presence.

Despite this seeming timelessness, fossil pollen tells us that during past climatic changes sequoia populations have waxed and

MARIPOSA GROVE OF GIANT SEQUOIAS

47

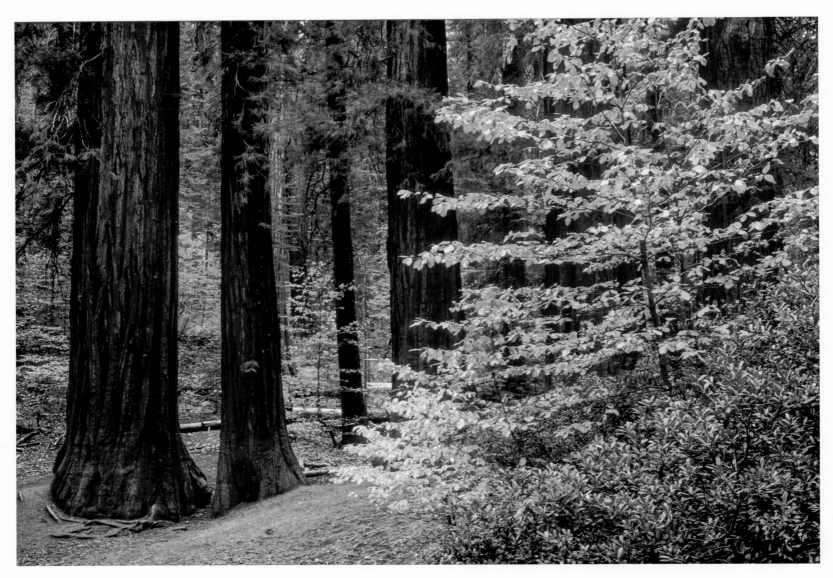

MERCED GROVE OF GIANT SEQUOIAS

waned, and marched up and down the mountain slopes. Near the height of the last glaciation, perhaps 20,000 years ago, sequoias appear to have been more abundant than they are today. As temperatures warmed and the glaciers retreated, sequoias moved upslope to their current elevations. But during a warmer, drier period between 10,000 and 4,500 years ago, sequoias seem to have retreated to a few wet meadow edges and creek sides, and the species could even have been at risk of extinction. As cooler, moister conditions started to return roughly 4,500 years ago, sequoia groves expanded out to today's boundaries. Some of the

big sequoias we admire now could be the offspring of the original pioneers of that "recent" grove expansion.

The copious water requirements of sequoias limit them to the wettest parts of the mixed-conifer forest landscape. On a typical summer day, a big sequoia can easily transpire 700 gallons (2,650 l) of water into the atmosphere. All of that water must be absorbed by roots and, against the pull of gravity, transported up into the tree crown, sometimes more than 300 feet (90 m) high—a remarkable feat of natural engineering. With such copious water use comes exceptional growth: a sequoia can add more than a

thousand pounds of wood to its frame in a single year. Sequoias become the most massive trees on Earth by coupling this rapid growth with exceptionally long life. In most tree species, rapid growth is associated with a short life, reflecting a kind of "live fast, die young" strategy. But sequoias commonly live past 2,000 years, and a handful even exceed 3,000 years. Part of their secret is the exceptional rot resistance of their heartwood—a consequence of tannins and other chemicals that inhibit decay fungi. In addition, for reasons that remain unclear, sequoias seem to be unusually resistant to native bark beetles.

The sequoia life cycle is intimately connected to fire. In his 1901 book, *Our National Parks,* John Muir described watching a fire burn through a sequoia grove, its creeping flames "slowly nibbling the cake of compressed needles and scales with flames an inch high, rising here and there to a foot or two." But interspersed with this placid scene were "big bonfires blazing in perfect storms of energy where heavy branches mixed with small ones lay smashed together . . . [and] young trees vanishing in one flame two or three hundred feet high." Localized but severe hot spots like those described by Muir create the forest openings that are essential for giant sequoia reproduction. The intense flames send a heat pulse into nearby sequoia canopies, which respond with a delayed rain of seeds. The seeds land on bare mineral soil prepared by the fire, without which young sequoia seedlings cannot establish. The "perfect storms of energy" kill most nonsequoia trees and shrubs in patches ranging from fractions of an acre up to a few acres, ensuring that the newly established sequoia seedlings have the sunny, moist environment they need to thrive and grow rapidly. Today's stately groups of sequoias were truly born of fire.

Yet even as fire gives birth to the next generation of sequoias, it can set the stage for the eventual death of a big tree. Sequoias do not die of old age. Rather, as evidenced by enormous logs scattered around the groves, their lives typically end by falling during a windstorm or fire or under heavy snows. Often fallen sequoias have been weakened by large fire scar cavities that are so common at their bases, created over the centuries by dozens of small fires gnawing a cavern in the ancient wood. But this drama plays out on the sequoias' timescale, not ours; only about one sequoia in a thousand falls during a given year. Standing next to one of these ancient monarchs—a tree that may have thrived for more than forty human life spans—it is not surprising to feel we are in the presence of something eternal.

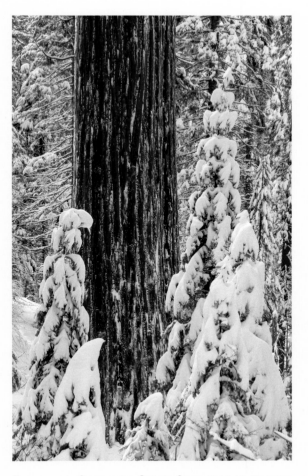

TUOLUMNE GROVE OF GIANT SEQUOIAS IN WINTER

Nathan Stephenson is a research ecologist with the US Geological Survey's Western Ecological Research Center, stationed for thirty-nine years in Sequoia and Kings Canyon National Parks. Nate's roots in the Sierra Nevada go back five generations, and he has spent much of his life hiking the mountains. His overarching goal is to improve our ability to understand, forecast, and adapt to the effects of ongoing global changes on forests, particularly changing climatic and disturbance regimes. Nate's past research has focused on fire ecology, giant sequoia ecology, and restoration of forests that have been altered by prolonged fire exclusion. He is the author of "Ecology and Management of Giant Sequoia Groves," a chapter in *Sierra Nevada Ecosystem Project: Final Report to Congress, Vol. II, Assessments and Scientific Basis for Management Options.*

CALIFORNIA BLACK OAK

(Quercus kelloggii)

Black oaks are excellent photographic subjects. As one season slips into the next, their colorful leaves and elegantly arched branches are hard to resist. Here, an early snowstorm creates a perfect fall-to-winter juxtaposition and draws me like a beacon to the scene.

The California black oak is in many ways nature's one-stop shop. Animals nest or den in the cavities of mature trees, deer browse its leaves, and birds forage its bark and leaves for insects. Possibly the most valuable of all are its acorns, which not only provide nourishment for wildlife, but also were and are a preferred staple for many native peoples, including the Ahwahneechee of Yosemite Valley. It's been well documented that the Ahwahneechee used fire to actively manage the Valley landscape for the benefit of the black oak. Animals also play a part in the black oaks' survival by caching acorns for later consumption; acorns in forgotten caches seem to be more likely to germinate than those sowed randomly under the trees.

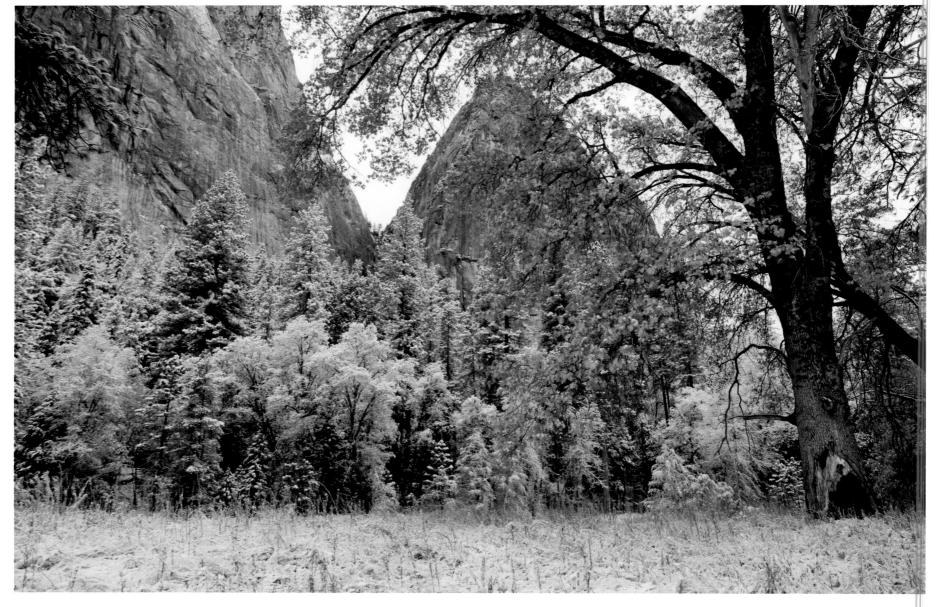

BLACK OAKS, YOSEMITE VALLEY

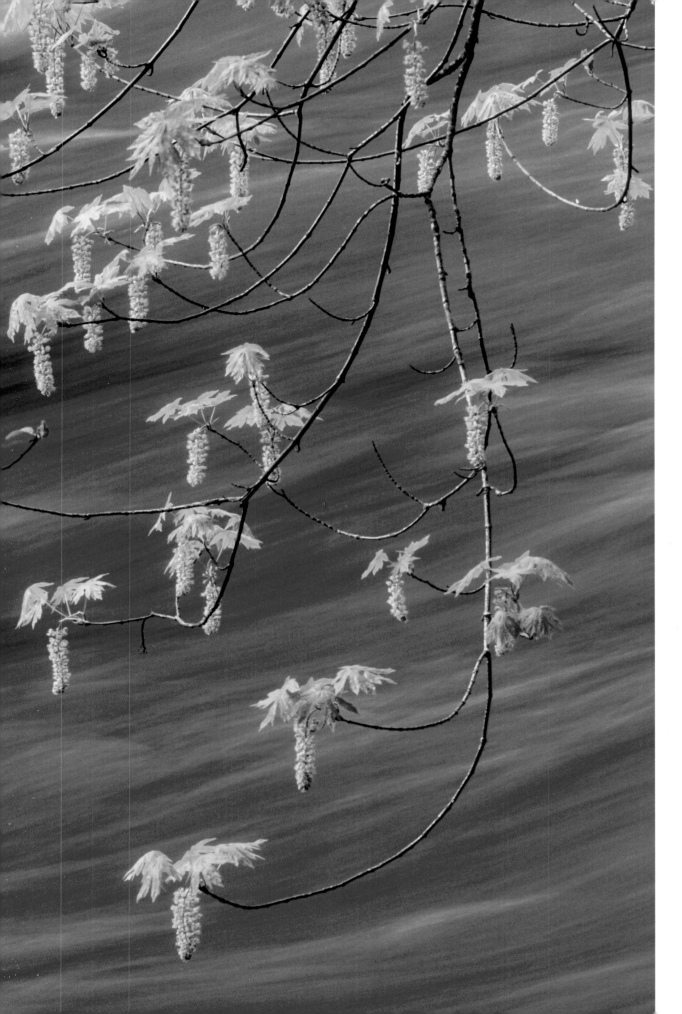

Composing this image by emphasizing the backlit branches and luminous flowers is easy; waiting for the wind to subside is not. I hold my breath and, at just the right moment, fire the multisecond exposure.

BIGLEAF MAPLE

(Acer macrophyllum)

When the weather in Yosemite Valley starts to warm after a long winter, the bigleaf maple is one of the first trees to bloom. The maple's flowers, brilliant clusters of 6-inch-long (15 cm) pendulums, float through the forest or hang over the water and glow with a yellowish-green hue. These clusters are monoecious, containing both male and female flowers. When pollinated, they develop samaras, a remarkable type of seed with a fibrous papery wing. When released from the tree, samaras spin like tiny helicopter blades and are carried away from the parent tree by the wind, ideally landing in a suitable place for germination.

FLOWERING BIGLEAF MAPLE
OVER THE MERCED RIVER

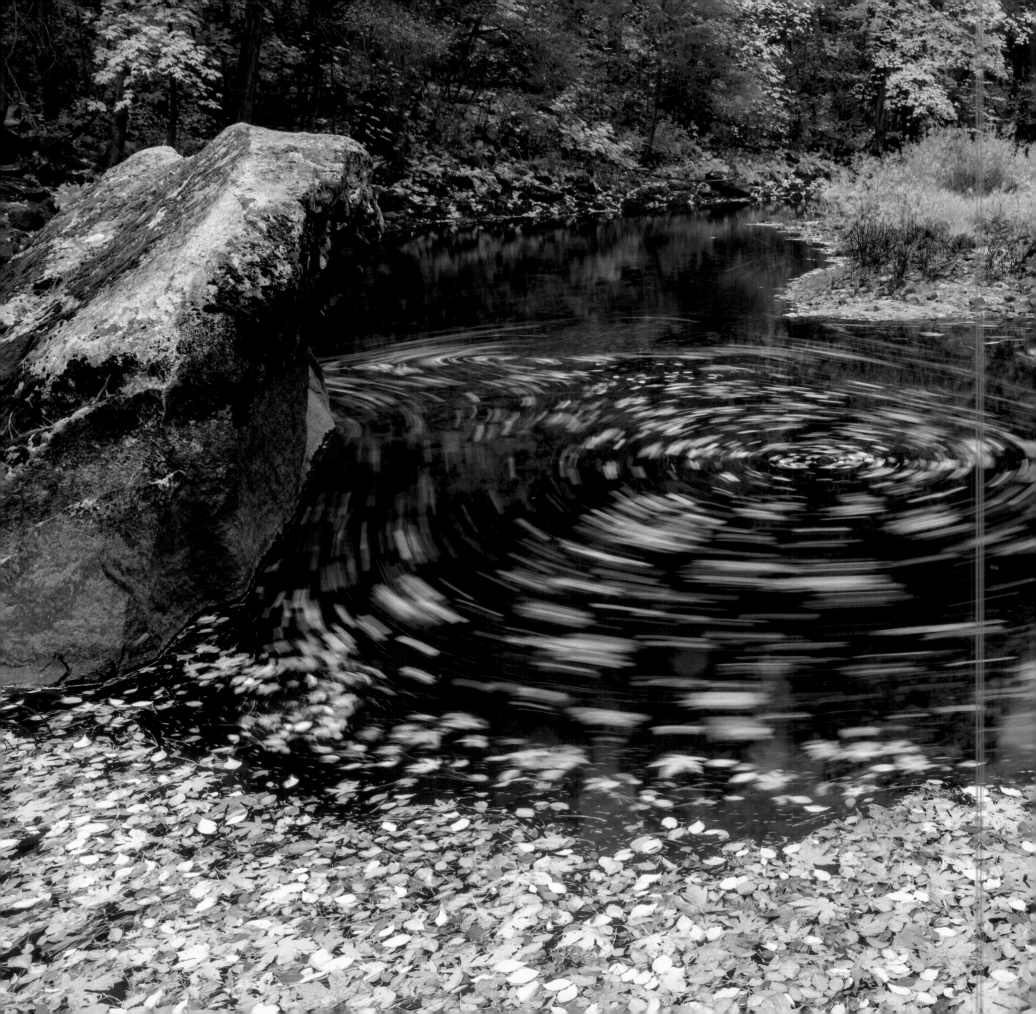

Leaf Litter

WHERE WE WALK

BY PETE DEVINE

Leaf litter (or duff) is not what you might think of when contemplating Yosemite, but it surely belongs in a book about the Sierra. In addition to the majestic towering cliffs, gushing waterfalls, and soaring sequoias, Yosemite is composed of many small working parts contributing to the grand whole. This is bewitchingly evident every autumn, when going for a walk in parts of the Sierra holds the particular delight of shuffling through newly fallen leaves of black oak, mountain dogwood, and bigleaf maple. Much of California—with its desert, scrub country, year-round trees, and coniferous forests—doesn't host the sensory and ambulatory pleasure of scuffing up leaves along a path. In Yosemite we get to savor that special feeling.

FALLEN LEAVES IN THE MERCED RIVER

53

FALLEN LEAVES IN A SMALL POOL

The best places for kicking through deep leaves might be found in Yosemite Valley and Wawona, where acres of deciduous trees shed leaves at the end of the dry season, before the snow and cold of winter arrive. In other parts of the park, both higher and lower, there are different kinds of duff, without the romantic "shufflability" but vital nonetheless. Most of forested Yosemite grows cedar, pine, and fir, which shed their needles more evenly through the seasons. Needles are tough and decompose slowly, especially at higher elevations where cold slows biology. While perhaps less pretty than bright maple leaves, that thick mat

of needles under, say, lodgepoles is an important part of life. The same applies to the Sierra's lower elevations, where sclerophyllous leaves (small, tough, drought-resistant leaves like those of live oak, ceanothus, and chaparral shrubs) pile up. Here it's dryness that slows their decay, but the long warm season means this leaf litter provides essential cooler, damper habitat for many living things.

Wading through noisy arboreal litter, you're likely to remark on the smell. The odor of decomposing leaves tells you that bacteria and fungi are at work, breaking the leaves down into their smaller constituents. The soil fungi fed by

Fewer people see Yosemite in autumn, where brilliantly colored leaves . . . genuinely brighten the light.

this fast food delivered from above (along with the deeper fungi attached to tree roots) are a significant carbon sink. In some places this fungi holds carbon in amounts comparable to what's in the fallen leaves and sticks; it's a considerable stopover in the carbon cycle, of which we are all a part. Think of that rotting-leaf smell as the exhalations of helpful fellow organisms.

You may also notice certain birds that spend their time kicking through leaf litter. Watch for fox sparrows, hermit thrushes, two species of jay, and three species of towhees hopping, shuffling, and flicking aside leaves in search of food. Some of their food is seeds, but the best stuff is the vast buffet of invertebrates found among leaves. The dead leaves are food for detritivores like earthworms, ants, millipedes, the larvae of butterflies and beetles, and springtails. Those marvelous springtails are worth special mention: perhaps one hundred thousand of these little hoppers per square meter (ten thousand per square foot) occupy their dense cities in layers of the forest floor. All these small critters feed a host of predators like birds, salamanders, scorpions, centipedes, and bigger beetles.

Leaf-fall adds immensely to soil moisture (fast food with a beverage!) and protection from erosion by wind, rain, and snowmelt runoff. Burned slopes without leaves or needles covering the soil are vulnerable to debris flows. Leaves that fall into water (such as those of cottonwood and alder) deliver food and shelter to a rich web of aquatic life. In the Sierra, leaf litter (broad-leafed and coniferous) and downed branches are the main fuel of Yosemite's healthiest forest fires. Less common big fires can kill everything, but most of Yosemite's fires are low-intensity. With short flame lengths, these fires singe the trunks of mature trees while thinning out grasses, shrubs, the smallest trees, and small, nonwoody plants called forbs. This house-cleaning function on the litter carpet makes the most diverse, productive, and resilient forests. Duff burned in a fire releases micronutrients like iron, calcium, magnesium, potassium, and phosphorus into the soil, where they nourish the next generation of new growth. Duff that decomposes slowly, without fire, adds loads of vital nitrogen to the soil as well. The tiny seeds of giant sequoias generally don't germinate on a layer of litter; they do so much better when a fire has removed the duff and converted it to nutritious ash.

Fewer people see Yosemite in autumn, where brilliantly colored dead leaves on the ground, along with meadows that have turned golden, genuinely brighten the light in the Valley and elsewhere. This increased albedo attracts artists and photographers to scenes that glow far more than those of even the longer days of summer, when the sun is higher. When we notice the least regarded components with all our senses, the precious national park is all the more enchanting.

...

Pete Devine has a degree in biology and has worked internationally as an interpretive naturalist, national park ranger, river guide, teacher, archeologist, and outdoor educator. He has lived in Yosemite most of his life, where he has directed education programs for Yosemite Conservancy and NatureBridge (formerly the Yosemite Institute). Pete has hiked, skied, and cycled throughout Yosemite in every season and is an expert on the park's history and natural history, specializing in its glaciers, Galen Clark, and Steller's jays. He features in several "Yosemite Nature Notes" videos, including the viral "Frazil Ice" episode. Pete most enjoys sharing the awe of discovery in the park with both first-time and veteran visitors.

HIGH COUNTRY

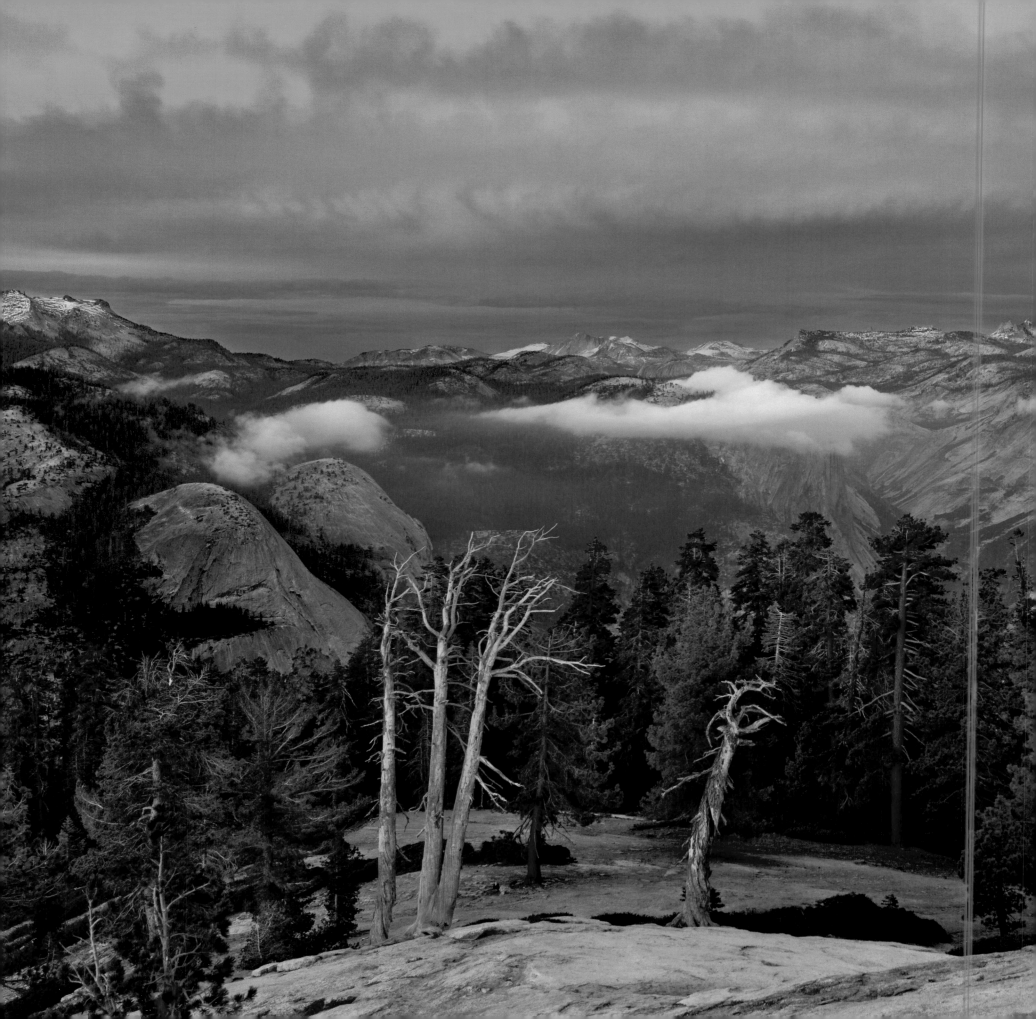

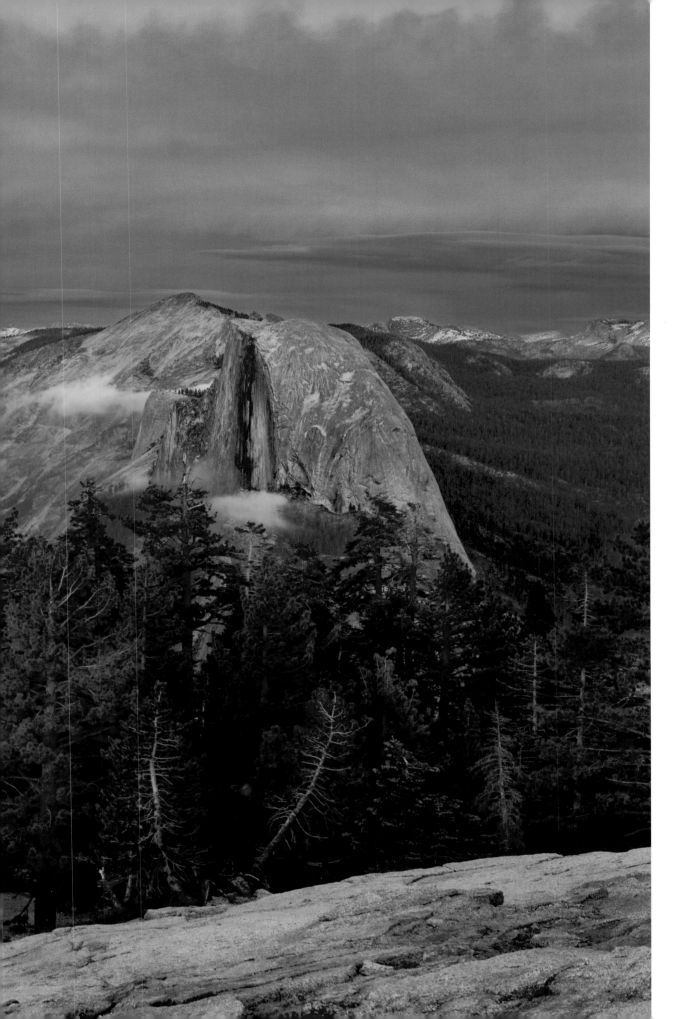

SUNSET FROM SENTINEL DOME

A 2-mile (3.2 km) run from Taft Point to Sentinel Dome leaves us out of breath but enthusiastic about capturing what promises to be a spectacular sunset. Earlier my workshop client and I had been working at Taft when I noticed high clouds filling the sky with texture and definition, and a gap below the clouds on the western horizon—ideal conditions for dynamic light.

Photographers are always trying to predict when a good sunset will appear, and it's usually a futile effort. Today, however, the odds seem to be in our favor, making the run worthwhile. I find a pleasing scene halfway up the dome and leave the camera and tripod in place while working with my client on his photography. Over the next twenty minutes, we are treated to a most stunning light show, and I occasionally run back to my camera and capture a few frames.

HALF DOME, TENAYA CANYON, AND YOSEMITE HIGH COUNTRY

Tuolumne Meadows

AN UNPARALLELED LANDSCAPE

BY KAREN AMSTUTZ

Tuolumne Meadows, one of the largest high-elevation meadows in the Sierra Nevada, may be the closest to heaven a person can get. At 8,600 feet (2,621 m) above sea level, Tuolumne epitomizes the High Sierra: an impossibly clear blue sky embellishing the shimmering granite domes and the slow, meandering Tuolumne River. Cathedral and Unicorn Peaks beckon the adventurer for a hike, and Mount Dana and Mount Gibbs inspire delight and curiosity. After many years living and working seasonally there as a naturalist, I have been deeply influenced by the wild majesty of this unparalleled landscape. Slowing down enough to notice minutiae, with senses piqued, I allow the place to teach me who I am and how I affect the world around

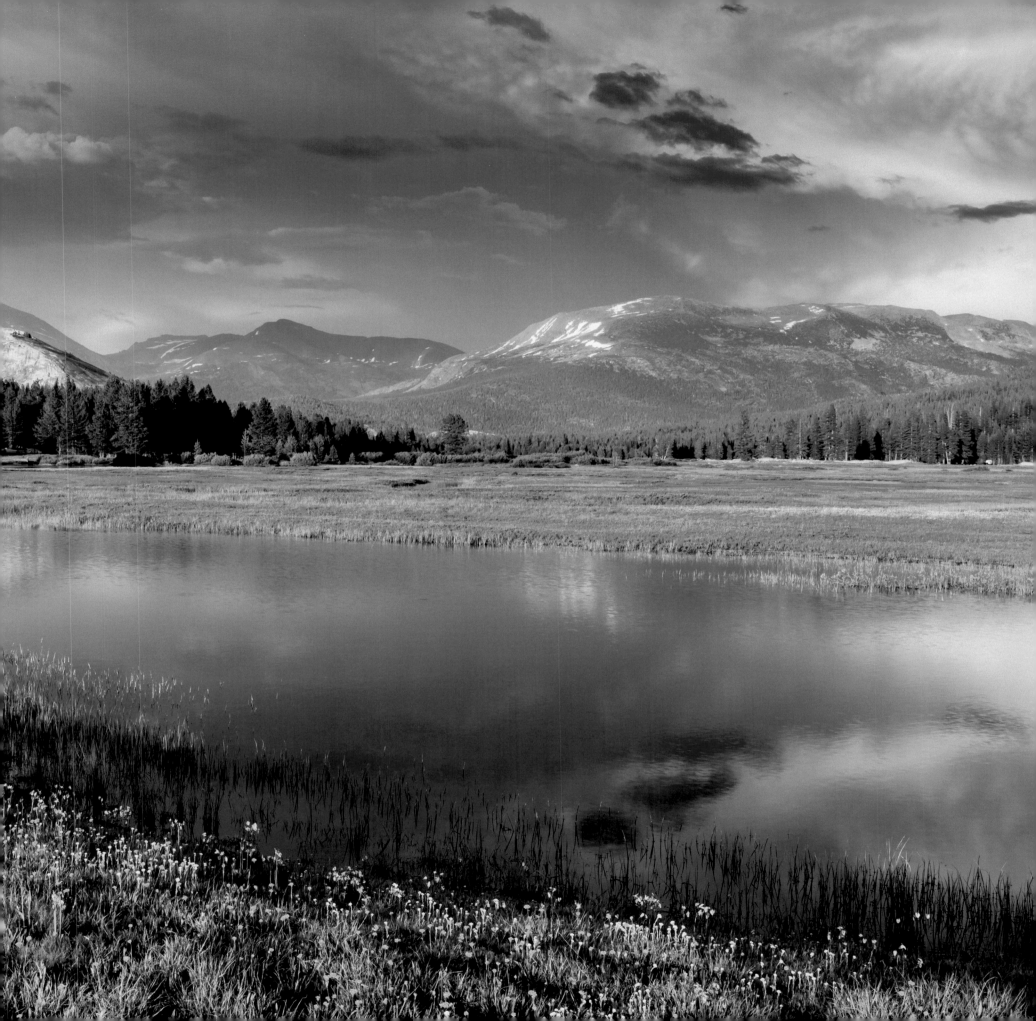

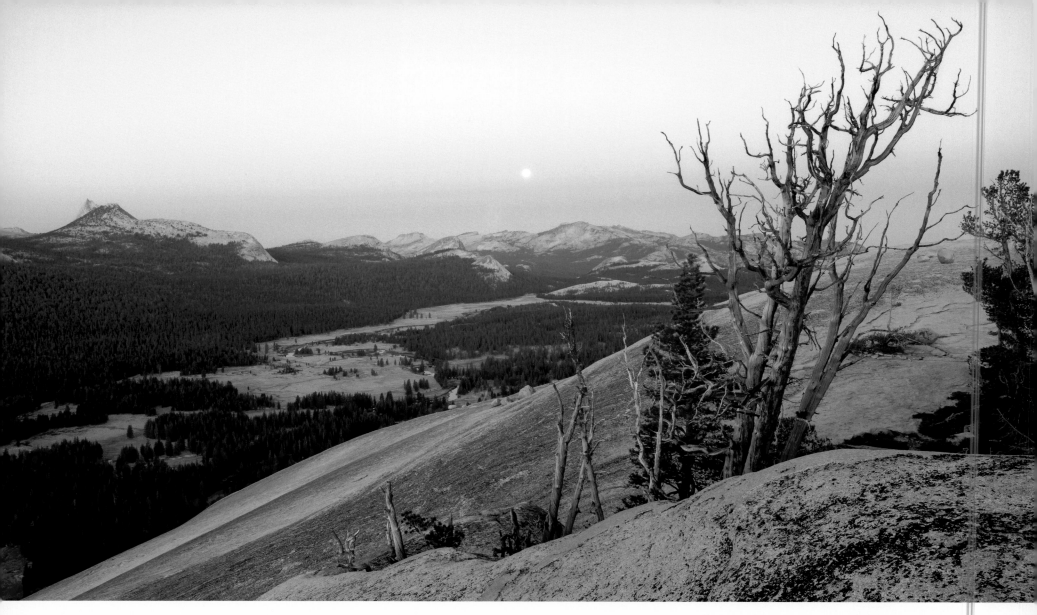

Full moon setting over Tuolumne Meadows

me. Perhaps one of the most treasured lessons learned in Tuolumne is appreciating wildness.

Tuolumne Meadows is accessible by car for about half the year, making days spent there precious ones. During winter a deep, protective snow blankets Tuolumne Meadows and the High Sierra. When Tioga Road opens to cars (usually around late May), I am lured by the promise of another blessed season drenched in natural beauty. Life's rhythms are dictated not by dates on the calendar but rather by the advance and retreat of the annual snowpack. Seasonal human inhabitants are fond of saying that the Tuolumne has two seasons: the longest being winter and the other being "spring-summer-fall." At this

high elevation, life is dependent on the intricacies within the perennial balance. Here, winter can endure for six to seven months, with snow depths accumulating up to 9 feet (3 m). The first snow can come as early as September, though winter conditions may not settle in until October or November. Tioga Road, at the southern edge of the meadow, closes to vehicles, and most humans depart with the first storm series, after which the universal quiet becomes profound. Predators like the ermine, Sierra Nevada red fox, coyote, bobcat, and great horned owl silently hunt for jackrabbit, pika, chickaree, and deer mouse, while Yosemite toad, frog, yellow-bellied marmot, Belding's ground squirrel, and chipmunk are in the

deep repose of hibernation. Mountain chickadees, kinglets, and other intrepid songbirds glean overwintering insects while the icy river moves languidly under the snow cover.

With the warm breath of spring, the blanket of snow melts, saturating the meadow soils, opening the streams, and overfilling the riverbed. The instant the snow is gone, the first intrepid flowers begin blooming. The sunny meadows are alive with yellow buttercups, vivid pink shooting stars, and white bitterroot. Birds arrive from downslope and southern locations to compete for the best nesting sites. The rival songs of hermit thrush, red crossbill, dark-eyed junco, and yellow-rumped warbler fill the air, harmonizing with the river's runoff. Surviving marmots and other hibernators come out of hidden dens hungry for their first food in months. The fever pitch of the short breeding season is on for every form of life. Tioga Road opens to cars during this fervid time, and the flood of human visitors arrives to soak in the dramatic beauty of Tuolumne Meadows.

The blush of spring passes quickly with the greening of the sedges and grasses and the recession of the river to its bed. Summer is signaled by the succession of subalpine flora and the proliferation of countless midseason blossoms, including Lemmon's paintbrush, cinquefoil, columbine, and pussypaws. Hazy yellow cross-meadow breezes of pollen erupt from bounteous lodgepole pines that cover the slopes up to tree line at 10,500 feet (3,200 m). Fawns take their first wobbly steps and hide, apart from their mothers, in shrubs and tall grasses. Mama bears and cubs seek nourishment in meadows, forests, river, and lake edges. Baby ground squirrels emerge as hawks arrive to hunt. Fledgling birds take to the air, learning fast or becoming prey as they follow parents in search of insect quarry, seeds, or other foods. Myriad natural dramas play out during the long summer days.

Summer's vibrancy fades to autumn with a sudden crispness in the air, a lengthening of shadows, waning streams, and the blooming of asters and gentians among the golden meadow blades and willow thickets. Black bears and mule deer graze in the meadows, then head downslope to fatten on acorn

and low-elevation seeds. Marmots disappear, storing enough fat to enter hibernation in cozy dens. The annual sequence repeats with the first snow. The rhythm of the seasons calls for the adaptability and resilience that is built into the intricate balance of this subalpine ecosystem.

. .

Karen Amstutz lives on the edge of Yosemite National Park with her husband, Paul, and their daughters. Undertaking a seasonal migration upslope to Tuolumne Meadows, she works as a national park ranger supervising the Tuolumne Meadows Interpretation operation. Karen's vibrant programs are renowned, and she is proud of the way her staff interprets the subalpine mysteries for people. She has an MA from Humboldt State University and a lifetime of summers spent steeped in the Sierra Nevada. Her career as a naturalist spans almost thirty years. With her binoculars always around her neck, Karen has traveled near and far seeking adventure and learning from Earth's wild places.

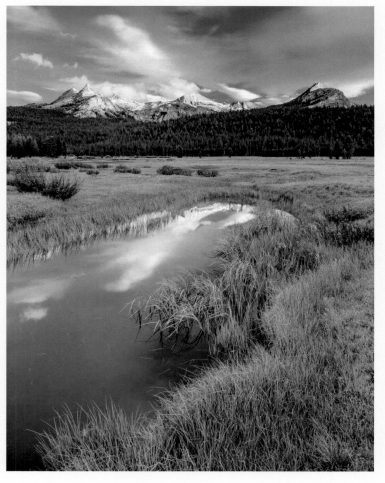

TUOLUMNE MEADOWS AND THE CATHEDRAL RANGE

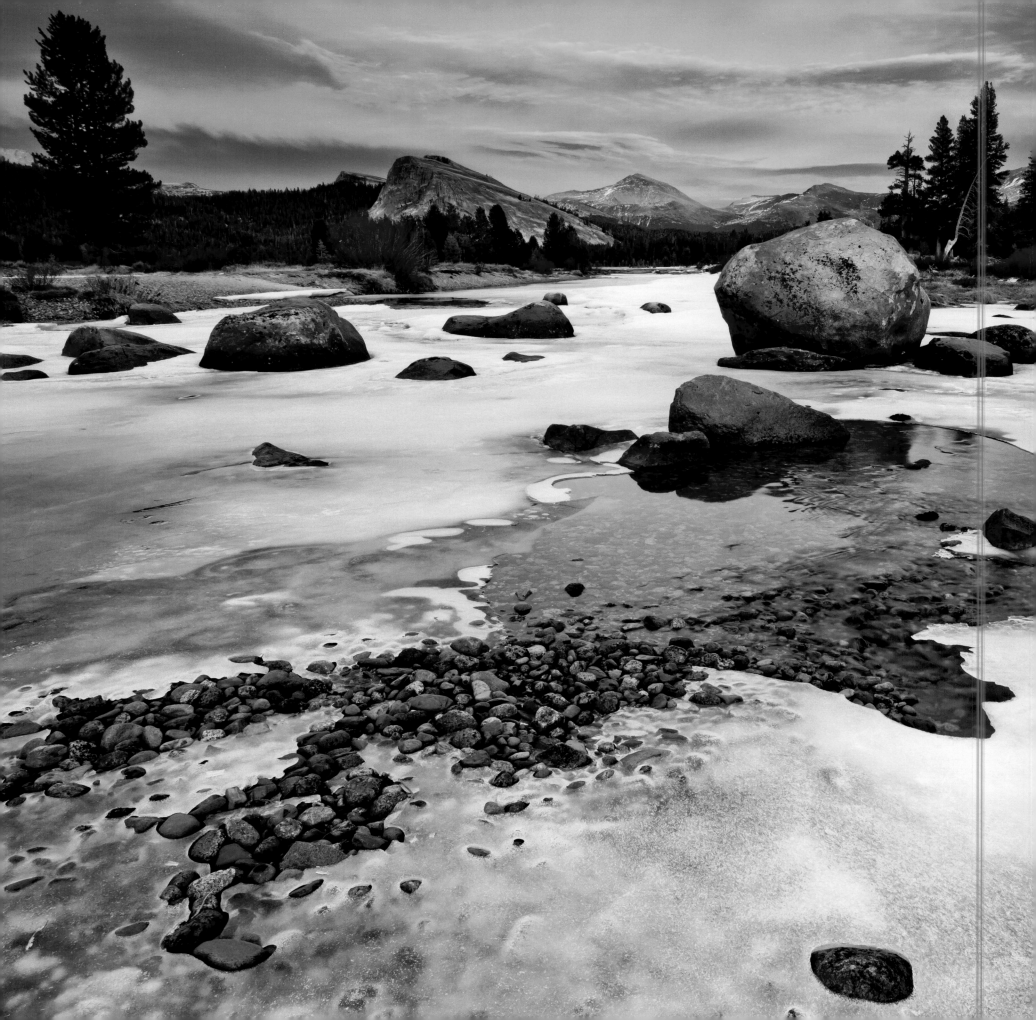

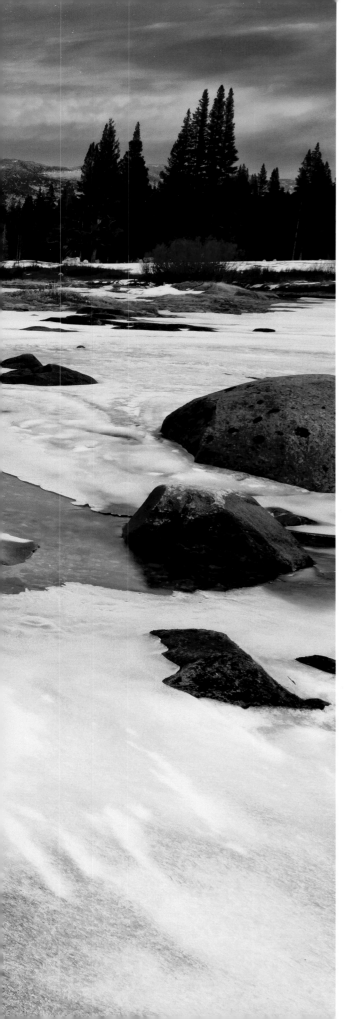

WINTER, TUOLUMNE RIVER

The winter of 2011–12 was truly a special one. Visitors to Yosemite were presented with a rare opportunity to drive into the high country during a time of year when access is usually limited to skis and snowshoes. Typically, Tioga Road is closed after the first big snow in the fall and stays closed until the following spring or summer. That winter, however, was one of the driest on record, and the road was open through mid-January, providing a unique window of access.

I spent several frigid days wandering around Tuolumne Meadows, pondering life at 8,600 feet (2,621 m), where the nightly temperatures drop to single digits (below 0 degrees Celsius) and daytime temps hover just above freezing. It was so cold, I wondered about the animals. Most birds had moved on, but small mammals, amphibians, and fish were still nearby, utilizing a variety of specialized adaptations to survive until the spring thaw.

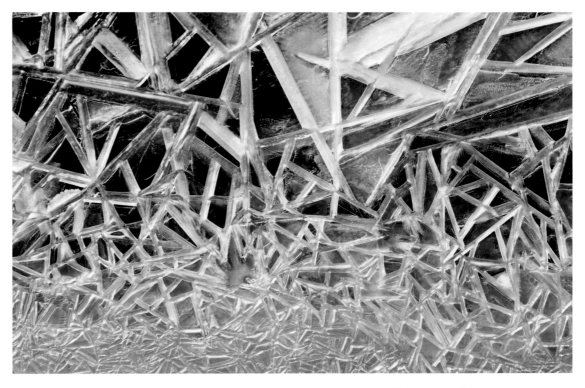

TUOLUMNE RIVER ICE CRYSTALS

Photographically, I gravitated to the alluring ice formations along the Tuolumne River, working to capture them as unique entities on their own and in the context of the surrounding landscape.

TUOLUMNE RIVER AND LEMBERT DOME

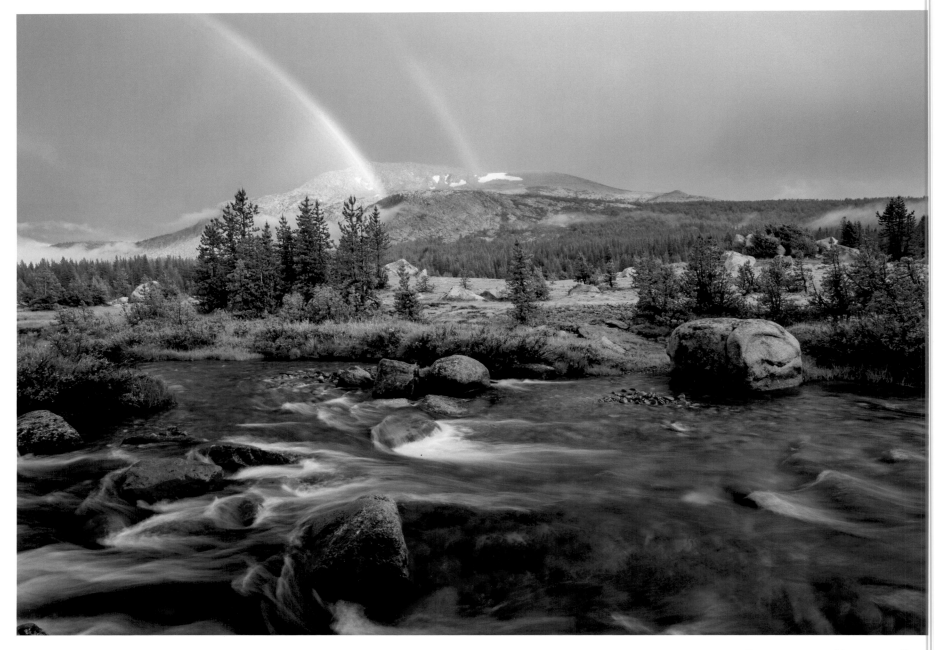

RAINBOW OVER MAMMOTH PEAK

SUMMER THUNDERSHOWERS

Caught out during a Sierra Nevada summer thundershower, I find shelter and hunker down for this most intense and exhilarating experience. These storms—born from moist air rising from the Central Valley, pushing up against the mountains, then condensing and cooling into imposing, water-heavy cumulonimbus clouds—are known for lightning and intense localized rain or hail. The squalls are typically short-lived and are sometimes followed by dynamic light, so I often wait them out (my motto is "all storms clear").

As this one passes, I see a gap in the sun's trajectory to the west, which often means that a rainbow will soon show up. Anticipating where it will appear, I set up my tripod. As the sun clears the obstruction, a most vivid double rainbow materializes, not exactly where I predicted, but close enough to complete the composition.

TENAYA LAKE

As is the case with most mountain lakes, sediment deposited by the creeks that feed it will eventually fill the basin and it will transition from water to meadow and, ultimately, to forest. Tenaya Lake's past and its future fate give me reasons to appreciate every moment I spend there.

I'm working on the shore of Tenaya Lake and framing the scene in my viewfinder—a scene that was created over millennia. The clouds roll by and the light changes during the few hours I'm there. It's a striking juxtaposition of time.

Near Tioga Road, Tenaya at 8,150 feet (2,484 m) in elevation, is the park's most easily accessible high-elevation lake. The shallow depression, only 100 feet (30 m) deep, was carved under the immense pressure and weight of the 2,000-foot-thick (610 m) Tuolumne ice field as it slid past. When the last glacier retreated about 15,000 years ago, runoff from the surrounding watershed filled the depression, and a lake was born.

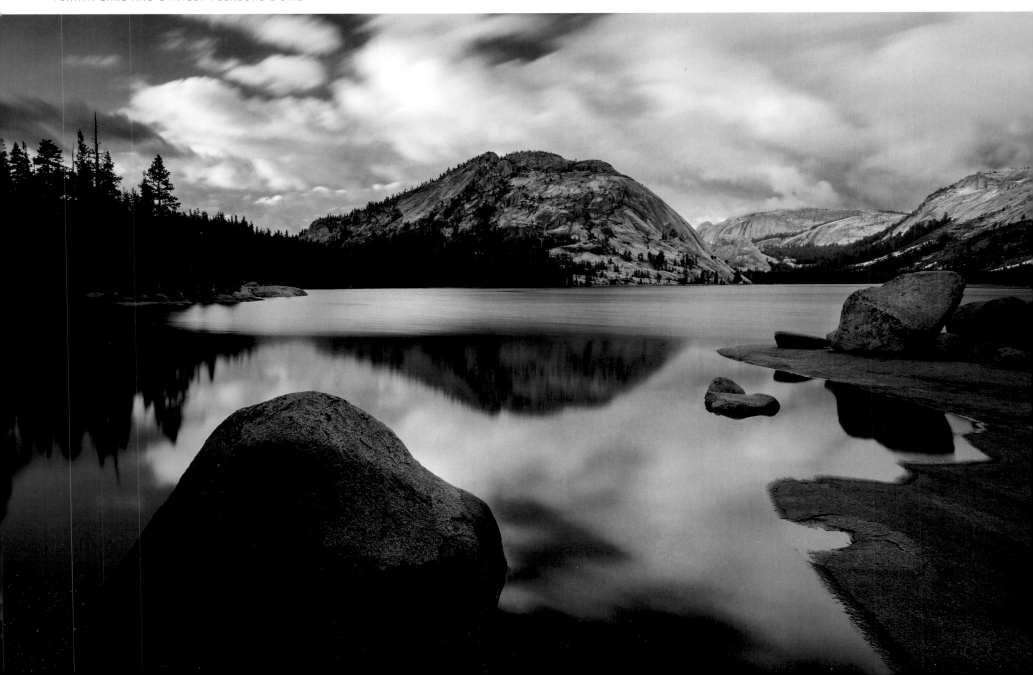

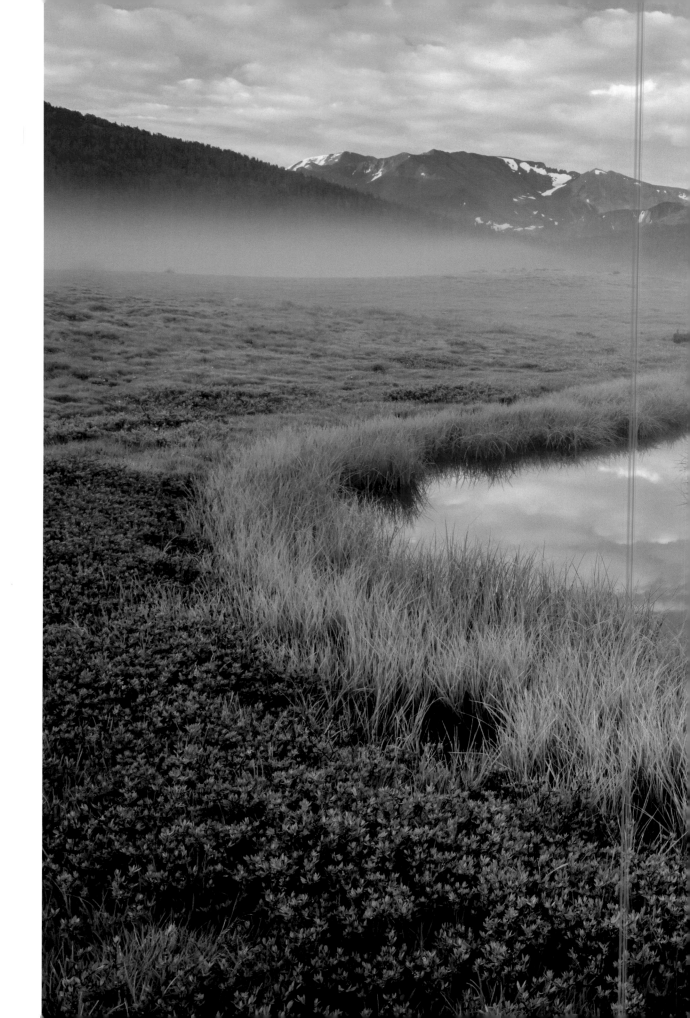

KETTLE,
DANA
MEADOWS

Waking up well before dawn isn't necessarily something I enjoy, but the peaceful serenity of the first few hours of the day is more than enough inspiration to heed the alarm. The excitement of not knowing what the impending daybreak will hold drags me out of bed, and the abundant sounds of animal activity after a long night's sleep is always entertaining regardless of the photographic success.

Dana Meadows, near Tioga Pass at the eastern edge of Yosemite, is one of my regular sunrise destinations, as the shooting direction lends itself to early morning light. The meadows are dotted with small kettles, shallow water-filled depressions created when large blocks of ice from the last of the Tuolumne ice field were deposited into the poorly drained glacial sediment (which geologists call till) some 15,000 years ago. This timeless scene—sunrise, mountains, mist, cloud-dappled water, the kettle's lush and sinuous border—is well worth the sacrifice of a few hours' sleep.

MISTY SUNRISE IN DANA MEADOWS

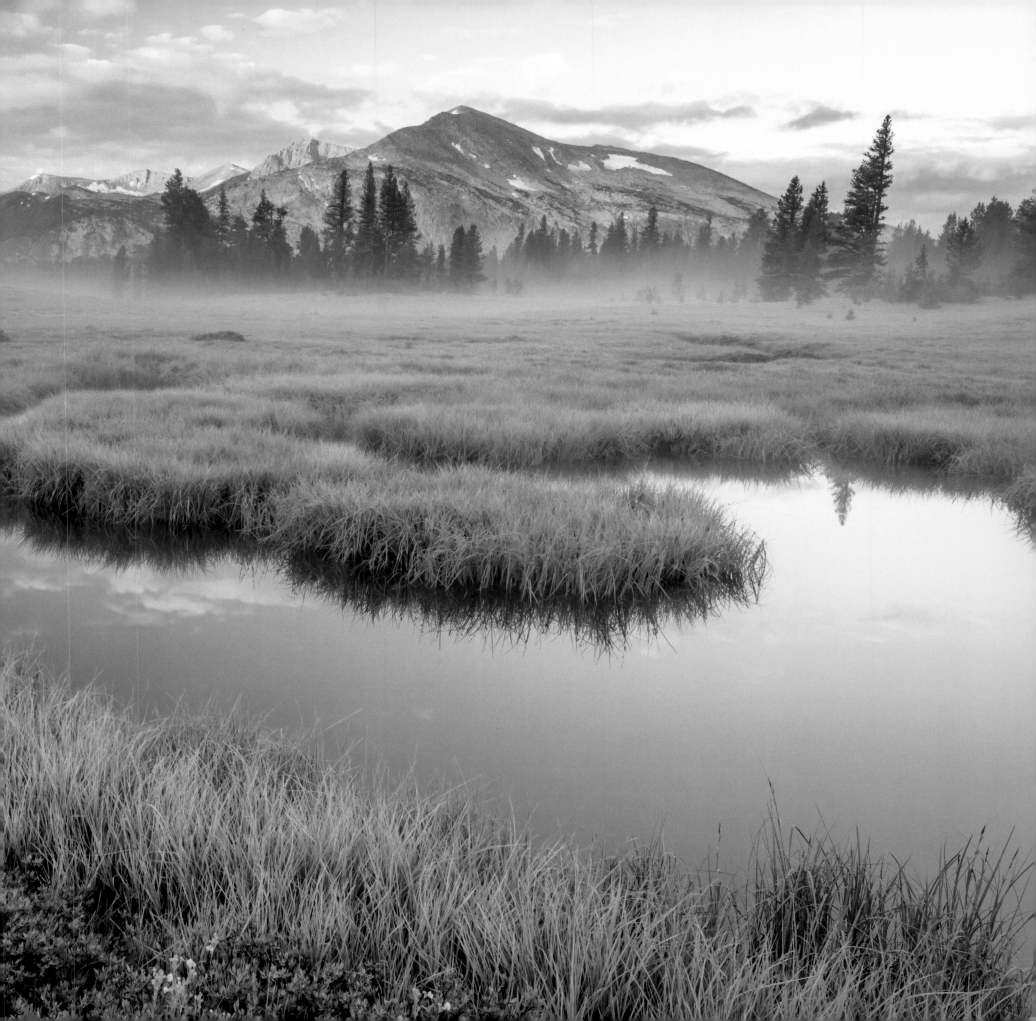

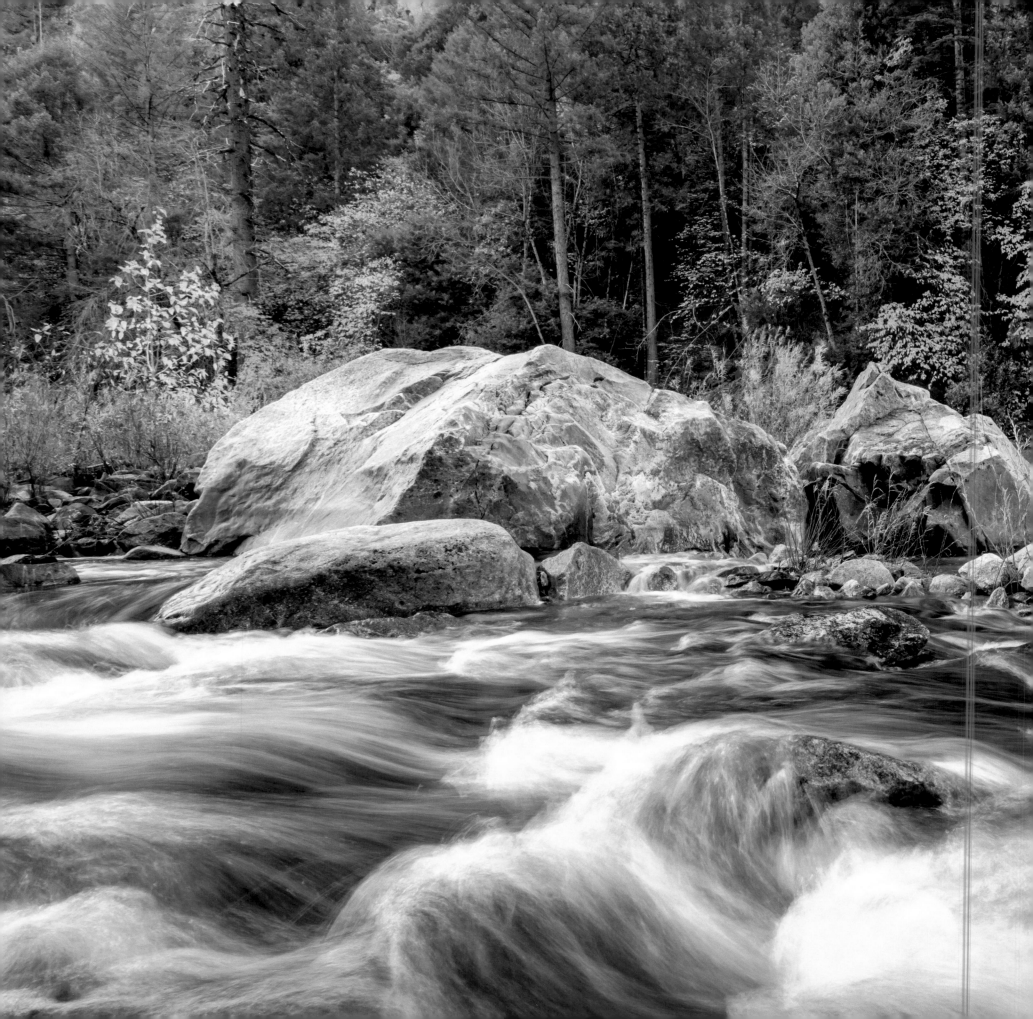

The Rivers of Yosemite

SHAPING LAND, NOURISHING LIFE

BY TIM PALMER

Many of us know Yosemite as the most beautiful place on Earth and as a park brimming with life. But anyone who loves the splendor of this Valley and its mountain stronghold has got to love its rivers as well. Yosemite wouldn't be Yosemite without its rivers.

The mountains were first created by tectonic and seismic uplifts, but then it was the rivers, including their frozen iteration as glaciers, that shaped those mountains into the exquisite forms we know today. Erosion by flowing water and the Pleistocene's slower flowing ice sculpted the grandeur found in Yosemite Valley, the subtler beauty of Tuolumne Meadows, and the hidden enchantment of thousands of stream courses that gather to create the larger flows. As highlights of the park and a big draw, waterfalls

THE MERCED RIVER IN YOSEMITE VALLEY

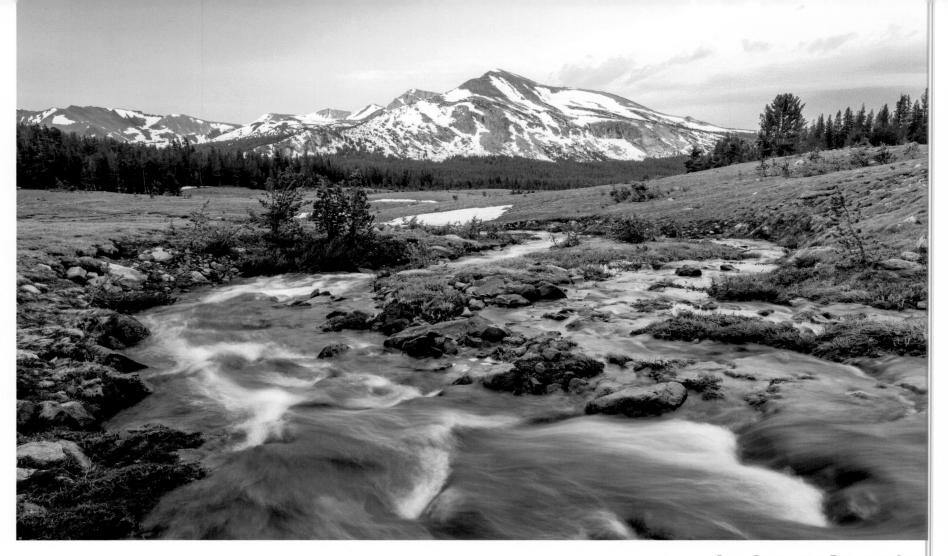

DANA FORK OF THE TUOLUMNE RIVER

from Bridalveil to Vernal and Waterwheel are really just steep-gradient pitches of Yosemite's rivers and streams.

The rivers have shaped this place, and now they nourish its life. In the region's Mediterranean climate of wet winters and sunbaked summers, wild creatures congregate at the streams. Up to 70 percent of bird and other wildlife species depend on riparian habitat. Many migration routes—from high-country salad gardens in summer to sheltered enclaves in winter—follow the courses of waterways. The river corridors link to vital winter ranges for deer in lowlands to the west and for bighorn sheep on the precipitous east side of the Sierra crest.

Perhaps most fundamentally from our perspective, flowing water is beautiful. When I roam the mountains, I'm always impressed by the bubbling rush all around me. The simple, two-element compound of water becomes extraordinary when combined with the Sierra Nevada's

gradient down granite stairways and the luminous glow of both sun and moon. Shimmering, riffling, and reflecting constantly, water is the part of the landscape that moves.

At high elevations Yosemite's streams showcase the snowmelt bursting from winter's drifts and a few precious remaining glaciers, although those natural water-making factories with their slow-motion delivery of runoff are disappearing quickly in the age of global warming. At middle elevations the rivers plunge through canyons cut to echoing depths in the granitic core of the range. Lower, the accumulating waters drift through hanging valleys and pitch downward toward foothills of pines, oaks, and grassland savanna outside the park.

Yosemite lies wholly within two of California's great watersheds—the Tuolumne and Merced—each of stunning beauty, statewide importance, and national fame. The Lyell and

Maclure Glaciers melt and become the Tuolumne's headwaters. In lodgepole pine forests, below the lofty wonderland, the Dana and Lyell Forks join to create the main stem in Tuolumne Meadows, with its sunny medley of wildflowers, pines, and rock—the desired destination of many visitors. The river then powers down through the Grand Canyon of the Tuolumne—as deserving of this prefix as the Grand Canyon itself, and perhaps the most extraordinary of all high-country watercourses in America. During peak flows in early summer, the Tuolumne's waterfalls and intervening rapids create a spectacular hydrologic phenomenon. The river is later tapped heavily for irrigation, for San Francisco, and for other Bay Area cities, while the lower river remains crucial to surviving runs of salmon.

Meanwhile, just south of the Tuolumne, snowmelt from summits and ridgetops embarks on an equally remarkable path down the Merced watershed. Careening over Nevada and Vernal Falls, the river enters Yosemite Valley and meanders like a tranquil dream with views to Half Dome and El Capitan, past the sublime and reverently quiet beauty of Leidig Meadow, and into canyons that ramp down to foothills of green and gold. Like the Tuolumne, the lower Merced is diverted for farms and cities, although its flows are vital to fish, by the lower San Joaquin River, and by the Sacramento–San Joaquin Delta.

The Tuolumne River plays prominently not only in Yosemite's conservation drama but also in the environmental history of America. It was here that John Muir launched his final conservation initiative, which aimed to spare from damming the nation's only valley similar to Yosemite. He lost that battle, and the park's integrity was compromised with O'Shaughnessy Dam and its flooding of Hetch Hetchy Valley's sublime beauty. Though dispiriting to Muir and others, the loss provided the seeds that grew into a full-blown national movement to protect parklands and wild rivers all across America.

Rivers have made Yosemite what it is. They've been on the front line of threats to the natural environment and also on the leading edge of protection efforts. Shaping the land, nourishing its life, and enlivening everything around them, Yosemite's rivers draw their vitality from headwaters up above while their flow has for eons been critical to life down below. The rivers forever remind us—as Muir proclaimed—that everything in the universe is connected.

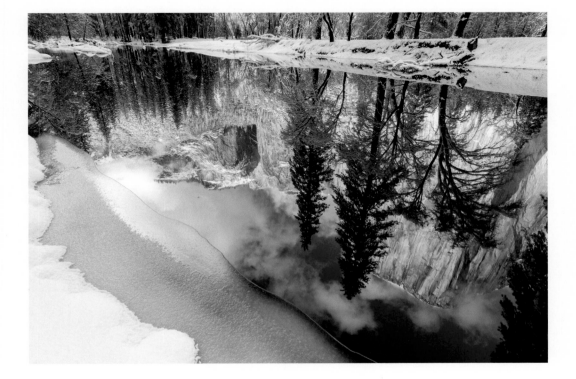

Tim Palmer is the award-winning author and photographer of twenty-six books about rivers, the environment, and adventure travel. He has been involved in river conservation since 1970 and has received a Lifetime Achievement Award from American Rivers and also a Peter Behr Award and a Mark Dubois Award from California's Friends of the River. *Paddler* magazine named him one of the "ten greatest river conservationists of our time" and one of the "one hundred great paddlers of the past century." Tim has written about the rivers of Yosemite in *Luminous Mountains: The Sierra Nevada of California; The Sierra Nevada: A Mountain Journey; Rivers of California;* and *Field Guide to California Rivers.*

Merced River reflection

GLACIAL ERRATICS, OLMSTED POINT

Looking like toys randomly scattered by giants, the boulders that dot Olmsted Point are clues to its long-ago past. Geologists call them glacial erratics, and they were carried here by the ice field that spilled over from Tuolumne Meadows into Tenaya Canyon and, eventually, Yosemite Valley. Like a massive conveyor belt, the river of ice transported the boulders within it; later, as the climate warmed and the ice retreated around 10,000 years ago, the boulders were left behind on the bedrock, reminders of the forces that shaped this landscape.

Olmsted Point, an exceptional place to ponder the nature of these erratics, also provides stellar views of Half Dome and Clouds Rest and has become a regular destination for photography. As I work on this composition, it's difficult to keep my focus on the landscape—a sooty grouse is performing its showy breeding-season display nearby.

SUNSET FROM OLMSTED POINT

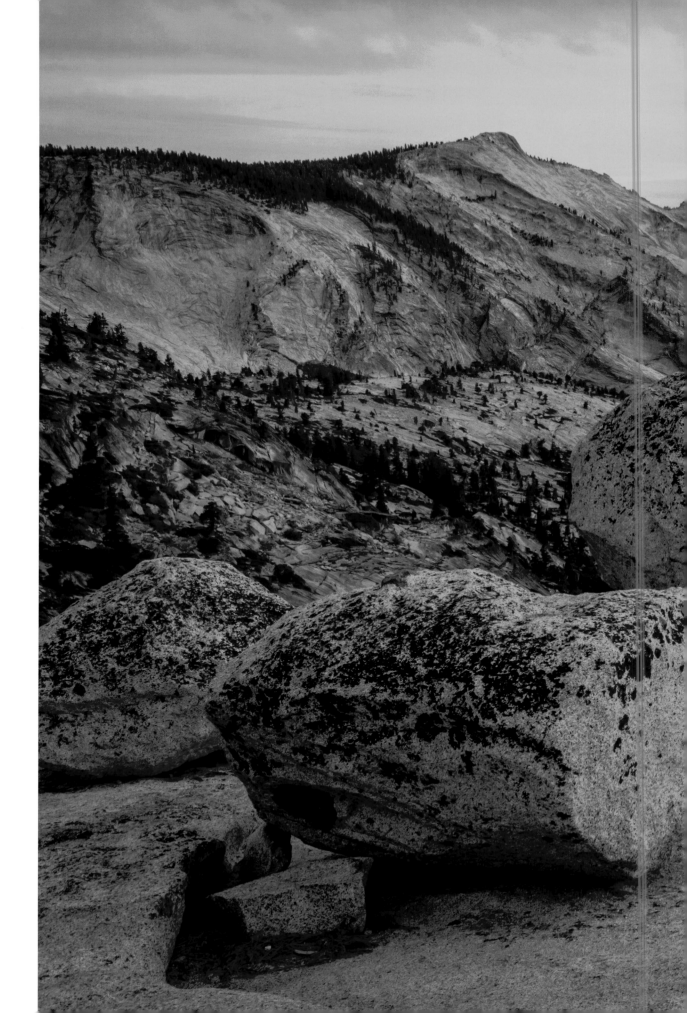

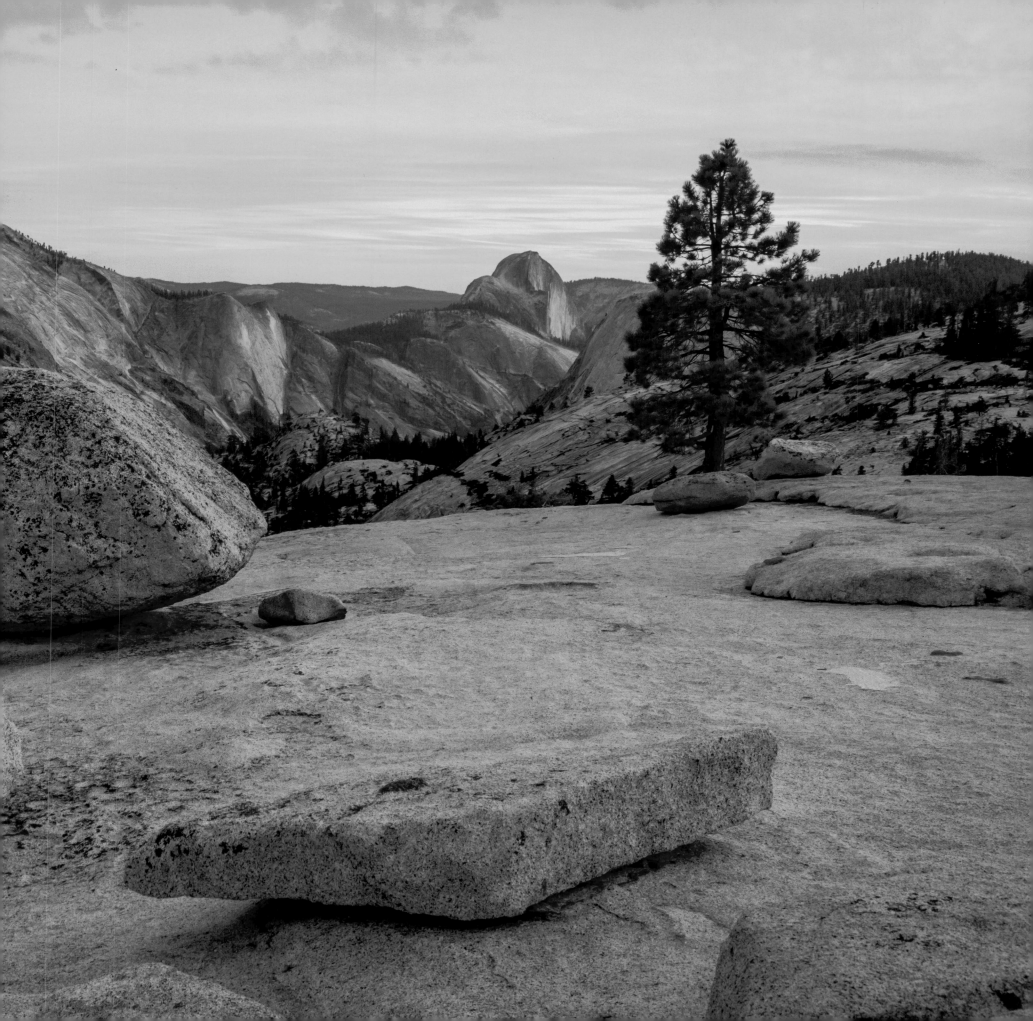

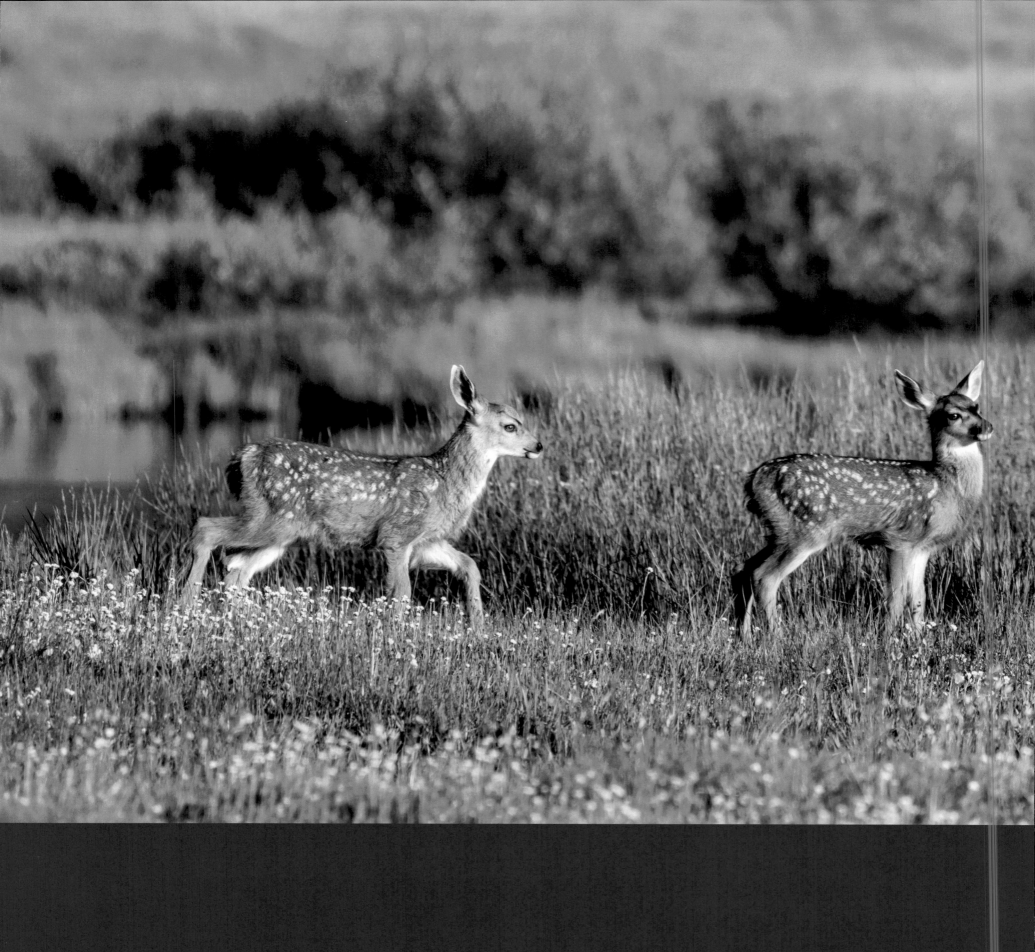

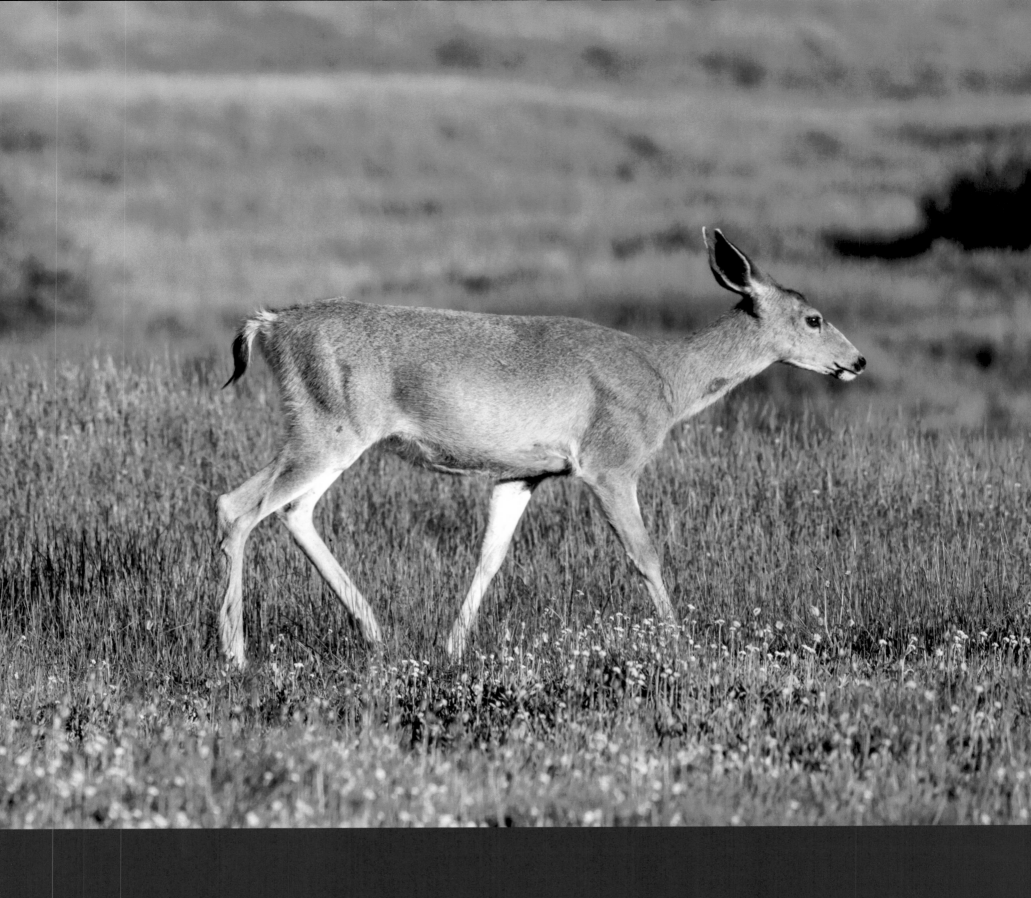

FAUNA

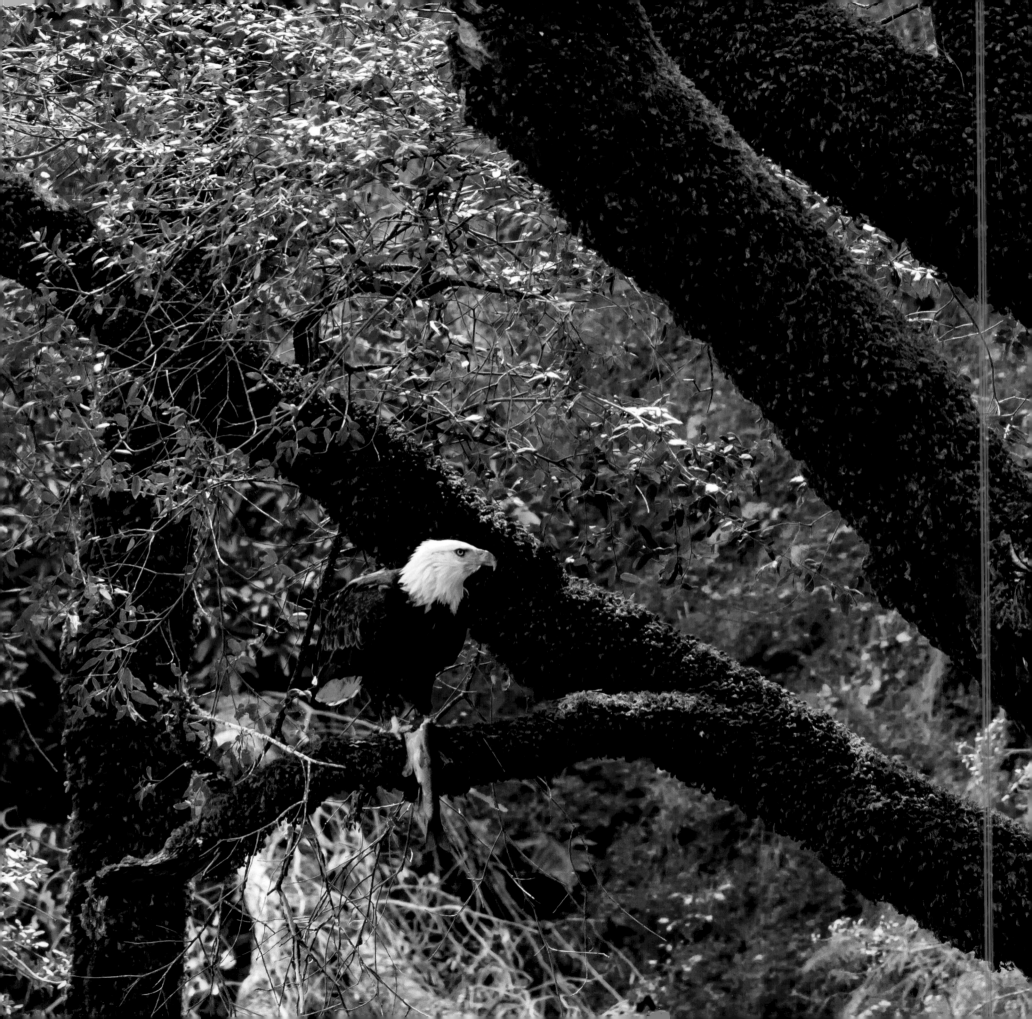

BALD EAGLE
(*Haliaeetus leucocephalus*)

Driving along the Merced River one spring morning, I suddenly see an unmistakable black-and-white streak flash across the canyon. Bald eagle! This is a rare sighting here in Yosemite, and I instinctively pull over to the side of the road. Calculating the trajectory of the bird's flight, I grab my gear and run to intercept it. As I cross the riverside berm, there it is, perched on the branch of a solitary oak, a flapping trout in its talons.

Bald eagles prey on amphibians, reptiles, birds, and mammals, but it is fish that they are uniquely fashioned to seize. Their extraordinary eyesight is four to eight times stronger than ours; their long, sharp talons are made to snatch and hold; and spicules (small bumps on the bottoms of their feet) allow them to keep a tight grasp on their slippery prizes. Mesmerized, I watch through the camera's eyepiece as the eagle dines, devouring the trout whole—tail fin and all.

BALD BAGLE AND FRESH CATCH

79

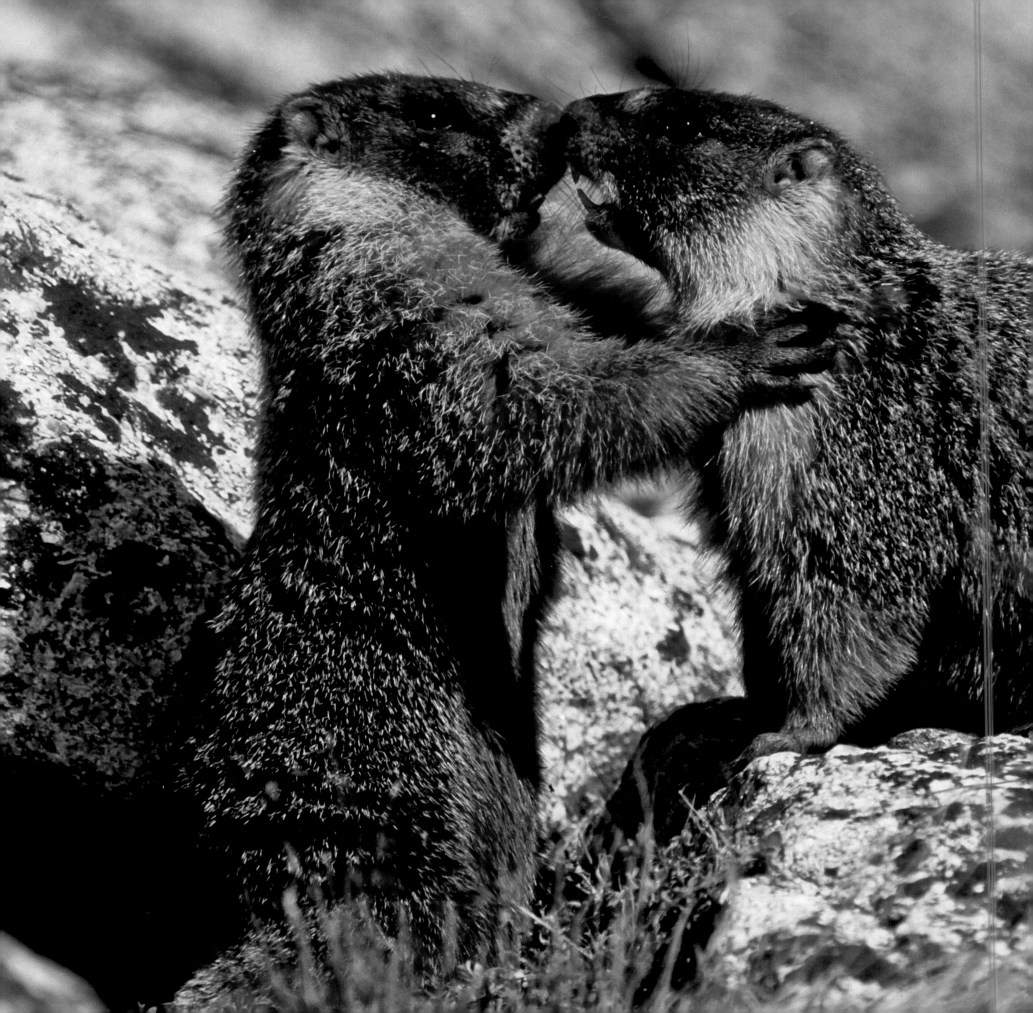

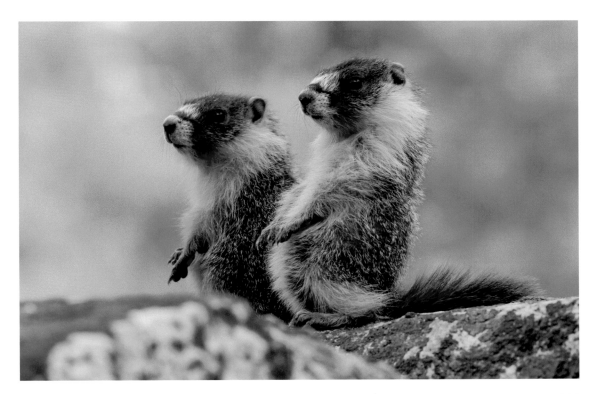

JUVENILE YELLOW-BELLIED MARMOTS

YELLOW-BELLIED MARMOTS
(*Marmota flaviventris*)

Sometimes, being in the right place at the right time beats weeks of planning. For example, while scouting high-country landscape photography locations one afternoon, I notice two yellow-bellied marmots scurrying around a rock outcrop. The largest members of the squirrel family (about the size of a large house cat), marmots are among the most entertaining and charismatic of animals.

Grabbing my binoculars, I watch the two adults for a while, then find an inconspicuous spot to set up my tripod and hunker down. They quickly become accustomed to my presence, and over the next couple of hours, I observe them chasing, wrestling, hugging, and nuzzling one another, endearing displays of marmot behavior. Whether the pair are courting or not, I can't be sure, but when I return to the territory a few months later, I see exuberant youngsters exploring their new surroundings.

YELLOW-BELLIED MARMOTS EMBRACE

81

Yosemite Birds

DIVERSITY OF SPLENDOR

BY SARAH STOCK

With their intense beauty, vibrant feathers, and lively songs, birds imbue the human soul with a sense of wonder and pleasure that reflects the natural world. In Yosemite National Park, people who come to soak in the essence of nature immediately sense an abundance of bird life. The park's species list approaches 270 bird species, which represents almost a quarter of the species observed across the lower United States. This one national park about the size of Rhode Island can foster such a diverse bird community because of its extraordinary topographical relief, spanning 11,000 feet (3,353 m) in elevation from the high windswept peaks of the Sierra crest down to the thick foothill chaparral along the park's western boundary. Adding to the complexity of the topography, two major watersheds—

MALE MOUNTAIN BLUEBIRD (*Sialia currucoides*)

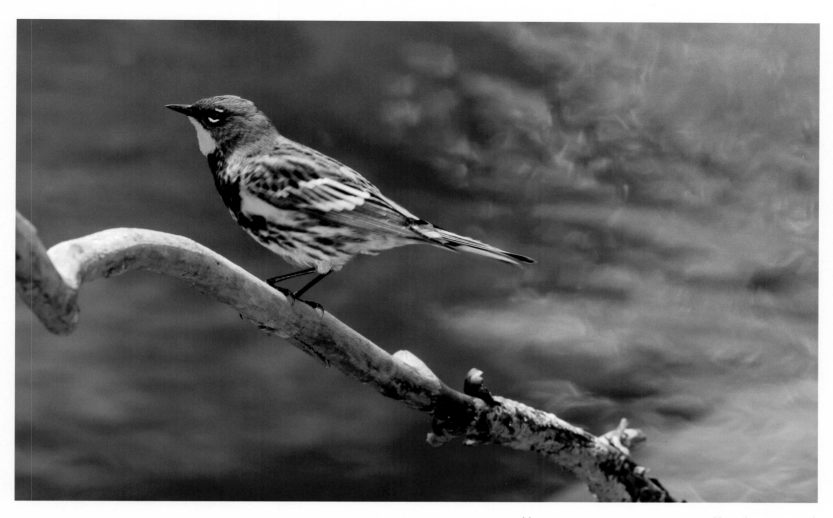

MALE YELLOW-RUMPED WARBLER (*Setophaga coronata*)

the Tuolumne and Merced Rivers—originate from the park's highest snowfields and remnant glaciers, mingle with mountain springs, and distribute water to lower life zones.

Within this heterogeneous landscape, people can experience a vast array of birds. The lower foothill chaparral and oak woodlands offer habitats for the year-round, ubiquitous California quail, oak titmouse, house wren, and California towhee. Come spring, these residents are joined by orange-crowned warbler, black-throated gray warbler, and lazuli bunting; boisterous songs fill the air, signaling the newcomers' arrival. The higher conifer forests host white-headed woodpecker, mountain chickadee, and golden-crowned kinglet as year-round residents. In the spring and summer, yellow-rumped warbler, hermit warbler, western tanager, and black-headed grosbeak join them and enliven

the forest with their bright and colorful plumage. Higher still, at tree line, Clark's nutcracker, mountain bluebird, and red crossbill brave colder weather. Above tree line, where temperatures can dip below freezing at any time of year, rock wren, American pipit, and gray-crowned rosy-finch make their homes among boulder fields and windswept mountain peaks.

The full breadth of the diversity of Yosemite's bird life invites exploration of a range of habitats at key times of the year. The sheer number of birds peaks in abundance in mid- to late summer when fledglings essentially double the number of the park's birds. At this time of year, parent birds busily bring food to their fledglings and sound alarms when they sense predators nearby. These behaviors are on full display in Yosemite's meadows, where the abundance and diversity of birds exceed all other habitats in the park.

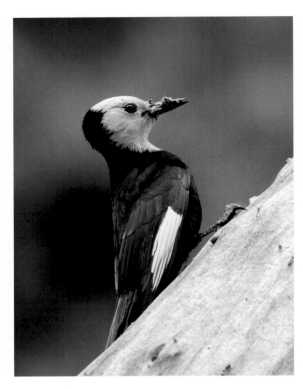

WHITE-HEADED WOODPECKER (*Picoides albolarvatus*)

As long-distance migrants, many of these breeding birds leave their nesting grounds in Yosemite in late summer and spend their winter farther south in Mexico and Central America. Meanwhile, wintertime in Yosemite brings a shift in the bird community from higher to lower elevations. Birds concentrate in the lower Merced River corridor, where food is more easily accessible and where the milder winter brings more rain than snow. This is the only life zone in the park where the variety of wintering bird species exceeds the variety of summertime breeding species.

Wildlife protections are mandated in Yosemite. However, the park is not immune to the widespread decline of bird populations occurring around the world. Several rare birds are either in steep decline or disappearing in

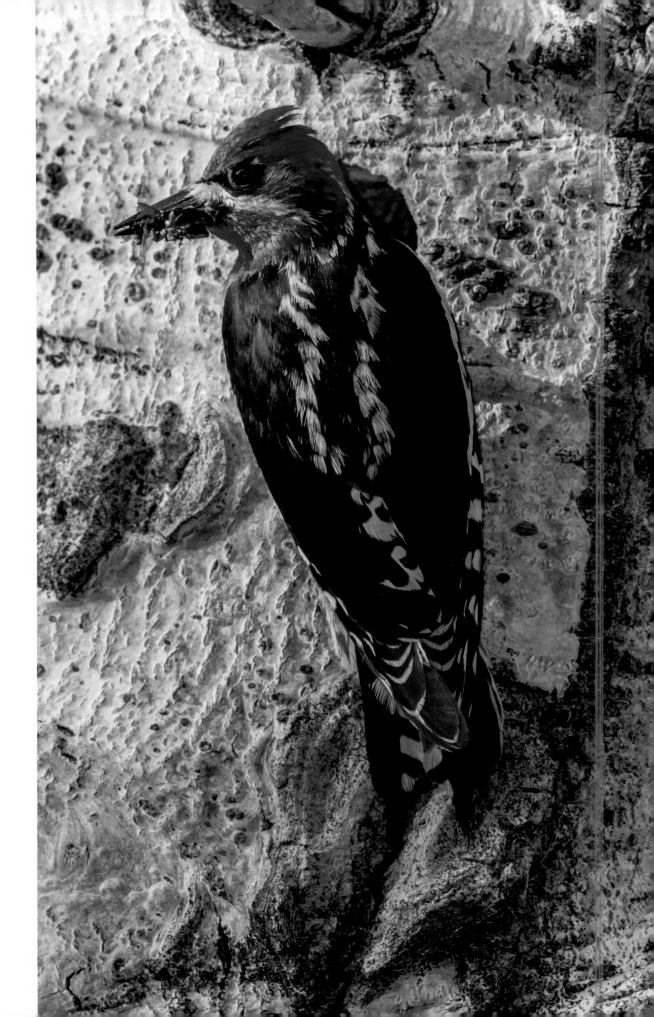

RED-BREASTED SAPSUCKER (*Sphyrapicus ruber*)

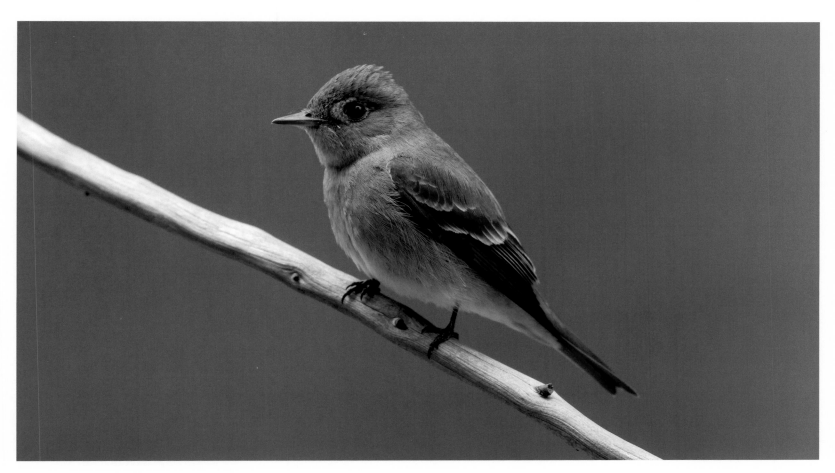

WESTERN WOOD-PEWEE (*Contopus sordidulus*)

the Sierra, and Yosemite is no exception. Once fairly common, the Swainson's thrush has been heard in Yosemite Valley perhaps only a time or two in the past twenty years. Also once fairly common, willow flycatchers are now endangered in California; breeding populations have not been observed in Yosemite in more than fifty years. The other two state endangered birds, the great gray owl and bald eagle, breed in very low numbers in the park. Great gray owls in particular are vulnerable to human disturbance, which can negatively affect their reproductive success. Whereas some species' futures are uncertain, the once endangered peregrine falcon has begun to flourish in Yosemite. Recovery efforts—including banning DDT, releasing juveniles raised in captivity, and temporarily closing rock-climbing routes—have proved among the most successful in the history of endangered species conservation.

Millions of people know and love Yosemite for its giant cliff faces, glacially carved valleys, and tumbling waterfalls,

as well as for the opportunity to feel soothed by the natural world. Here, birds find their homes, forage for food, defend their territories, care for their young, and escape from predators. Birding in Yosemite can be richly rewarding. Heed the wisdom of Yosemite's naturalists by exploring the wealth of Yosemite bird life away from roads, being patient and attentive, listening, taking notes, and joyfully and unabashedly sharing your stories.

..

Sarah Stock is the wildlife ecologist for Yosemite National Park, where she has overseen the program for terrestrial wildlife biodiversity since 2006. Early in her career as a field ornithologist, she explored bird populations in Alaska, California, Hawaii, Idaho, Louisiana, and the South Pacific. She earned her graduate degree at the University of Idaho, with a research focus on the migration ecology of forest owls. In Yosemite, in addition to birds, Sarah studies bats, fishers, bighorn sheep, and Sierra Nevada red foxes. With her family she lives in Yosemite Valley, where she enjoys birding, scrambling on steep cliffs, and naturalizing.

BOBCAT
(Lynx rufus)

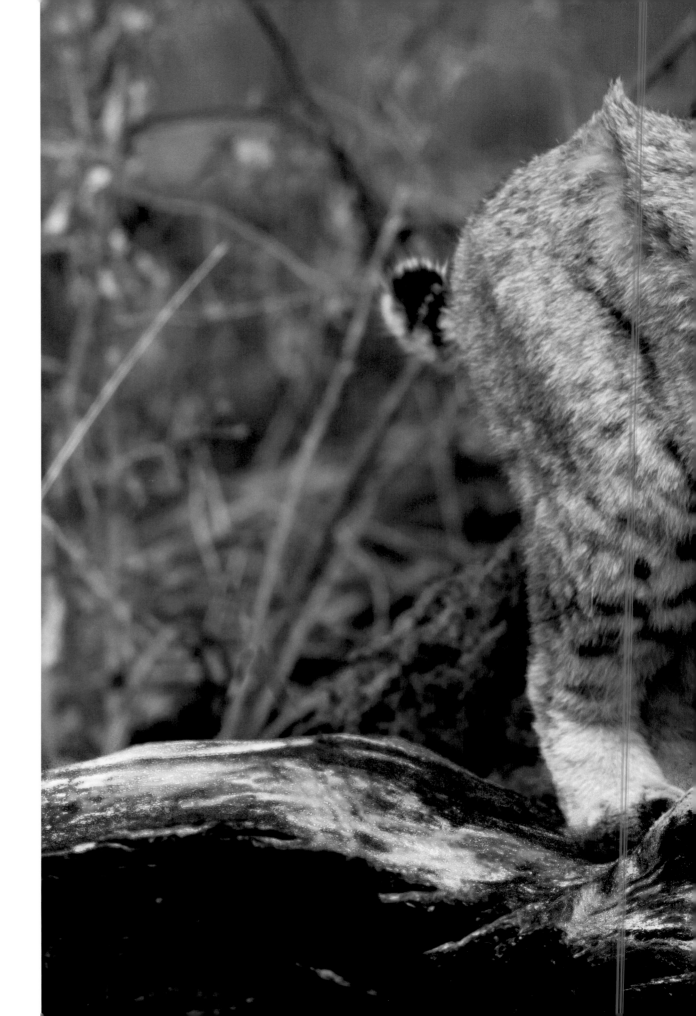

Shy and elusive, bobcats are the most common wildcat in North America, with a range that extends from southern Canada across the contiguous United States and into Mexico. They are extremely adaptable, occupying a wide array of habitats and adjusting their behaviors accordingly. Primarily crepuscular (active around dawn and dusk), bobcats hunt a variety of prey, including rodents, rabbits, birds, and occasionally deer. They adjust their hunting techniques to the size of the prey. With smaller animals, they use a "crouch, wait, and pounce" method; when the prey is larger, they employ a "stalk, approach, and rush" attack.

I've had a couple of incredible encounters with bobcats in Yosemite Valley. Following this one while it made its rounds through the forest and meadows, far enough away to avoid affecting its behavior, I witnessed its hunting prowess firsthand.

Bobcat looking for prey

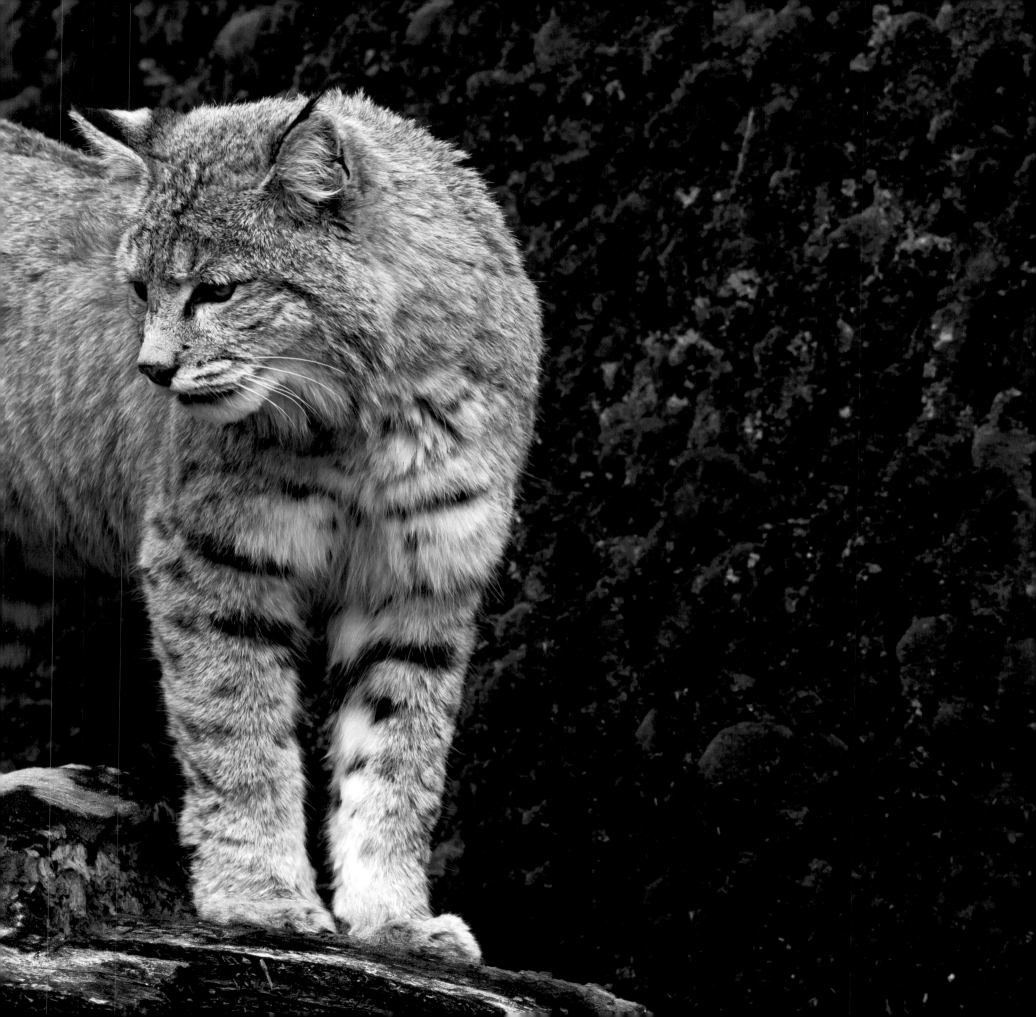

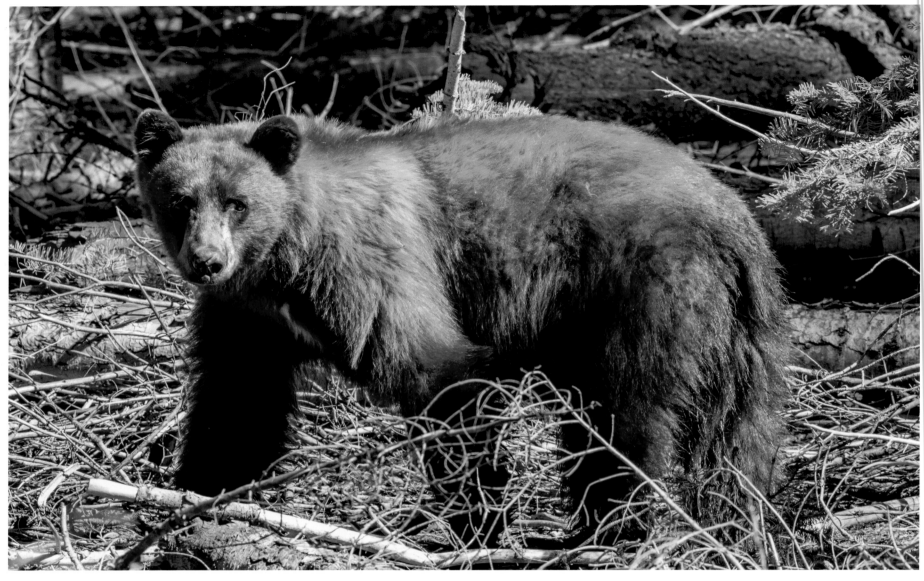

BLACK BEAR FORAGING IN CRANE FLAT MEADOW

AMERICAN BLACK BEAR
(*Ursus americanus*)

Through the viewfinder, I see the bear suddenly stop foraging and turn to stare at me. My heart skips a beat and I nearly forget to snap the shutter.

The sight of an American black bear prowling across a Yosemite meadow thrills me, and I marvel that a 250-pound (113 kg) animal can move so gracefully. Downwind, tripod in hand, I tiptoe quietly to the forest edge, my heart racing, until there are no obstructions between us.

A black bear's coat color can be cinnamon, tan, or brown, which often leads to misidentification. While strong enough to rip apart logs in search of grubs and other insects, they feed primarily on grasses, berries, and acorns, all of which they eat with a surprising daintiness. They consume up to twenty thousand calories a day in the fall in preparation for winter hibernation. However, unlike deep hibernators, their body temperature does not drop significantly, and on mild winter days, they may wake to forage.

The Pika

KING OF THE HIGH COUNTRY

BY BETH PRATT

My highly anticipated rite of spring—the opening of Tioga Pass in Yosemite—means access to the wonderland of the High Sierra. Above tree line is my happy place. Yosemite Valley is a grand cathedral, which I cherish, yet its granite walls tower over me in a cloistered and weighty embrace. Give me the alpine expanses of the Sierra, where the peaks stand like small islands in the enormous ocean of the never-ending blue sky. It's not just the spectacular scenery, however, that has me anxiously waiting for the pass to open every year. I am also quite eager after the long winter to greet my favorite wild

PIKA CACHING FOOD FOR WINTER

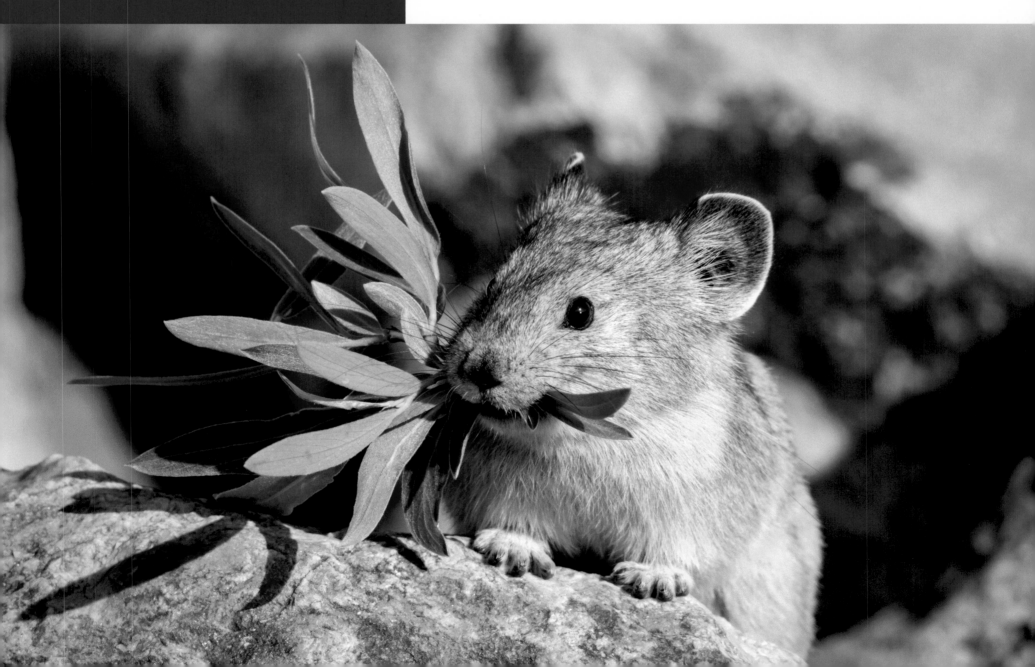

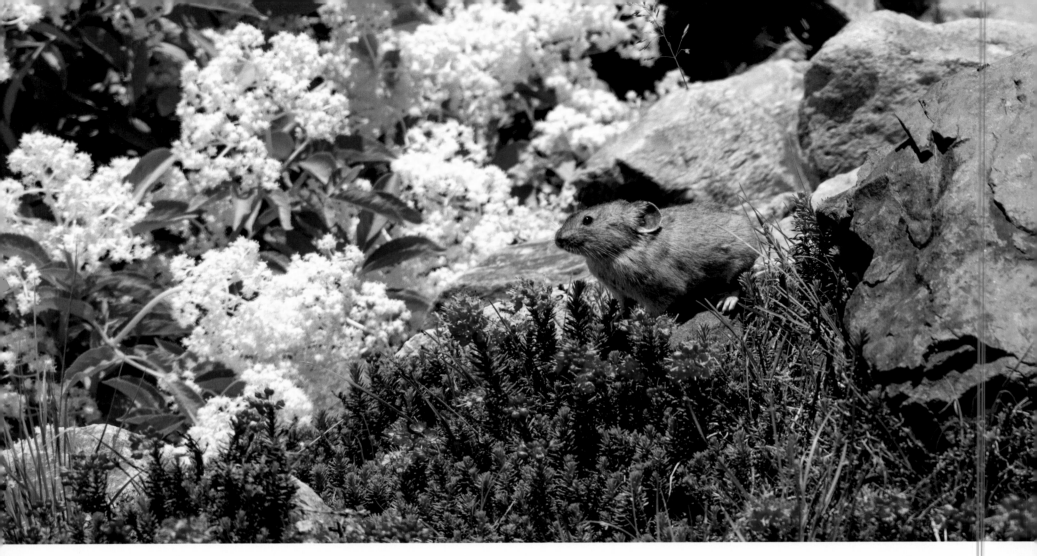

friends—a small creature easily missed in the enormity of the landscape. This creature ranks as the most adorable animal on Earth, as well as one of the most hardcore critters on the planet. Let me introduce you to the reigning king of the high country, the pika.

Picture an animal the size of a potato, a round ball of fluff that looks like a bunny-hamster hybrid. Don't make the mistake of comparing them to mice; as any pika aficionado will correct you, they are not rodents but lagomorphs, occupying the order that includes rabbits and hares. Nicknamed whistling hares, rock rabbits, or little chief hares, pikas live in Asia and North America. In the United States, observant hikers may encounter the American pika (*Ochotona princeps*) typically in rocky terrain at elevations from 8,000 to 13,000 feet (2,438 to 3,962 m).

For all their beauty, these subalpine and alpine

environments are some of the harshest places on Earth. Sierra Nevada winters—admittedly milder than those of its Rocky Mountain cousin—bring below-freezing temperatures, relentless winds, and dense snowpacks to the higher elevations. Most wild animals at these altitudes either choose to move downslope, migrate, or hibernate away the winter months. Pikas rank as one of the few mammals in the continental United States that set up a year-round and active residence in the alpine zone.

Imagine these industrious little critters spending their summers scurrying over boulders and talus carrying colorful bouquets of vegetation, sometimes far larger than themselves. They dine immediately on some of their bounty and use the leftovers to create haypiles—some as big as a bathtub—that cure in the sun. During the winter, pikas contentedly munch on their stash under the snowpack,

which insulates them from the cold and wind. Some of the plants they gather help preserve their pile by inhibiting bacterial growth. Plants that contain toxins are simply consumed later in the season, once the toxic chemicals have safely dissipated. In addition to their winter hay, pikas eat their own poop and that of other critters like marmots. This supposed vegetarian has recently been documented dragging dead birds back to its haypiles and feasting on their brains.

These intrepid fluffballs, even with their resourceful brain- and poop-eating survival strategies, are not immune to the changing climate. Dr. Erik Beever, who has conducted some of the most compelling research on this animal, is helping to shed light on their ability to persist despite the challenges of climate change, which are now starting to manifest in Yosemite. Early theories predicted the cold-loving pika, who is prone to overheating, would keep moving upslope in search of cooler temperatures until it ran out of heights to climb. More recent studies suggest that although climate change is certainly having an impact, how pikas may or may not adapt is a more complex issue. Dr. Beever studies the behavioral plasticity of this animal—the ability

for it to make temporary changes to cope with the chaotic environmental conditions brought by climate change. For example, to deal with increasing temperatures, pikas may forage at night instead of during the day. At a certain point, short-term adaptations like this won't help if the temperature gets too hot, but for now pikas seems to be holding on.

The next time you are fortunate enough to wander in the Yosemite high country, be sure to search for the amazing pika. As they are camouflaged perfectly to match their surroundings, pikas are more likely to be heard than seen. Many careful listeners have described pika calls as *me-ep me-ep* or *eek-eek*! But no one gets it as right as the biologist Joseph Grinnell, who conducted a comprehensive survey of Yosemite's animal life in the early 1900s. Listen for what he described as "the clinking together of two flakes of granite" (*Animal Life in the Yosemite*, 1924). Grinnell also recounted that the pika "has been observed bleating on moonlight nights." This tiny animal stands guard on ancient rock surrounded by peaks towering thousands of feet above its tiny head, not intimidated in the least, and calls out as boldly, confidently, and kingly as any wolf howls at the moon.

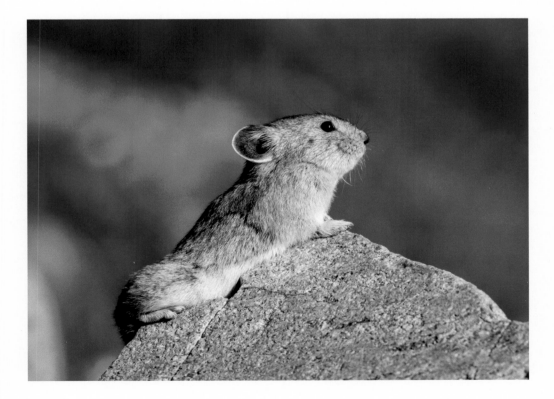

Beth Pratt, a lifelong advocate for wildlife, has worked in environmental leadership for more than twenty-five years, and in two of the country's largest national parks: Yosemite and Yellowstone. As the California regional executive director for the National Wildlife Federation, she says, "I have the best job in the world—advocating for the state's remarkable wildlife." She also leads the #SaveLACougars campaign, with the aim of building the world's largest wildlife crossing. Her conservation work has been featured by *The New Yorker*, the *Wall Street Journal*, the *Washington Post*, *BBC World Service*, *CBS This Morning*, the *Los Angeles Times*, and NPR. Her book, *When Mountain Lions Are Neighbors*, was published by Heyday in 2016. Beth makes her home outside of Yosemite, "my north star."

PIKA WARMING ITSELF

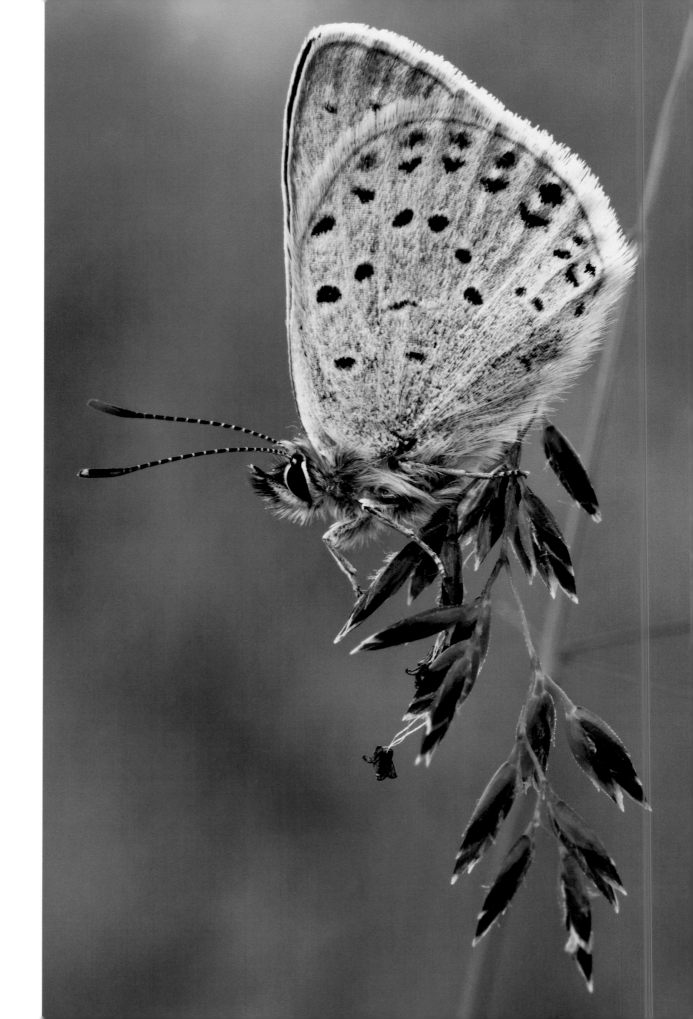

BUTTERFLIES

I have always been fascinated by butterflies, and not just for their exquisite beauty. Watching their seemingly haphazard flight, it's easy to forget how purposeful their movements are. Guided by a variety of acute senses, they actively navigate to their destination, whether it be a potential mate or a plant to feed from or lay eggs on. Their enormous compound eyes detect movement and color, including the ultraviolet spectrum, outside of the range of human vision. Receptors for their well-developed sense of smell occur in several places on their bodies but are concentrated on the antennae. Taste organs are also scattered about, including on their legs and feet; adult butterflies can literally taste the plant when landing on it.

I don't actively seek out butterflies to photograph, but when an opportunity presents itself, I'm happy to commit all my attention to these amazing insects.

GREENISH BLUE (*Plebejus saepiolus*)

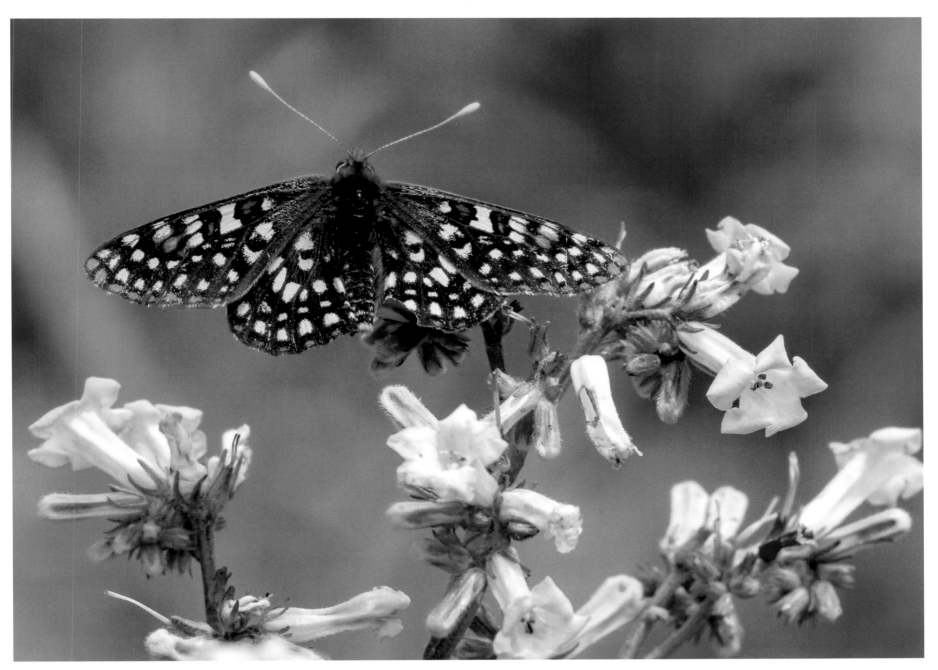

CHECKERSPOT (*Euphydryas chalcedona*)

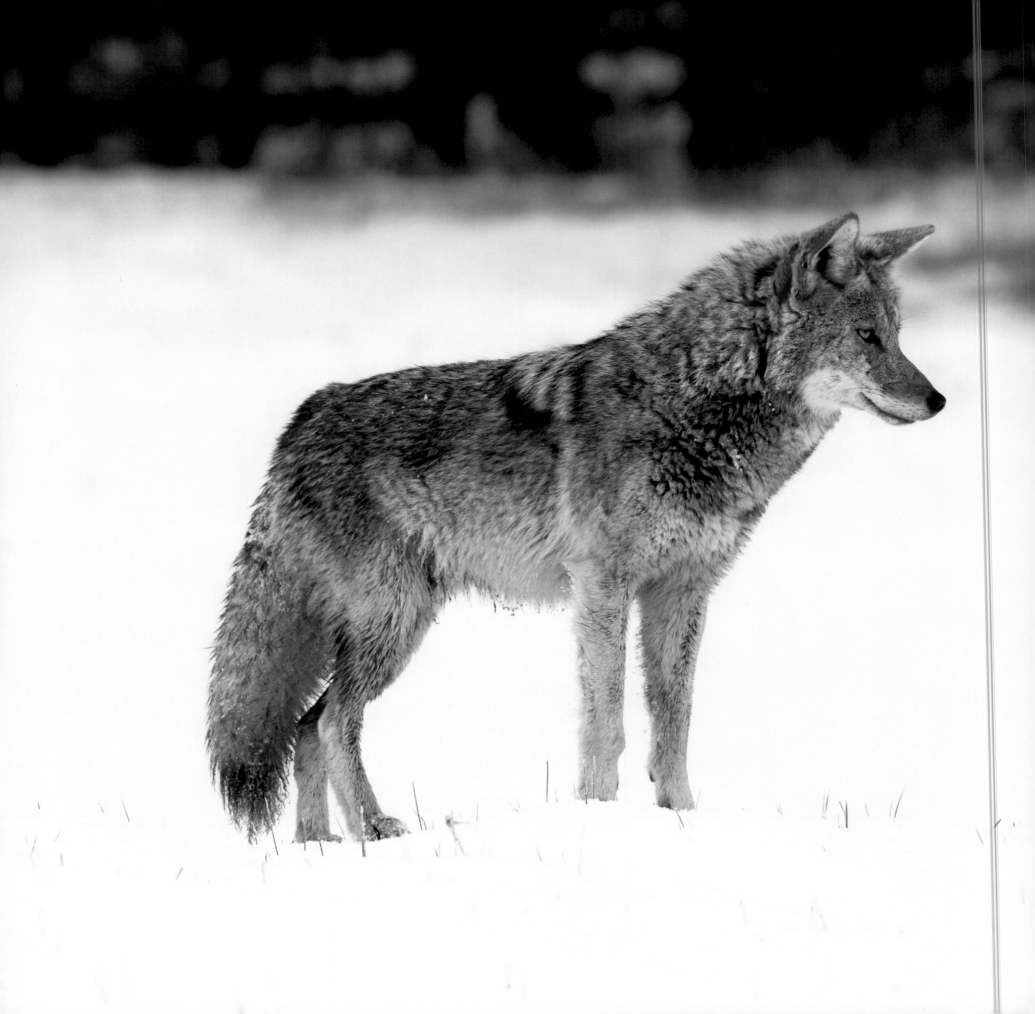

COYOTE
(*Canis latrans*)

Stop. Listen. Pounce! An animal on the hunt is fascinating to watch—coyotes especially so, particularly during the winter, when snow occasionally covers Yosemite Valley meadows and skews the odds slightly in their favor. Under the blanket of white, rodents are busily excavating runways, unaware that their movements reveal their location to the opportunistic hunters patrolling above them.

Using their well-tuned hearing to catch the slightest of sounds, coyotes move their heads back and forth to pinpoint the source. Then, they leap in the air and dive front-feet-first into the snow. If they're successful—and remarkably, they often are—they will have trapped a rodent under their paws.

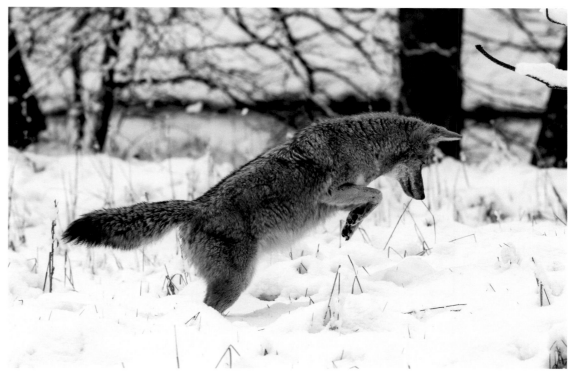

COYOTE HUNTING RODENTS

Always on the lookout for these opportunities, I spot a coyote on the far edge of Leidig Meadow and head out there, following at a distance for a couple of hours. The coyote, focused so intently on hunting, appears unaware of my presence, and I'm able to observe and photograph unobtrusively.

COYOTE PATROLLING LEIDIG MEADOW

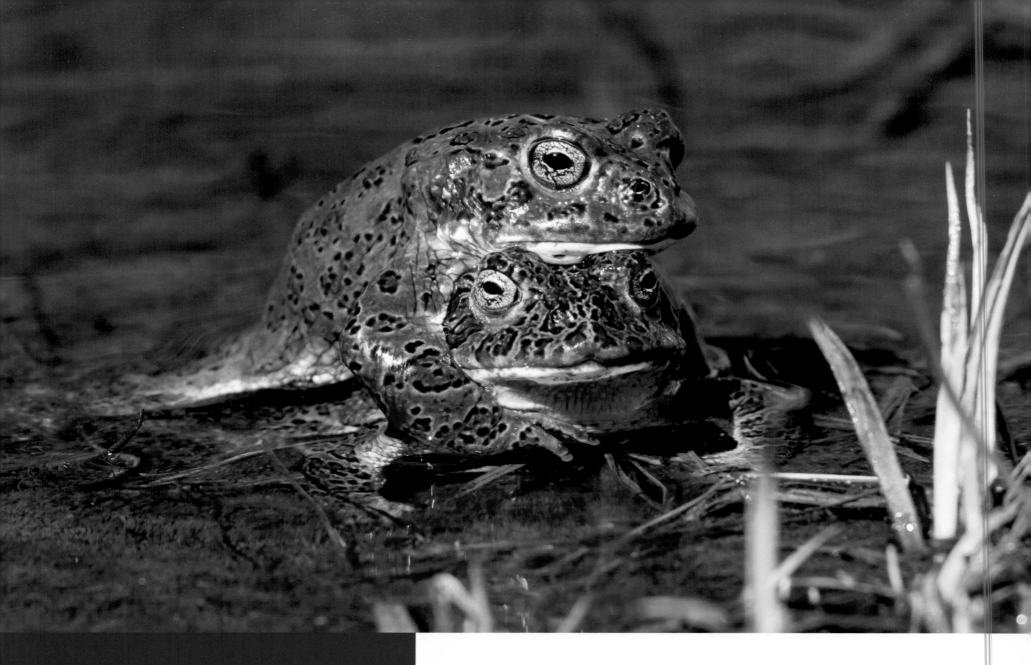

Yosemite Toads

LIFE ON THE EDGE

BY ROB GRASSO

It's spring in California's Sierra Nevada, but you'd hardly know it from the snow-covered landscape draping the Gaylor Divide in Yosemite National Park. The meadow in view, poised at over 10,000 feet (3,048 m), its vegetation lackluster from winter snow, initially appears lifeless; then suddenly a faint, almost birdlike call sounds from the distance over a light wind. This is life reborn every spring when the Yosemite toad (*Anaxyrus canorus*), after months of being held captive under snow and ice, jubilates in the warm, newly formed shallow pools, only inches deep, along the meadow edge.

MALE YOSEMITE TOADS WRESTLING

During a few short weeks each spring, a ritual is performed where males vigorously defend breeding areas by engaging in brief territorial disputes. Intruders are momentarily suppressed in a tight clasp, then released. The victor claims the breeding rites for the most suitable meadow pools.

Female Yosemite toads, who may visit the meadow only once every three years, listen for just the right trilling call made by the male that likely signifies his size and prominence in the meadow. Avoiding younger, inexperienced males lying silently in wait on the meadow edge to intercept her, she slowly makes her way to the calling male of her choice. Once the male detects her movements toward him, he elevates his posture so that when he calls, his bright white vocal patch acts like a beacon, speeding her approach toward him.

While calling in the meadow, the drab olive coloration of the males perfectly camouflages them against the dead vegetation of their surroundings. Females, however, appear as works of abstract art against the same backdrop. This striking difference, referred to as sexual dichromism, is very rare in amphibians and is better known in the colorful males of the bird world. That the female Yosemite toad is actually more colorful than the male is something even more exceptionally rare in nature. The female's exquisite marbling of orange, brown, and white mottling against black is thought to aid in her disguise while she forages in the pine forest, matching the rusty pine needle–covered setting.

A female Yosemite toad, when stimulated by the male, will deposit her clutch of about fifteen hundred eggs (a far cry from the western toad, which may lay ten thousand eggs every year!). Once released, the eggs are fertilized by the male. These eggs are toxic—a toxicity every toad is able to retain for life, protecting them from predators.

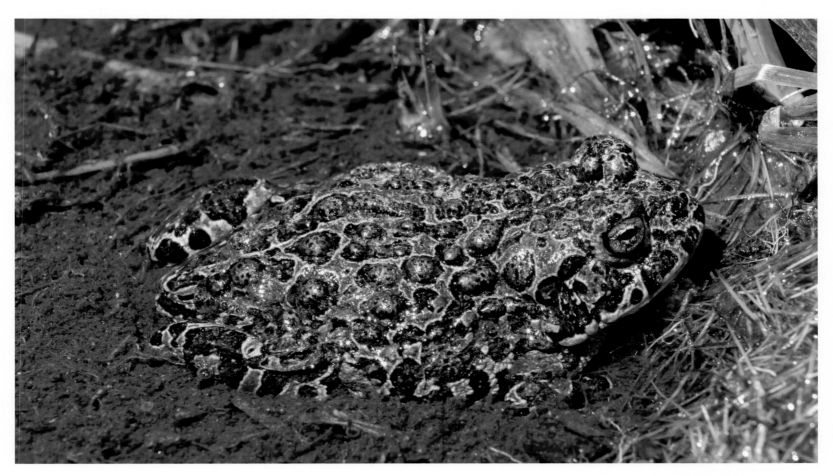

FEMALE YOSEMITE TOAD

Once courtship is over, eggs deposited will hatch in a matter of days, and tadpoles will need to reach metamorphosis in as little as six weeks or they may perish. Tadpoles are completely reliant on snow and the permanence of summer water for their survival. However, they need just the right amount of snow. Too much and the breeding season will be shortened and there may not be enough time for them to reach metamorphosis before the next winter. Too little snow, and without summer rains, the pools will likely dry up, prematurely stranding and desiccating tadpoles.

Today's Yosemite toad populations are a mix of the highly productive and stable populations along the Sierra crest to the small and isolated communities to the west. Some of this distribution pattern is a natural result of past glaciers, but it is mostly due to a highly virulent pathogen (amphibian chytrid fungus) that stormed across the park from west to east in the late 1970s through the mid-1990s, decimating populations. The iconic Yosemite toad has persisted through multiple prolonged droughts and disease outbreaks and so far has prevailed in many locations.

Yosemite toads are secretive creatures, announcing their existence for only a few short weeks each spring before retreating to the forest. They may live as many as fifteen years, so perhaps time is with them in the long run. Such longevity likely works in their favor once or twice in their lifetime, allowing them to successfully produce offspring when conditions are at their best. But one thing is becoming strikingly apparent in the West and in the Sierra: year-to-year weather variability is increasing, and more precipitation is falling as rain instead of snow (and thus cannot be stored for a steady and slow release to keep meadow pools filled). Such great interannual variability and reduction of snow are no longer concepts to be imagined but are upon us and the toad. Over millennia the Yosemite toad has mastered its surroundings in a predictable Mediterranean climate, where drought occurs every year and we call it summer. Researchers are attempting to hone in on the factors that most influence toad survivorship and hope to predict what it will mean for the toad over time and how to overcome challenges in the park, where the Yosemite toad continues to persist against the odds.

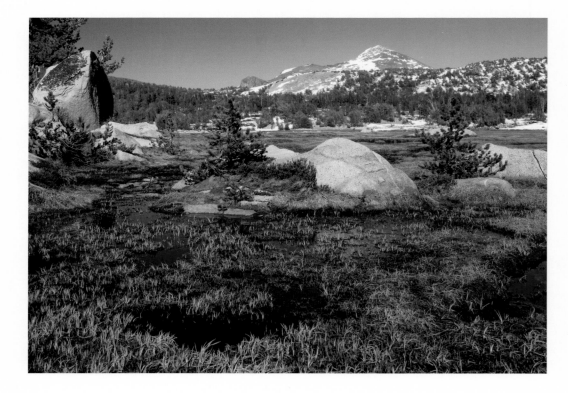

Rob Grasso, an aquatic ecologist, leads the Aquatic Wildlife Restoration Program in Yosemite National Park, restoring endangered amphibians and rare turtles. He earned his bachelor of science in marine biology from Stockton University in Pomona, New Jersey, and his master of science in conservation biology from California State University, Sacramento. Rob has close to twenty years of agency experience working in the West, ranging from protecting rare and threatened trout in the Rocky Mountains to studying amphibian declines in California's Sierra Nevada. He now works with a suite of collaborators and partners, including Yosemite Conservancy, to restore native species.

BREEDING HABITAT OF YOSEMITE TOADS

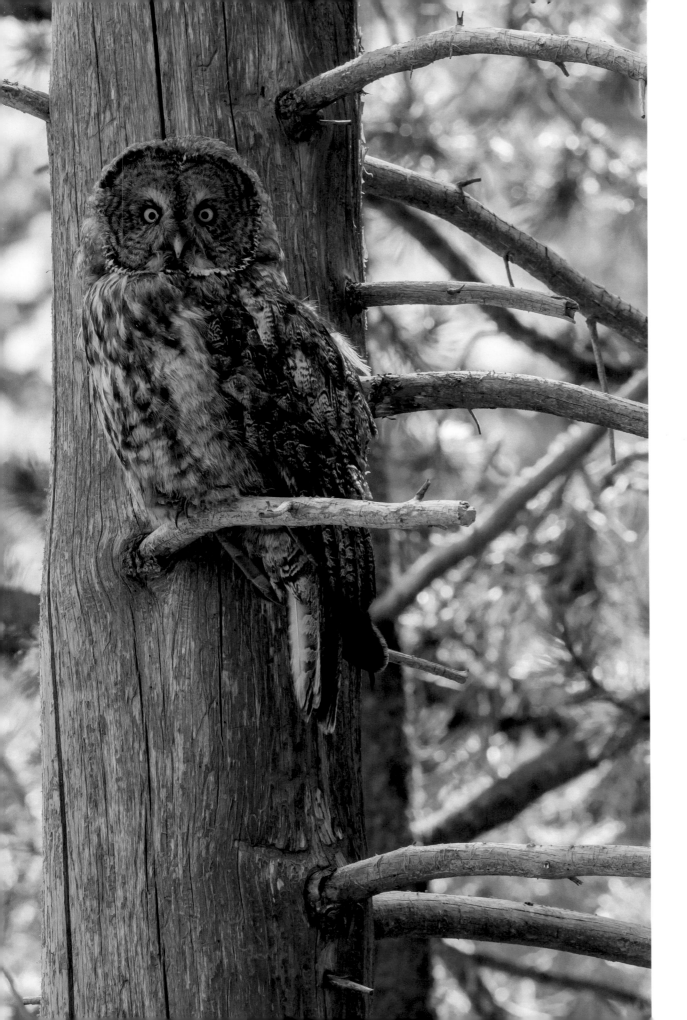

GREAT GRAY OWL
(Strix nebulosa yosemitensis)

A huge bird with a wingspan stretching more than 5 feet (1.5 m) flies silently past me at close range, giving me a good look at the largest of the North American owls. Hunting primarily by sound (their facial disks help funnel noise to their ears), they can hear an unsuspecting rodent's slightest movement in the grass or under the snow. Once locked in, they begin a quiet aerial assault, their approach concealed by flight feathers evolved to muffle the sound of their wings cutting through the air.

Great gray owls are rare in California—there are only an estimated two hundred to three hundred nesting pairs—and the majority can be found in Yosemite, near the southernmost end of their range. Opportunities to observe these unique birds are also rare, making every sighting a special occasion. With a long telephoto lens and a lot of patience, I am able to watch and photograph this individual without disturbing it as it patrols the edge of a meadow.

GREAT GRAY OWL PERCHING

Choosing a spot in squirrel territory, I sit quietly, tracking an individual through the viewfinder as it darts about. Suddenly, a nearby warning call commands its attention and, looking for the potential threat, it assumes an upright position. Click.

BELDING'S GROUND SQUIRREL

(Urocitellus beldingi)

The distinctive, shrill whistles of Belding's ground squirrels alert the colony to my presence as I wander Yosemite's high-country meadows. While they're a common species, they can be quite difficult to photograph; hardwired to scurry, they rarely stay still long enough for the camera.

These squirrels live in large groups and excavate underground burrows, where they spend three-quarters of the year in hibernation (among the longest of North American mammals) to avoid the High Sierra's long cold season. Socially, they're both a female-dominated and a nepotistic species. Shortly after weaning, young males disperse, but their female counterparts remain with the group, and relatives get preferential treatment.

BELDING'S GROUND SQUIRREL ON ALERT

COMMON MERGANSER
(Mergus merganser)

Common mergansers, found throughout the Northern Hemisphere, are often seen on Yosemite Valley and high-country waterways. Specialized for fishing, they use their powerful legs and webbed feet to dive in search of their prey, and their long, thin, serrated bills to hold on to their catch. Somewhat uncommonly for a duck, they nest in tree cavities, where they typically lay up to eleven eggs. The young are precocial; they leave the nest immediately after hatching and are able to feed themselves very quickly. At about twelve days old, the chicks are already catching fish on their own!

I see this one—based on the plumage, either a female or a nonbreeding male—on Tenaya Lake and follow it from shore as it hunts. The sun illuminates the forest and cliffs on the far side of the lake, and a beautiful reflection fills the frame. As though posing, the merganser flares out its head feathers, displaying its remarkable ornamentation.

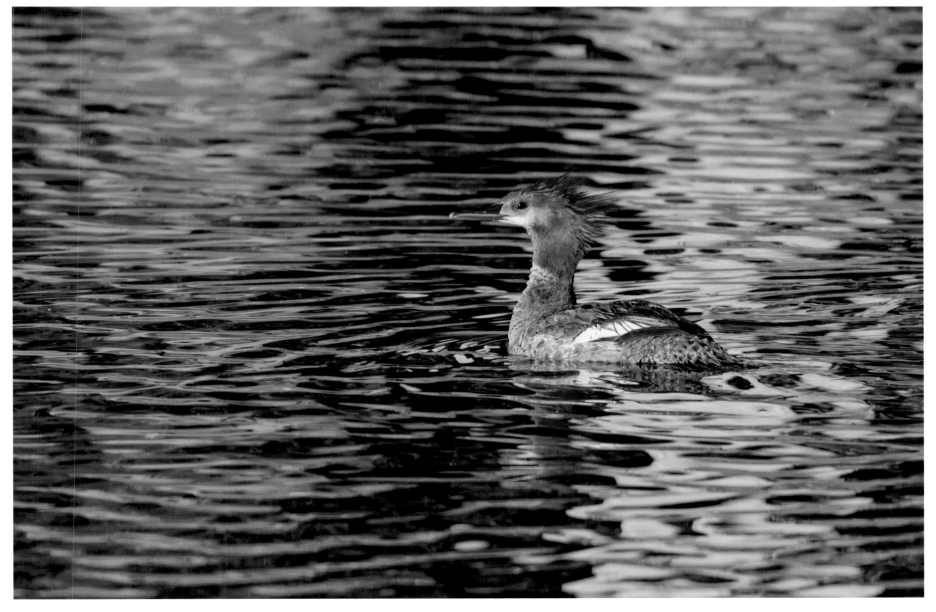

COMMON MERGANSER ON TENAYA LAKE

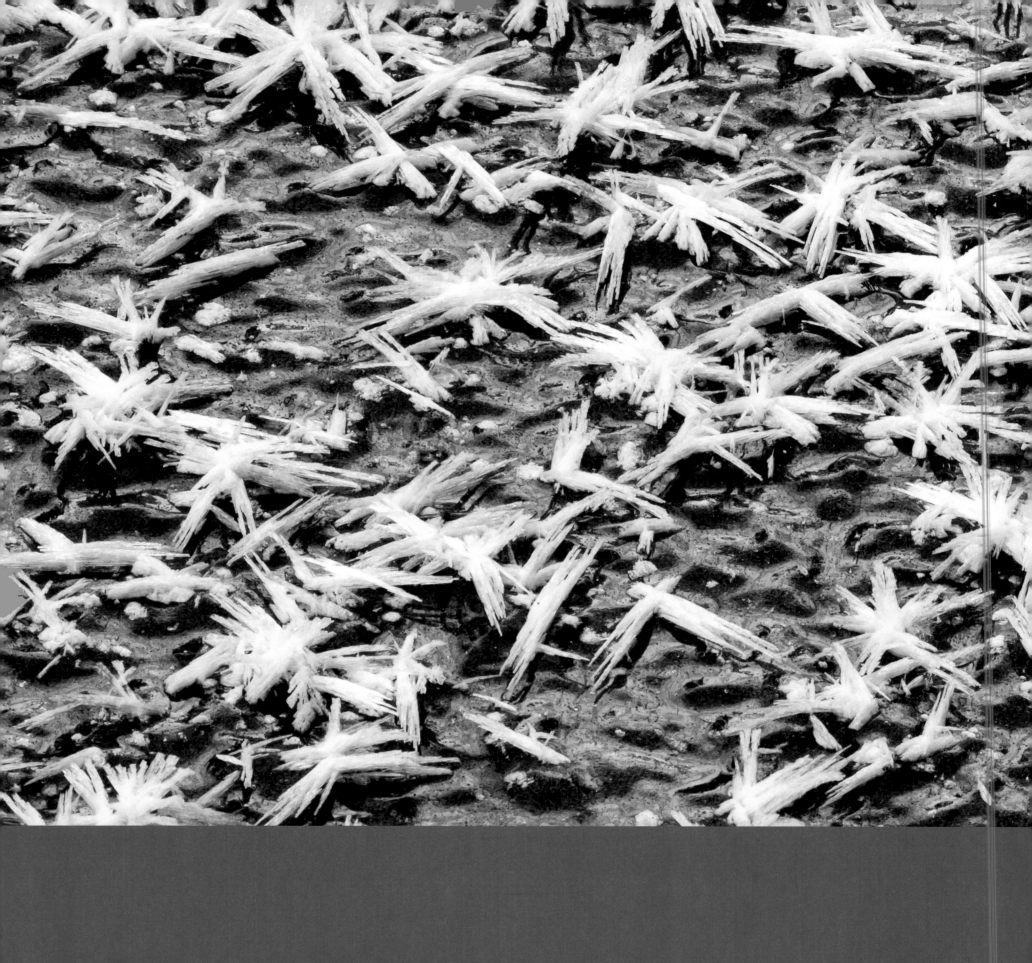

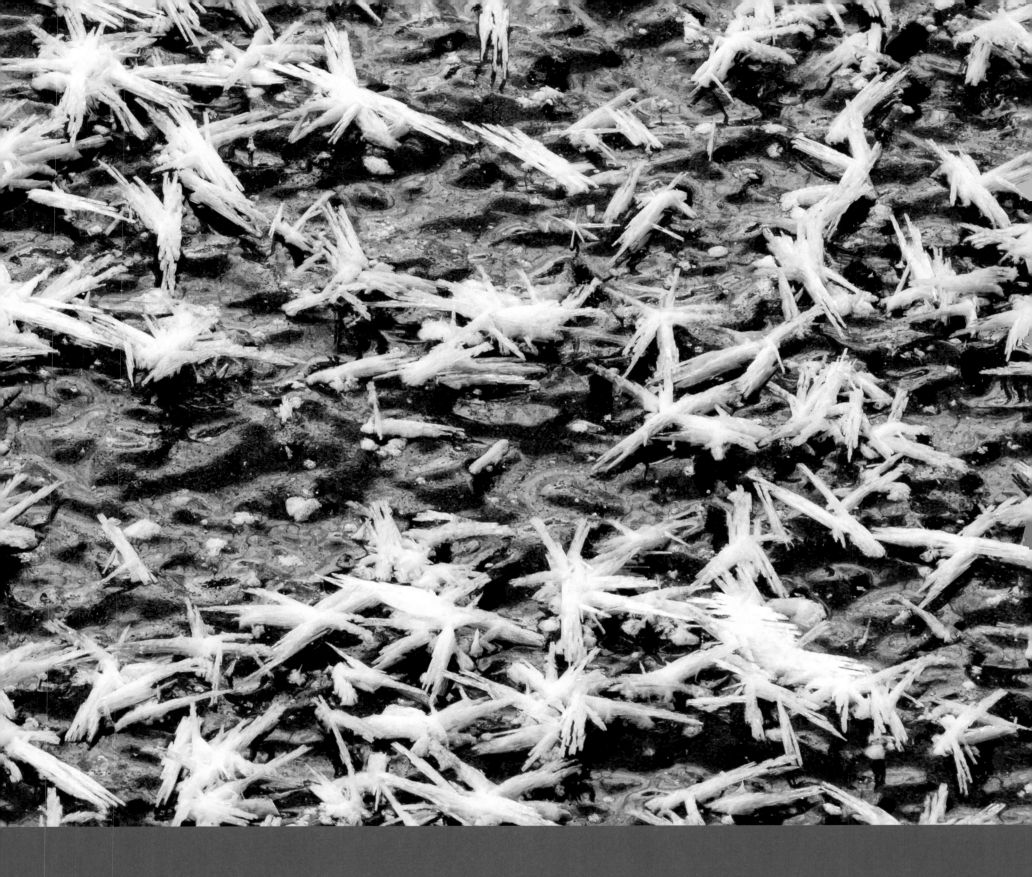

WILDERNESS

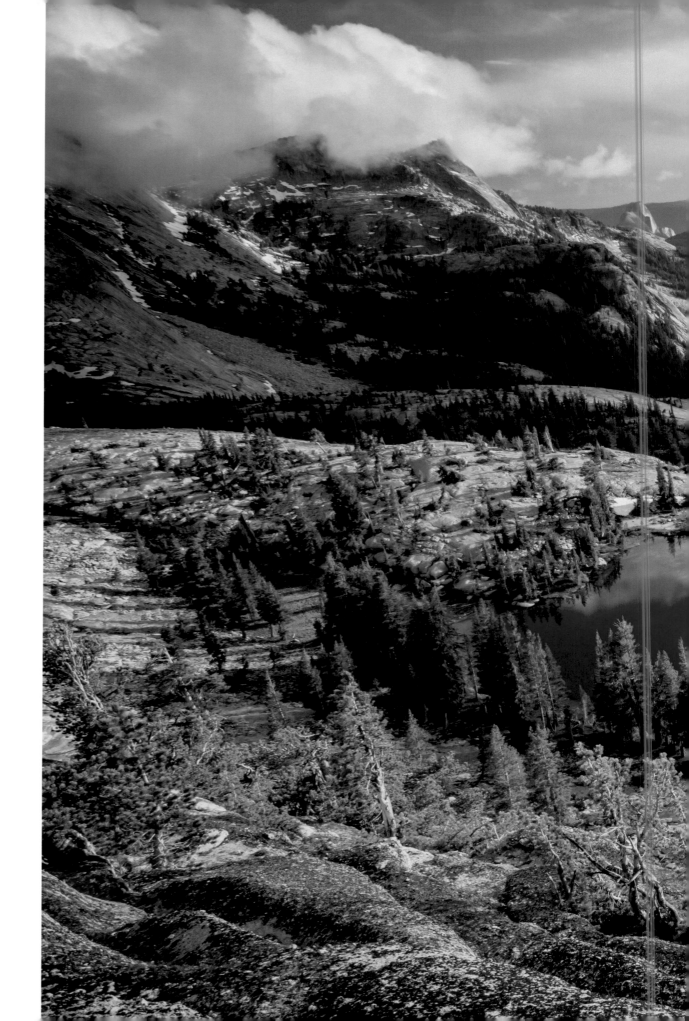

TARN WITH
A VIEW

As light and shadow move across the high country, I look out over one of my favorite Yosemite views and think about how this stunning landscape came into existence. If I'd been perched in this spot thousands of years ago, the ice sheet that shaped the granite and sculpted the distant lake and the foreground tarn would've slid right over me as it traveled downslope through the canyon.

A tarn is a small body of water in a depression excavated by the grinding power of rock and ice. Yosemite's high country is dotted with them, and some—like this one—are found on shelves, creating sweeping panoramic views. Trying to capture dynamic light, I have returned to this location numerous times over the years, but regardless of the photographic success, it's always an enlightening experience.

CLEARING SUMMER THUNDERSTORM

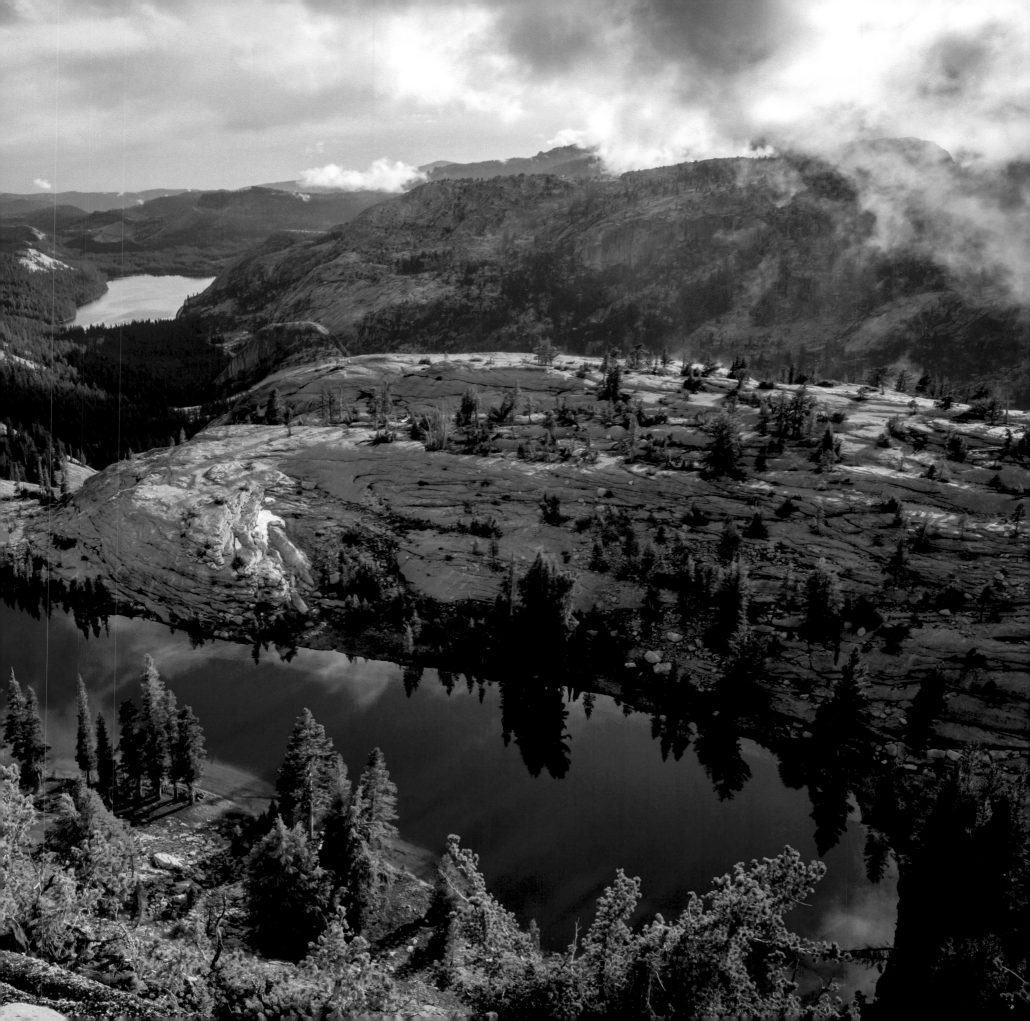

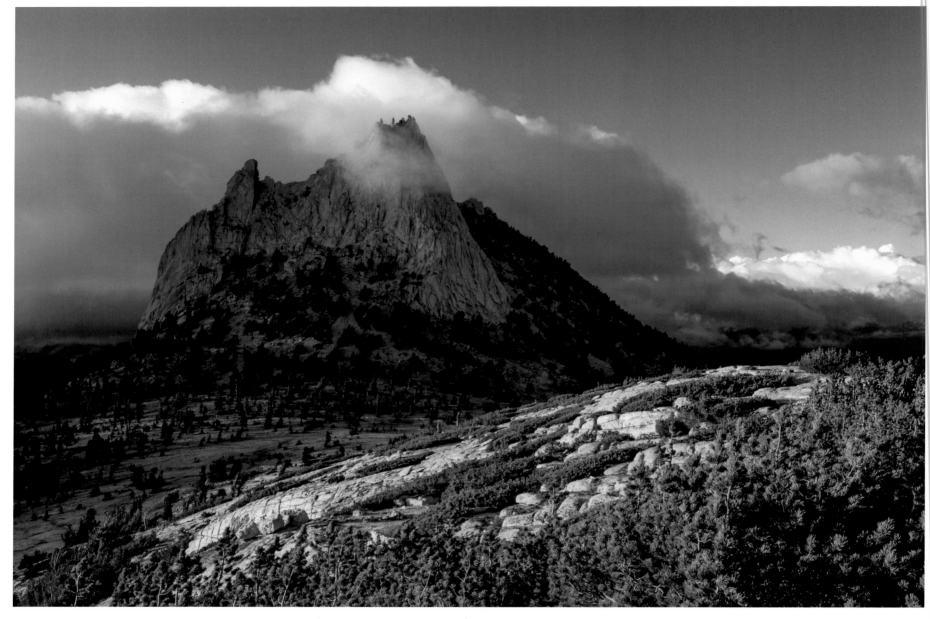

CATHEDRAL PEAK

Sculpted by ice, and considered one of the most recognizable landmarks in the Yosemite Wilderness, Cathedral Peak juts out from the surrounding landscape as it has for millennia. These granodiorite formations were visible even when ice up to 2,000 feet (610 m) thick covered the high country during successive glacial events, including the most recent Tioga glaciation. This is an example of a nunatak, an exposed peak, ridge, or mountain that projects above a surrounding glacier. As the glacier slides past, the sides are slowly carved away, often leaving jagged and sharp crests. The interesting geologic process also creates very photogenic subjects. Cathedral Peak has been featured in many outstanding photographs, usually taken from the lakes below. Searching for a different perspective, I follow an adjacent ridge for a more elevated view. Fortunately, clouds build up in the afternoon, adding another visually interesting element. After shooting the sunset, I happily spend the night out under the stars.

LICHENS

Shooting this scene in the shade, I use a small reflector to bounce light onto the composition, highlighting the textural details.

Nature's abstract art, lichens are visually quite beautiful. Their variety of textures, shapes, and colors never fails to draw my attention, and I'm constantly looking for specimens in the field. This typically involves poking around rock outcrops and exposed ridges, searching the nooks and crannies.

Composite organisms, lichens are complex combinations of fungus and algae; the fungus contributes protection and water absorption, and the algae provide energy via photosynthesis. Lichens grow on a wide variety of surfaces in a diverse array of habitats, including some of the most extreme places on Earth. Their ability to colonize such challenging environments is due, in part, to their capacity to withstand both extended dry periods and extreme temperatures. When growing on rock, some lichens slowly decompose the underlying surface, contributing to the process that gradually turns the rock into soil.

LICHEN DETAIL ON GRANITE

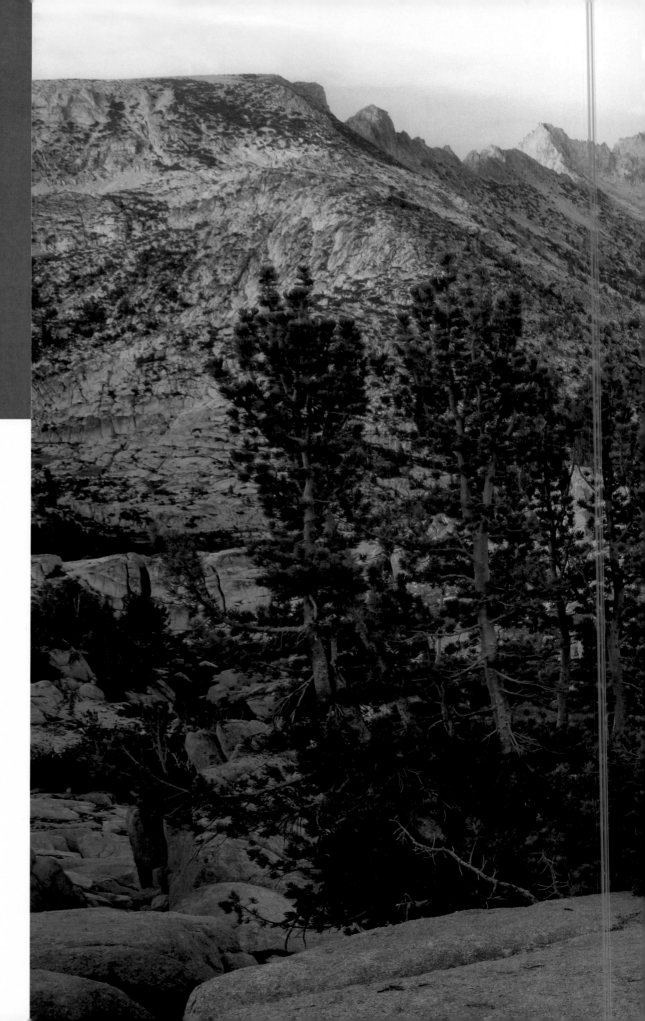

Yosemite Geology

GLACIERS ON GRANITE

BY GREG STOCK

Yosemite National Park preserves some of the most spectacular geology found anywhere on Earth. Spanning some 500 million years, the geologic story involves volcanic eruptions, earthquakes, mountain uplift, and glacial erosion. The oldest rocks in the region are metamorphosed sedimentary rocks. Deposited along an ancient shoreline between 300 million and 500 million years ago, the sediments were compacted into rock, then folded and faulted under immense pressure and high temperatures. Most of these rocks were obliterated by granite intrusion; the remnants were whittled down by erosion, leaving only a few scraps in the high country and along the park's margins. The areas

SAWTOOTH RANGE FROM MULE PASS

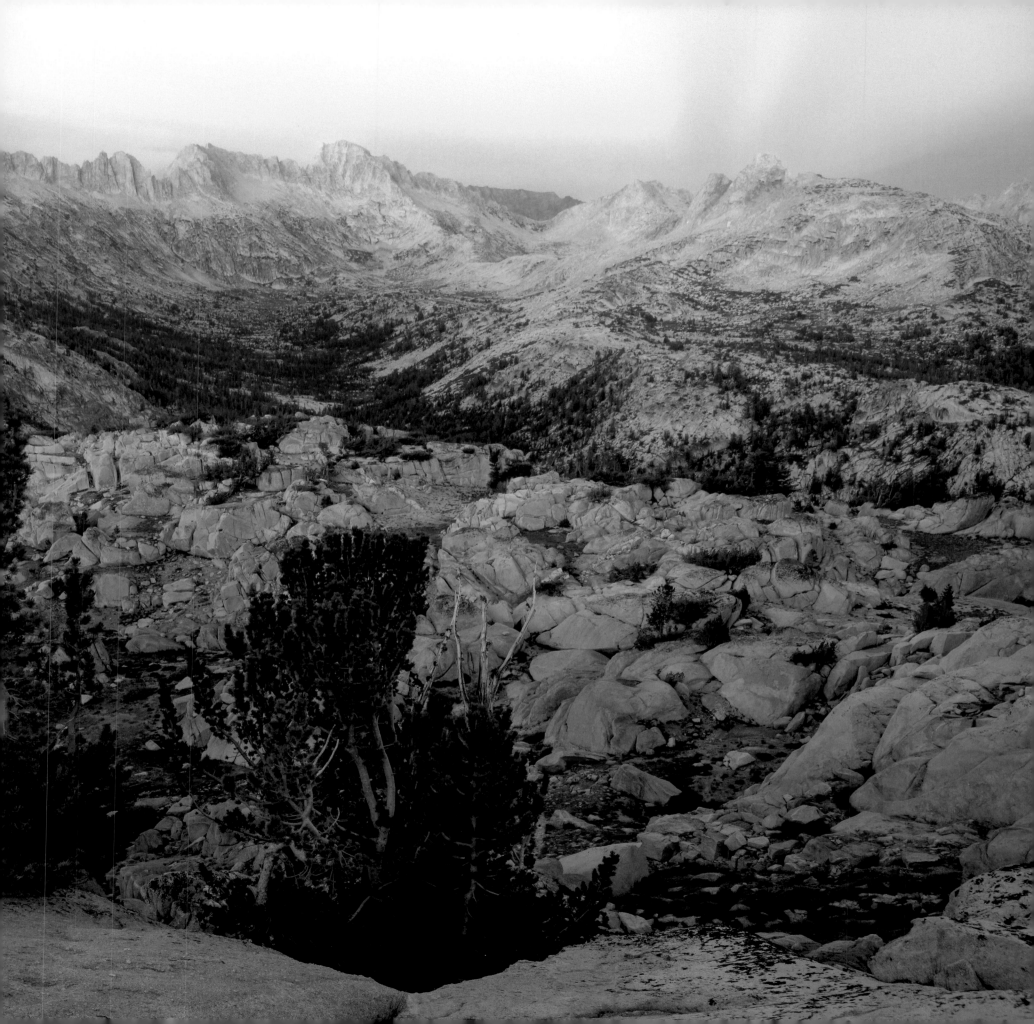

around May and Saddlebag Lakes display beautiful layered outcrops of these ancient rocks.

The granite of the Sierra Nevada was forged beneath a mountainous chain of volcanoes, similar in height and length to the modern Andes, from about 80 million to 120 million years ago, when an oceanic slab known as the Farallon Plate slid beneath (or subducted) the North American Plate. As the downgoing plate glided underneath the continent, it initiated melting of both plates, with the resulting magma (molten rock) rising toward the surface. The overall length of the Farallon Plate that subducted beneath North America is thought to have spanned some 12,000 miles (19,312 km), equivalent to roughly half of Earth's circumference, making this one of the greatest tectonic events in history.

A small amount of magma produced by subduction broke through to the surface, erupting violently from volcanoes in events akin to the 1980 eruption of Mount St. Helens. Rocks formed on the surface by volcanic eruptions are not especially strong because they cool quickly and are molecularly disorganized. However, most of the magma produced by subduction did not erupt at the surface; instead, it pooled up several miles below, where it slowly cooled over thousands of years. Slow cooling allowed time for the magma to become molecularly organized, leading to the formation of large, interlocking crystals of quartz, feldspar, biotite (black mica), and hornblende. These minerals account for the classic salt-and-pepper look of granites. The coherent mineral structure imparted great strength to Yosemite's granite, allowing it to support the soaring vertical and overhanging cliffs of Half Dome, El Capitan, and other Yosemite Valley icons. Slow-cooling magma also led to granite that is relatively free of extensive fractures, which contributes to the durability of the cliffs.

One particularly mind-bending aspect of this history is that the granites that formed in the guts of volcanoes many miles below the surface are now exposed. This is a testament to the slow power of uplift and erosion: it took more than 50 million years for water to strip away the miles-thick rocks over the granites. The erosional products—in the form of sand and gravel—were carried downslope into the Great Central Valley. Once a deep marine basin, the valley is now filled with a miles-thick package of sediments shed from the Sierra Nevada.

Over the past 10 million years or so, the Sierra Nevada experienced an uplift renaissance. Faulting along the eastern margin of the range caused the whole mountain range to tilt west, uplifting the crest and creating the strong asymmetry of the modern Sierra. As the western slope tilted, it steepened the paths of rivers that had previously meandered their way across broad valleys choked with sediment, causing them to accelerate and cut deep canyons. Uplift of the range is ongoing, usually at small annual rates but occasionally punctuated by rapid shifts during earthquakes. On March 26, 1872, a strong earthquake in the southeastern Sierra Nevada created a 15-foot-tall (4.6 m) escarpment in seconds, and the resulting ground shaking triggered many large rockfalls in Yosemite, including one near the Chapel in Yosemite Valley that John Muir witnessed with great enthusiasm.

Beginning about 3 million years ago, Earth's climate cooled and became more variable. As temperatures dropped, glaciers—huge masses of ice formed from snowflakes that move downslope under their own weight—formed at the crest of the Sierra Nevada and flowed down the existing river canyons. These glaciers plucked and abraded the bedrock over which they moved, deepening and widening the valleys and transporting vast quantities of sediment to their margins. At times a vast ice sheet covered the area around Tuolumne Meadows to a thickness of more than 2,000 feet (610 m). Only the highest peaks— such as Cathedral Peak, Sawtooth Ridge, and Mount Dana— projected above this sea of ice. The high peaks and ridges were sharpened as glaciers gouged their sides, whereas the surrounding ice-covered landscapes were smoothed and rounded.

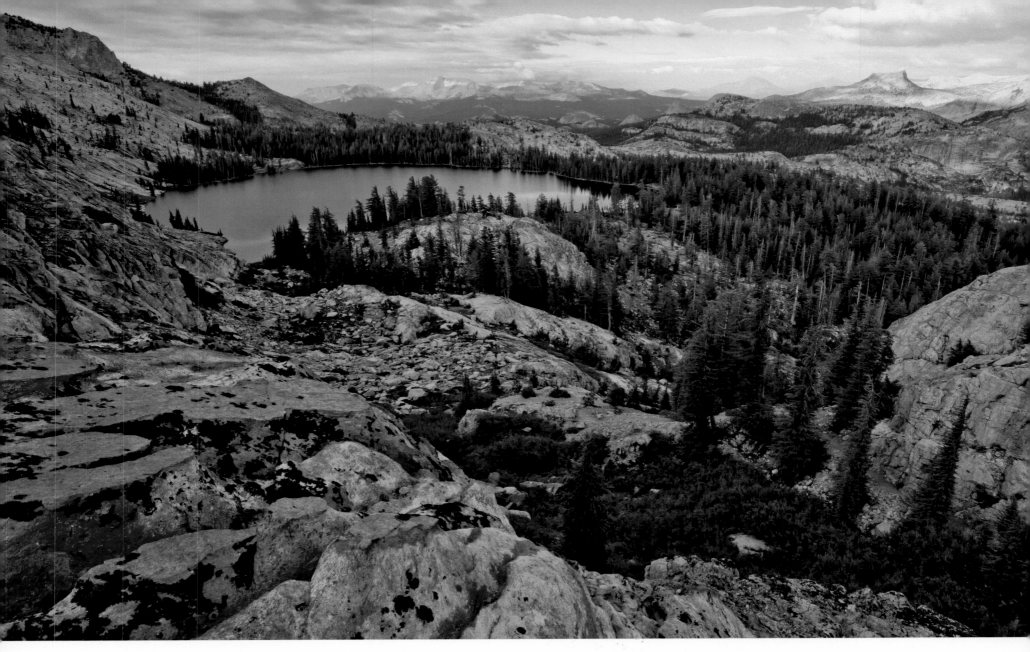

MAY LAKE AND YOSEMITE WILDERNESS

As the climate warmed, glaciers melted, revealing a scoured, gleaming granite landscape. Yosemite experienced many such episodes, each one etching deeper into the crystalline granite. Evidence of the most recent glaciation, which peaked about 20,000 years ago and had retreated by about 15,000 years ago, is everywhere in the high country: shining glacial polish, solitary erratic boulders, streamlined bedrock knobs. With the retreat of glaciers, rockfalls and floods have emerged as the dominant erosional processes in Yosemite. These powerful forces remind us that the geologic story of Yosemite is still being written in the rocks and landscapes.

Greg Stock is the first ever park geologist at Yosemite National Park. He earned a BS in geology from Humboldt State University and a PhD in earth science from the University of California–Santa Cruz. Greg has spent his entire adult life studying Sierra Nevada geology. He has authored or coauthored more than fifty peer-reviewed scientific articles, maps, and field-trip guides about the Sierra. Fascinated by all aspects of Yosemite geology, particularly glaciers and rockfalls, Greg lives in Yosemite Valley with his wife and daughter.

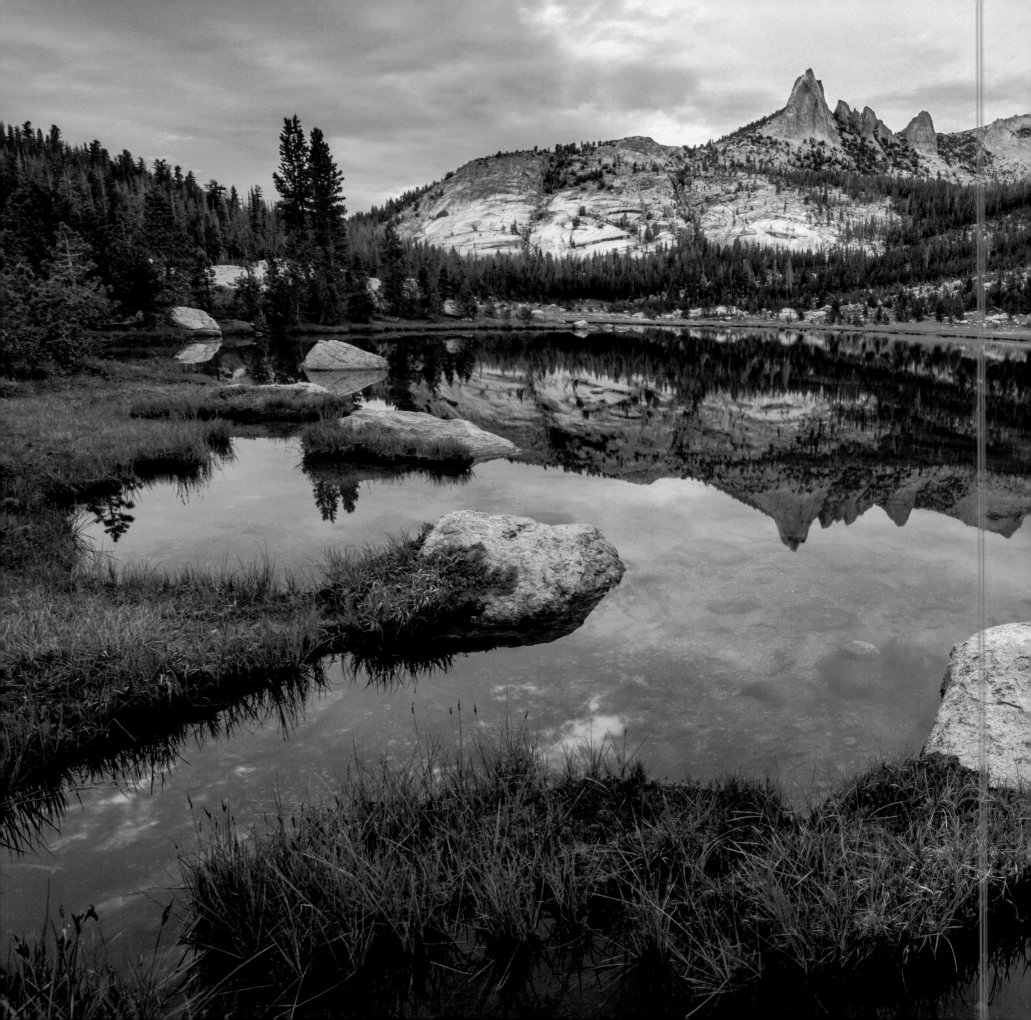

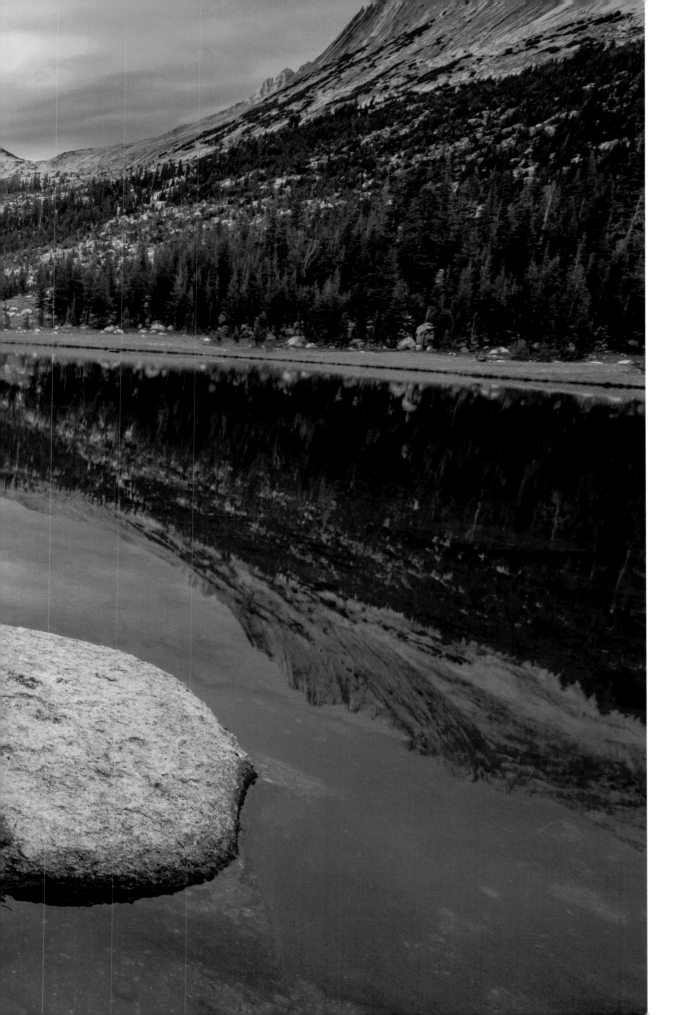

CATHEDRAL
RANGE
REFLECTION

This is one of my absolutely favorite compositions, but as much as the view is etched in my mind, the adventure I had getting here is the true experience.

Backpacking in the Cathedral Range, I am about 6 miles (10 km) into the hike when I see dark clouds rolling in from the north; I don my rain gear just as the first drops start to fall. The rain quickly turns to hail, but the pellets of ice are small and I continue on the trail. Suddenly, the hail turns marble-sized and—wham!—a few hit me on the head.

Now, it's about self-preservation, and I drop my pack and sprint for cover. Hail bombards the landscape, smashing into the granite, and I laugh out loud at the power of the natural world. The squall soon passes, and I collect my gear and continue on, ultimately arriving at this spot, feeling as though I've passed an important test.

SUNSET OVER THE CATHEDRAL RANGE

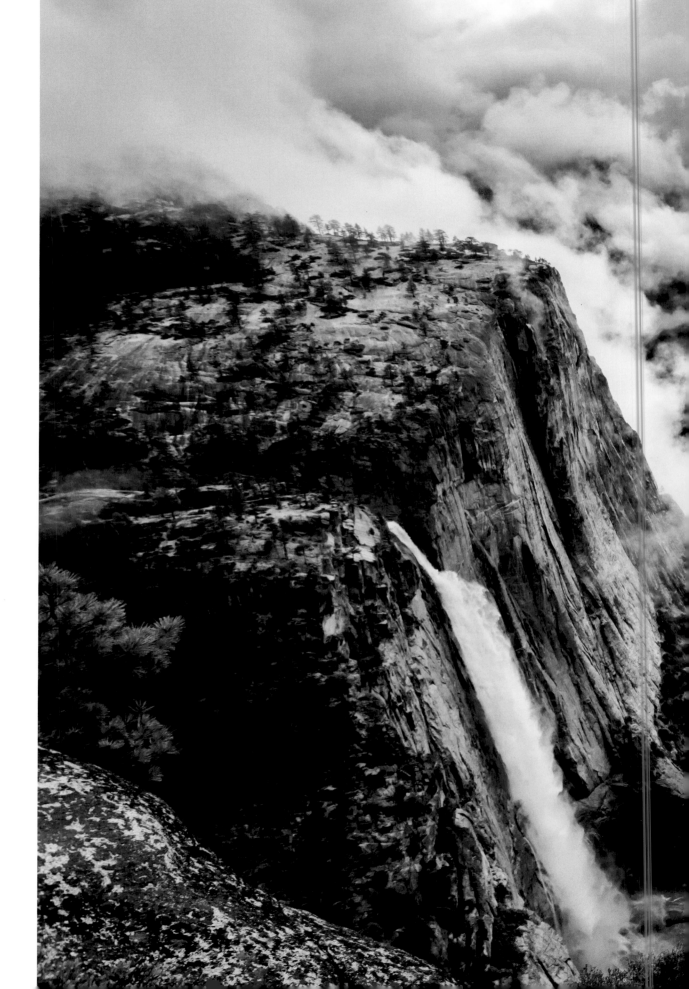

YOSEMITE VALLEY, NORTH RIM

The patter of raindrops fills my ears as I trudge up a trail with a pack full of gear to spend a few nights in the Yosemite Wilderness. Only 3 more miles (4.8 km) and a 3,000-foot (914 m) elevation gain to go before I arrive at my destination, and the rain's rhythmic cadence helps me along. Once on the north rim, I am wrapped in whiteness; visibility is less than 15 feet (4.6 m). I shoot some intimate abstracts, then see a little break in the weather and move to a spot overlooking the Valley. Like massive curtains being drawn, the clouds part and deeper vistas present themselves. Heart pounding, I stand at the precipice looking down at a 1,400-foot (427 m) waterfall and into Yosemite Valley! Within minutes, the cloud curtain closes, and the view is gone from sight. These ephemeral, magic moments are why I do what I do.

CLEARING SPRING STORM

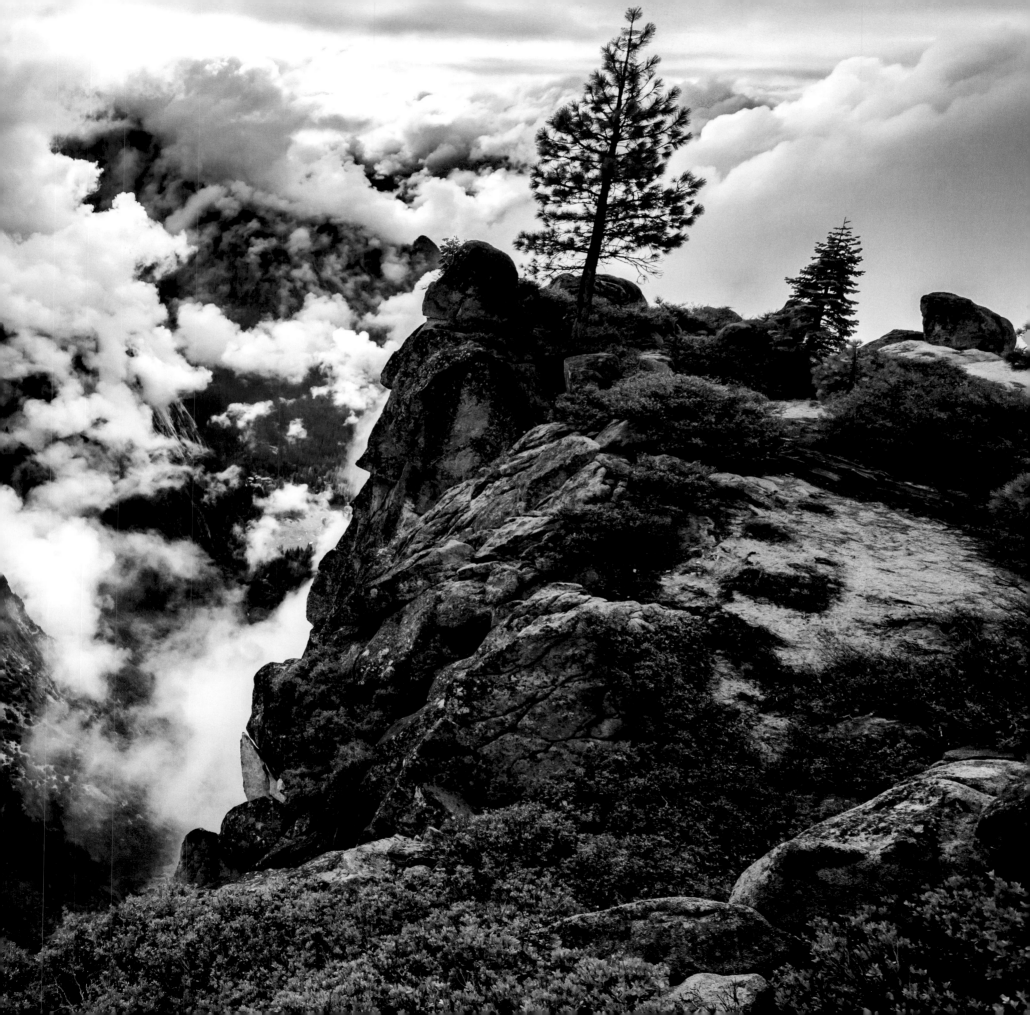

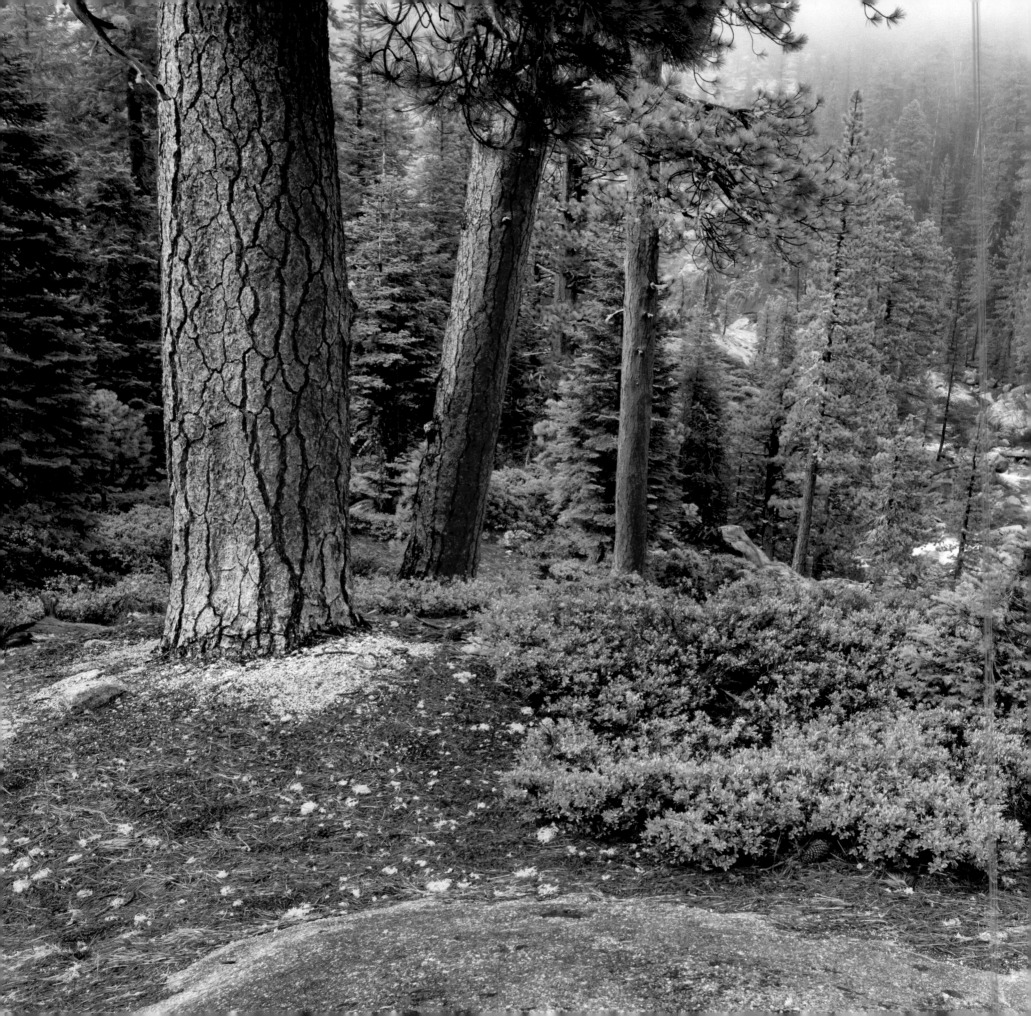

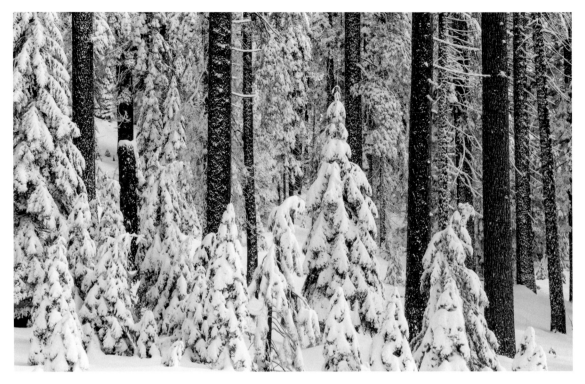

CONIFER FOREST, WINTER

UPPER MONTANE FOREST

Meandering through the upper montane forest's red fir and lodgepole and Jeffrey pines, I savor the sights, sounds, and smells that surround me. Here, roughly 6,000 feet (1,829 m) above sea level, where summers are cool and winters are cold, wet, and snowy, I feel intimately connected to the natural world, especially during stormy weather, when my attention narrows down to my immediate surroundings.

The upper montane is the third highest of Yosemite's five vegetation zones. It's preceded by the foothill-woodland (beginning at 1,800 feet; 549 m) and lower montane (3,000 feet; 914 m) zones and followed by the subalpine (8,000 feet; 2,438 m) and alpine (9,000 feet; 2,743 m) zones. Each zone has its own characteristic soil composition, climate, and moisture levels, which in turn are reflected in the types of plants and animals that have adapted to them. The higher up you go, the colder, wetter, and more extreme it gets. Above the tree line in the alpine zone, only quick-flowering herbaceous plants can find a foothold. One of Yosemite's unique opportunities is a hike with enough elevational gradient to experience these vastly different biomes firsthand.

YOSEMITE CREEK WATERSHED

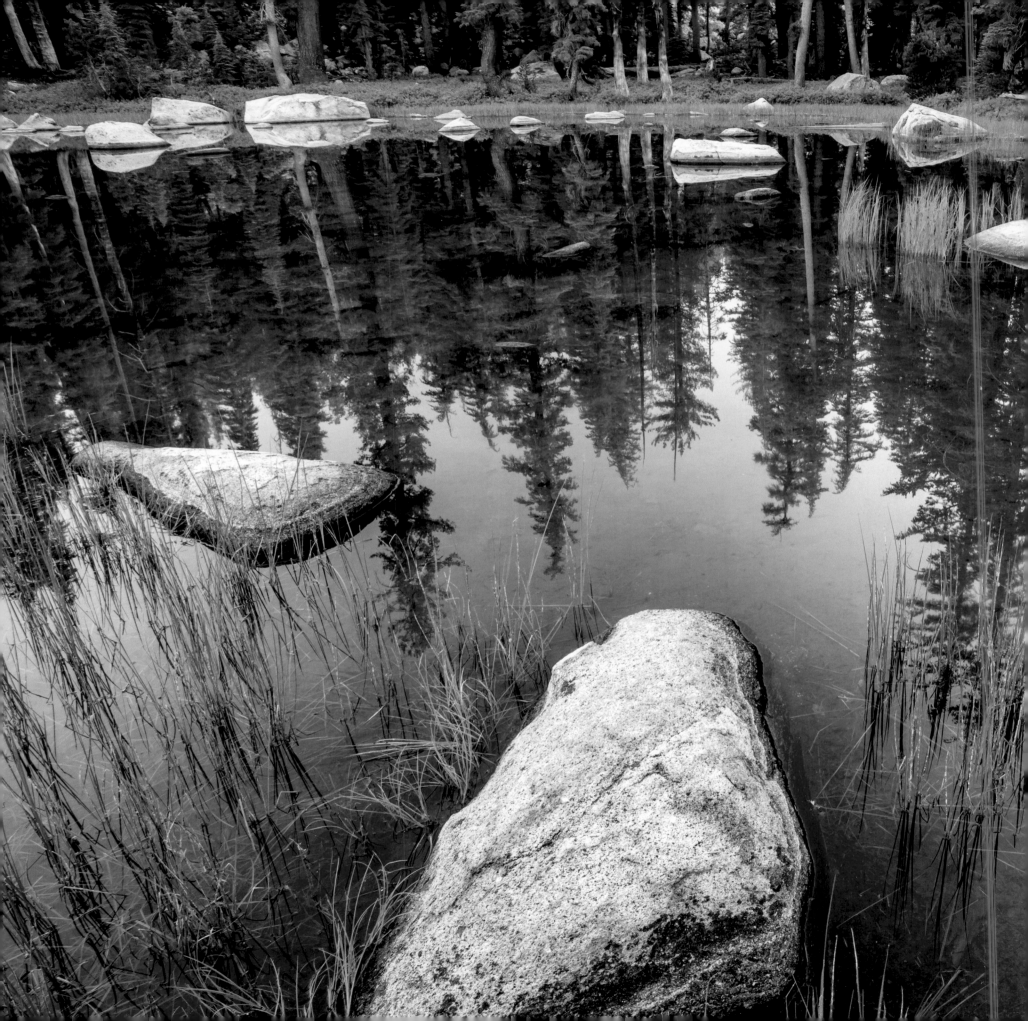

The Water Cycle

BY BROCK DOLMAN

A wind-whipped sunny day on the high seas south of Hawaii drives nature's own solar-powered desalination still, separating sweet water from the salty surface of the Pacific. The saline-free moisture rises and joins multitudes of other miraculous molecules, combining into a density of clouds flowing in the atmospheric river above. Driven eastward toward Yosemite, these aeolian acrobats fly up and over the coast ranges of California and race high above the immense flat floor of the Central Valley. The molecules feel the weight of cool air as they ramp over the foothills and ascend the forested western slopes of the Sierra Nevada, getting their first views of the white-capped spires where snow from the sea sleeps. And yet life seldom rests on Planet Water: without water, there is no life.

Many water molecules never make the mountain climb and fall away as rain on coast ranges, valleys, and foothills. Yet some tenaciously stick together and ascend en masse until the heights of the Sierra

HIGH-COUNTRY POND

119

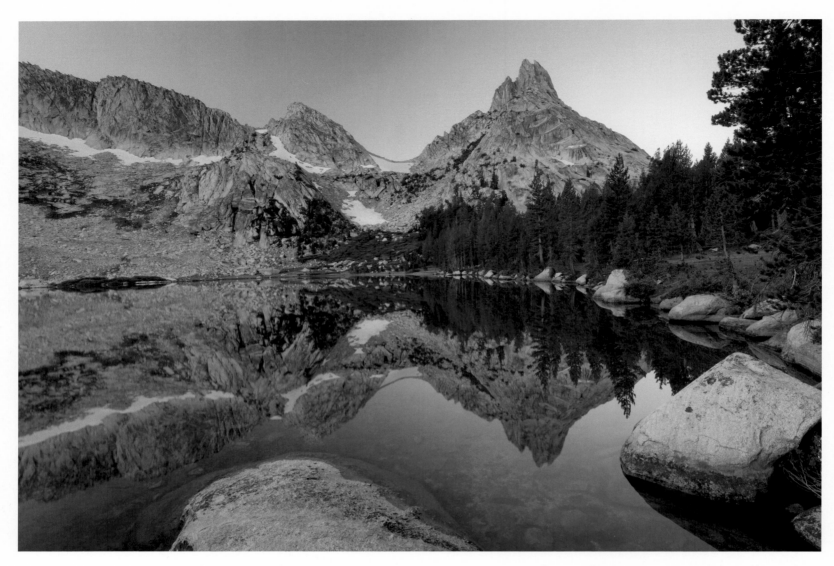

RAGGED PEAK REFLECTING IN LOWER YOUNG LAKE

Nevada cause them to fall, and the snowflakes pile up on the summits of the western slopes. A smaller number breach the barrier of the crest and cling to the precipitous eastern slopes. Very few make it beyond the Sierra Nevada, which casts a wide snow shadow over the high desert of Nevada's Sagebrush Sea.

Roughly translated, Sierra Nevada means snow-covered, saw-toothed mountains. The high Sierra Nevada is a glorious Range of Light, a name coined by John Muir, and it is also a blessed Range of White. Water that once danced in the warm, salty Pacific is held high as winter snowpack. As the seasons change, it is released from the toothy ridges and mountain meadows. In groves of western tanager–topped

trees known for tremendous trunks, the expansive shallow roots of giant sequoias are irrigated by the original drip system of slow-release snowmelt. Saturated soils and slick rocks release meltwaters to fill plunging waterfalls that grace the edges of Yosemite's hanging valleys, and rivers like the Merced and Tuolumne swell with water that has gravitational aspirations of returning to its ocean of origin. But the water's momentum is thwarted when much of it is captured in large reservoirs such as Hetch Hetchy, holding drink for denizens of San Francisco. Roughly 60 percent of California's developed water supply originates from the snow-sculpted watersheds draining off the slopes of the geologically dynamic Sierra Nevada.

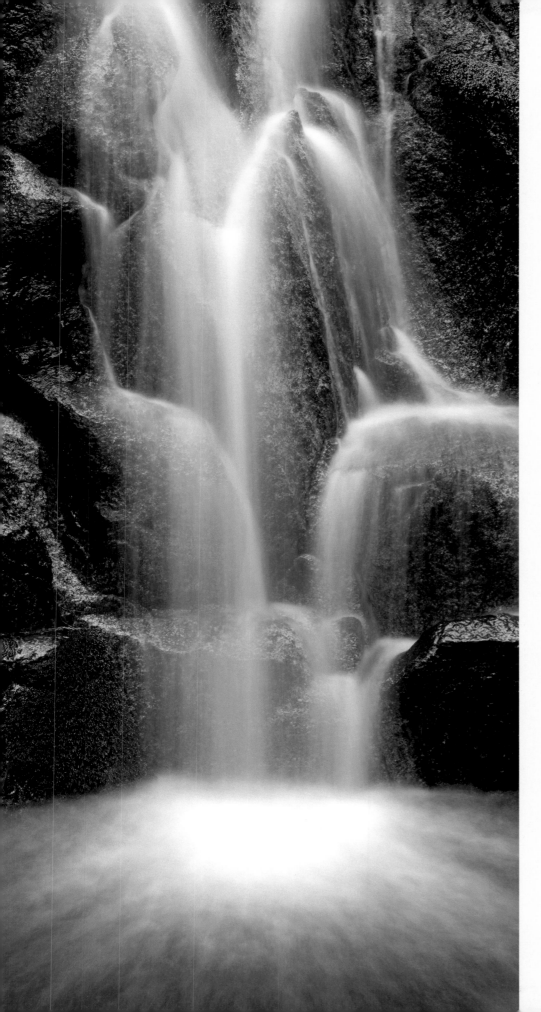

High in the Sierra, mountain lakes come and go, yielding isolated communities of aquatic life thriving in these stranded systems, such as Sierra Nevada yellow-legged frogs and Yosemite toads. In summer, frozen flakes fill lakes that spill forth in rapids of riverine revelry and rush down, down, down, bouncing boulders, pummeling pebbles, and sending sand grains on a journey fanned out onto the valley bottoms below. In Tenaya Canyon, for example, these clear, cold, and copious waters are perfectly suited to support subsurface-swimming water ouzels seeking bottom-dwelling bugs for breakfast while delivering oxygen-laden liquid downstream for spawning salmon from salty seas.

In response to the many spires east of the Pacific Crest Trail, gravity gives water but two choices for its next phase of life—the Great Valley to the west or the Great Basin to the east. The choice this water-parting divide offers is, literally, a watershed moment: Pacific Ocean or Sagebrush Sea? The journey toward the rising sun can be short, as the slopes are steep and the bottom is high, with Mono Lake as the salty reward. Brine shrimp born in these waters are eaten by a breeding California gull, which can return the water to the Pacific in the form of gull feces in Bodega Bay. On the other side of the divide, the journey toward the setting sun winds through the deep and steep Tenaya Canyon, charging the exhilarating Hidden Falls into a mirror lake feeding the meandering Merced in the shadow of Half Dome. Eventually, slowly sauntering, the mighty Merced mingles and mixes in the Sacramento–San Joaquin Delta. Buoyed by brackish bay sides, the water makes an estuarine exit through the Golden Gate to return to the great source that is the Pacific Ocean.

Some of Yosemite's no-two-alike flakes of frozen sky-water wait out the gravity of the situation. Below its namesake summit, the Maclure Glacier has persisted for centuries in its crystalline form. The Lyell Glacier is another enduring expression of the solid state, although tenuously

SMALL WATERFALL, YOSEMITE VALLEY

clinging on as a source of Tuolumne's headwaters. During formative times, these great glaciers grow gargantuan, and gravity helps them grind the granite beneath. Peaks are peeled and polished. Glaciers grow and flow, carving curvaceous canyons, making meadows, and linking lakes. Between granite and glaciers, rocks and rivers, water in elemental expressions has created the valleys of Yosemite and Hetch Hetchy, the meadows of Tenaya and Tuolumne, and the sublime summits of Mount Dana and Matthes Crest, giving testimony that H_2O is among the greatest change agents as it moves through its cycle on Earth.

..

Brock Dolman is a wildlife biologist, nationally recognized as a restoration ecologist and renowned innovator in watershed management and permaculture design. He integrates wildlife biology, native California botany, and watershed ecology with education about regenerative human settlement design, ethnoecology, and ecological literacy to engender societal transformation and illuminate living in partnership with an emergent Earth. A cofounder of the Sowing Circle, LLC intentional community, and of the Occidental Arts and Ecology Center (OAEC), where he resides, Brock is codirector of OAEC's Permaculture/Resilient Community Design Program, its Wildlands Program, and its WATER Institute. He has taught permaculture and consulted on regenerative project design and implementation in fifteen countries on five continents, as well as widely in the United States. He graduated with honors from the University of California–Santa Cruz in agroecology and conservation biology.

MOUNT DANA AND MOUNT GIBBS

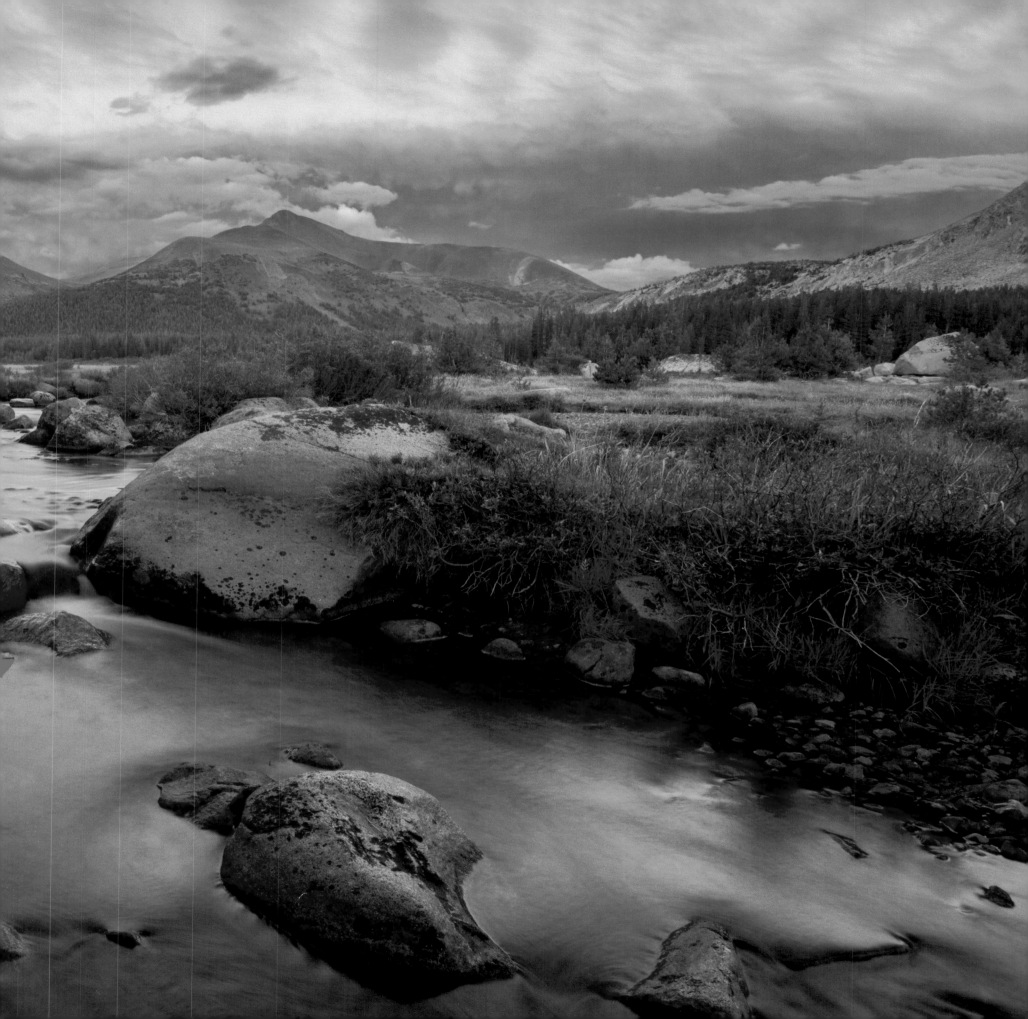

MISTY MOONRISE, YOSEMITE VALLEY

ACKNOWLEDGMENTS

...........................

Over the years, I have been privileged to interact with many amazing individuals who have influenced my life. Impossible as it is to name everyone, there are a handful of people who have had profound impacts and without whom this book would have never become a reality. My parents obviously fall into this category, not just for giving birth to me but for always supporting the varied paths my life has taken. An athletic mentor to me during my childhood, and later a good friend, Danny Porter brought a group of kids to Yosemite every summer, thus establishing my first connection to the park. My high school biology teacher, Tom Haglund, gave me the first and everlasting sweet taste of the biological world, steering me in the direction I would follow as a field biologist and later as a photographer of the natural world. During and after college, Peter Bowler and Bill Bretz provided unique opportunities and sage advice.

Nature photography is not an easy occupation. In part, success is the result of strong support and nurtured relationships. I want to thank my son, Noah (a stellar young man), and wife, Regina (the smartest person I know), for putting up with the obsessions of a nature photographer. Leading workshops, undertaking special projects, selling prints, and publishing are all important components of my life, and I'm thankful to YExplore Yosemite Adventures, the Mono Lake Committee, Tandem Stock, DuraPlaq, Direct Experiences Films, and Evergreen Lodge and Rush Creek Lodge for providing these opportunities. I also want to thank MindShift Gear and Think Tank Photo for making some of the best photography equipment on the market and for the support they've always provided.

Regarding this book, I appreciate the help of several individuals. Thanks to Adonia Ripple, Katie Coit, and the rest of the folks at Yosemite Conservancy for so enthusiastically embracing this project. Thanks especially to the thirteen brilliant contributors for providing their expertise and voices; I am truly honored to have their participation. In addition to writing the foreword, Jack Laws has been a true mentor for me; I couldn't imagine having a better one. Thanks to Nicole Geiger, who held my hand and walked me through the complicated process of publishing a book and helped refine the content. Susan Tasaki and Amy Smith Bell copy edited the text with sure and steady hands. Eric Ball's book design is everything I hoped for. Special thanks to Pete Devine for his review and thoughtful comments, and to Forrest Stanley for helping process some particularly challenging images.

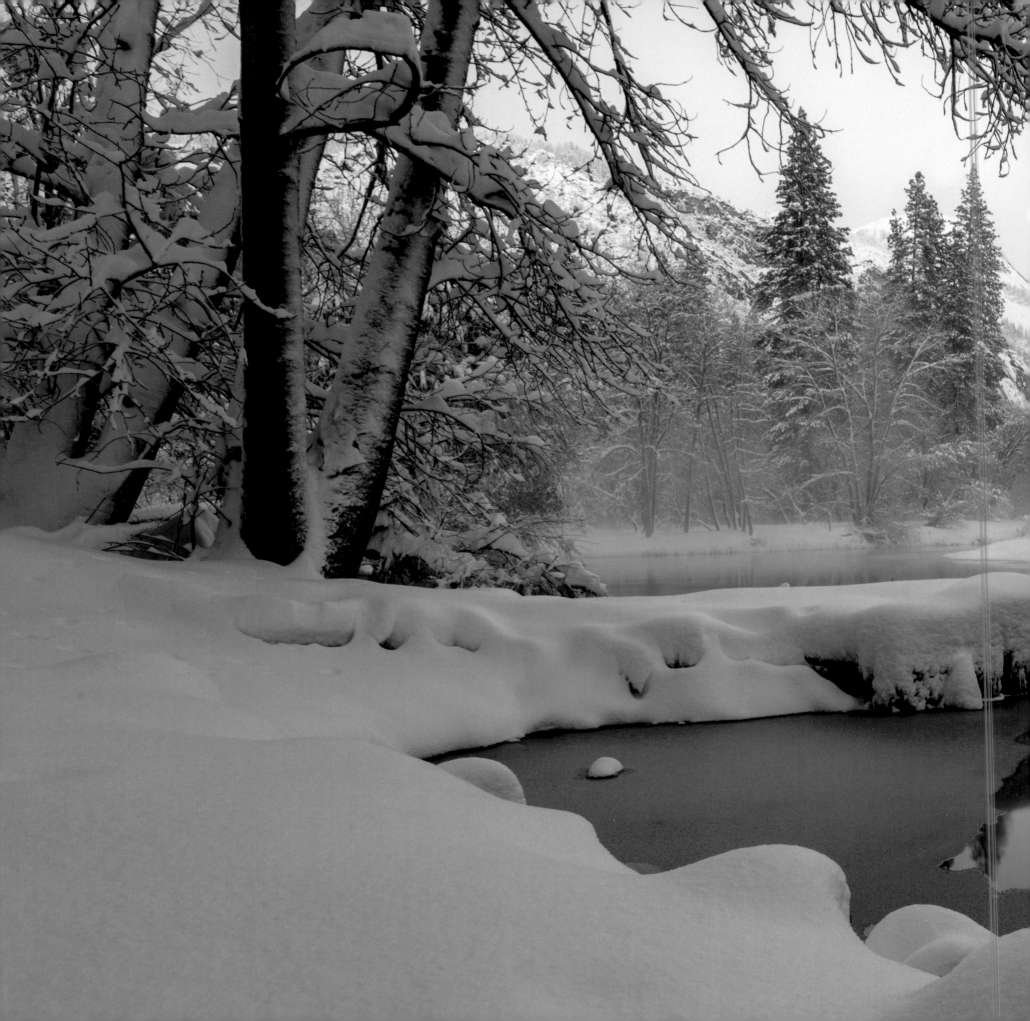

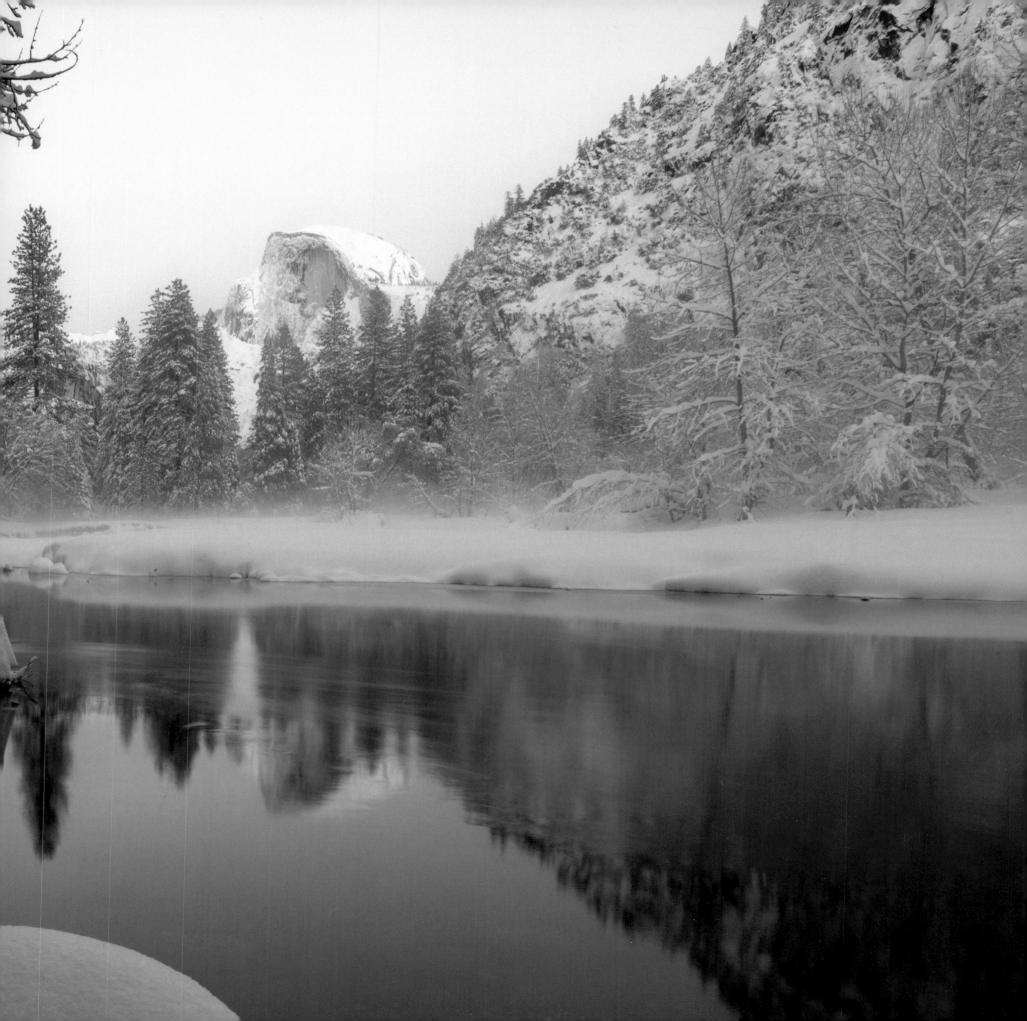

Photo: REGINA HIRSCH

ABOUT THE AUTHOR

..........................

Biologist by training, naturalist by heart, and photographer by passion, Robb Hirsch has an intimate relationship with the natural world. This connection was established early during annual childhood visits to Yosemite, which forged his bond with this magical place. After receiving his undergraduate degree from the University of California–Irvine, Robb began a career as a field biologist, working on a variety of projects for California State Parks, the US Geological Survey, and several private firms. His love for traveling and exploration has taken him through Africa, Central America, Tasmania, and the western United States. Initially, photography was a means to document his work and travels, but it soon became the focus. Robb's photography has been featured in international competitions, calendars, magazines, and gallery showings, and he leads customized small-group photography workshops in Yosemite and the surrounding Sierra Nevada. In 2002, Robb and his wife, Regina, moved to Groveland, California, where they live with their son, Noah, and two dogs. They founded Mountain Sage, a coffeehouse, art gallery, music venue, plant nursery, and garden. Robb's images and more information can be found at RobbHirschPhoto.com, and he is @robbhirsch on Instagram.